STAN LEE'S
MASTER CLASS

STAN LEE'S
MASTER CLASS

Lessons in Drawing, World-building, Storytelling, Manga,
and Digital Comics from the Legendary Co-creator of
Spider-Man, The Avengers, and the Incredible Hulk

WATSON·GUPTILL
CALIFORNIA | NEW YORK

Co-writers: Danny Fingeroth, Keith Dallas, Robert Sodaro, David Roach and Robert Greenberger.

Contributing artists: Abhishek Malsuni, Alex Ross, Erica Awano, PC Siqueira, Jim Lee, Jack Kirby, Masashi Kishimoto, Philip Tan, Elmer Santos, Louis LaChance, Chris Caniano, Marguerite Sauvage, Stefano Caselli, Pete Woods, Carlos Gomez, Jonathan Lau, Stephen Sadowski, Doug Klauuba, Jenny Frison, Edgar Salazar, Grant Bond, Carlos Paul, Debora Carita, Winsor Mc-Cay, José Luis García-López, Igor Lima, David Cabrera, Ross Andru, José Luis García-López, Jimmy Broxton, Moebius, German Erramouspe, Mike Mignola, Mike Ploog, David Petersen, Gene Colan, Johnny Desjardins, Jose Gonzalez, Stephen Sadowski, Mike Deodato, John Buscema, Dan Adkins, Francesco Francavilla, Joe Jusko, Alex Toth, Will Eisner, Jaime Hernandez, Erica Awano, Andy Belanger, Mirka Andolfo, Wally Wood, John Romita Jr., Bob Layton, H.W. McCauley, Bill Hughes, John Cassaday, Adam Hughes, J. Scott Campbell, Chic Stone, Carmine Infantino, Murphy Anderson, Howard Chaykin, Rapha Lobosco, Dave Stewart, Chris O'Halloran, Nick Bradshaw, Hayden Sherman, Kevin Lau, Takehiko Inoue, Thiago Vale, Naoko Takeuchi, Eiichiro Oda, Matsuri Hino, Macoto Takahashi, Eiichiro Oda, Tite Kubo, Makoto Nakatsuka, Steve Chanks, Carlos Gomez, Aaron Campbell, Bill Crabtree, Lee Ferguson, Marc Deering and Omi Remalante, Stephen Segovia, Minna Sundberg, Mike Esposito.

Produced in association with Dynamite Entertainment

www.dynamite.com

Nick Barrucci, CEO/Publisher
Juan Collado, President/COO
Brandon Primavera, V.P. of IT and Operations
Joe Rybandt. Executive Editor
Matt Idelson, Senior Editor
Kevin Ketner, Editor
Cathleen Heard, Senior Graphic Designer
Rachel Kilbury, Digital Multimedia Associate
Alexis Persson, Graphic Designer
Katie Hidalgo, Graphic Designer
Alan Payne, V.P. of Sales and Marketing
Rex Wang, Director of Consumer Sales
Pat O'Connell, Sales Manager
Vincent Faust, Marketing Coordinator
Jay Spence, Director of Product Development
Mariano Nicieza, Director of Research & Development
Amy Jackson, Administrative Coordinator

Library of Congress Cataloging-in-Publication Data on file with the publisher.

ISBN 978-0-8230-9843-9
eISBN 978-0-8230-9844-6

Cover illustration and color by J. Bone

Interior instructional art by Fernando Ruiz

Design by Erin Skeen Dominguez

Special thanks to POW! Entertainment, Inc., Gil Champion, Larry Lieber, Jim Salicrup, Mariano Nicieza, Danny Fingeroth, Luke Lieberman, Heritage Auctions, Roy Thomas, Chris Canino, Matt Humphries, Anthony Marques, Michael Lovitz, Marvel Entertainment, Carol Pinkus, Dave Altoff, Eli Bard, Gregory Pan.

Printed in China

10 9 8 7 6 5 4 3 2 1

First Edition

TO ALL
TRUE BELIEVERS,
KEEP ON
DREAMING!

I have been fortunate to surround myself with the

very finest artisans in the craft of storytelling for

the last 70 years. This book is dedicated to all

of them and the inspiration they have provided to

me and to countless readers.

CONTENTS

PREFACE

Hey, True Believers! We meet again.

I know, I know; you're scratching your head and wondering what's left to be said about drawing comics that we need a new volume. A Master Class, no less. What's a "Master Class", you ask? Beats me, having never taught one before, but having worked with the masters of storytelling for eighty years, I have picked up more tips and techniques than could fit in just one volume. So, if you haven't yet read *Stan Lee's How to Draw Comics*, start there. After devouring that and practicing your skills for a while, you'll be ready for what follows.

While the techniques have grown increasingly sophisticated since the days we were lucky enough to have pencil and ink for the art, the need to tell a clear, exciting story has not changed in the slightest. Readers need to know who is in each panel, what they're doing, and where they're doing it. The exciting part comes next, making it visually compelling. I developed the instincts to find the most dramatic and exhilarating angles and perspectives so the reader had no choice but to turn the page. Back before you could easily attend conventions or even take courses on graphic storytelling, John Buscema and I first put our joint experiences together in *How to Draw Comics the Marvel Way*, a classic if ever I saw one. There, we show how you can take a perfectly good, but ordinary, moment and find a way to capture the reader's attention and add some drama.

When I next cobbled together my thoughts in the first book in this series, I expanded the examples by showing you how the greatest artists throughout comics history told their stories, designed their characters, and made their fantastic worlds feel familiar. While I still go back to the classic pioneers, from Jack Kirby to Jim Steranko, I also make sure to include current favorites here. As you study the following pages, you will see how the styles have grown more sophisticated and realistic, but also pay heed to the larger-than-life needs of our kind of storytelling.

This time around, I go even further by including the internationally acclaimed and highly influential Japanese style of comic art, known as manga. We'll examine the styles: chibi (cute), shoujo (romance), shounen (action), furry friends and magical creatures, and, of course, monsters.

In every case and with every style, there remain certain basics that cannot be ignored, especially if you want to earn the title of "master artist." You have to talk the talk and walk the walk, my friend, and here I take you through the current terminology and tools of the trade. Man, if I had a laptop, I could have dialogued pages during the 1965 blackout rather than write by candlelight. You guys have it easy today, let me tell you.

Again, regardless of the style you develop, whether you're influenced by Van Gogh or McFarlane, Kirby or Cho,

you still need to understand the basics of anatomy, especially when putting your characters into action. I'll walk you through a dozen useful body poses to get you started. But that's not all! No, effendi, I also tackle the challenging, but necessary, perspective to ground your action in a realistic setting. We'll start you easy with one-point perspective but get you up to experimenting with curvilinear perspective and creating depth.

Now, I mentioned "realistic" a few lines ago, but clearly, not every story is set in New York City. Through the years, I've had to help imagine countless alien races from awe-inspiring galaxies and new civilizations. I'll share some of the tips I've learned along the way from lifeforms to machinery, architecture to clothing. After all, the Skrulls couldn't buy off the rack at Macy's, could they?

Let's say you've diligently worked your way through all this and are ready for more. Then we begin to put it together as you tell your story. For me, pacing is incredibly vital, so the action rises and falls, with each page forcing you to turn to the next. You'll learn how to design a page and wrench every drop of emotional drama out of each panel. You have to make sure the reader is rooting for the hero, hissing the villain, and hoping Earth survives to see another sunrise.

Let's say you're an artist but don't think you're ready to tell your own stories. No problem. For my Master Class students, I provide you with three practice scripts so you can practice without worry.

Now, books like this don't happen without a little help. This time, Dynamite Entertainment recruited Keith Dallas, David Roach, and Robert Greenberger to help me take you through the ins and outs of contemporary comic book drawing. Follow these tips and guidelines, learn to walk before you run, and in due time, you will feel like a master. The results are something I can only look forward to so for now, I wish you the very best of luck.

Excelsior!

Even heroes need the proper gadgets and devices to complete their job.
Project Superpowers #1 cover art by Alex Ross

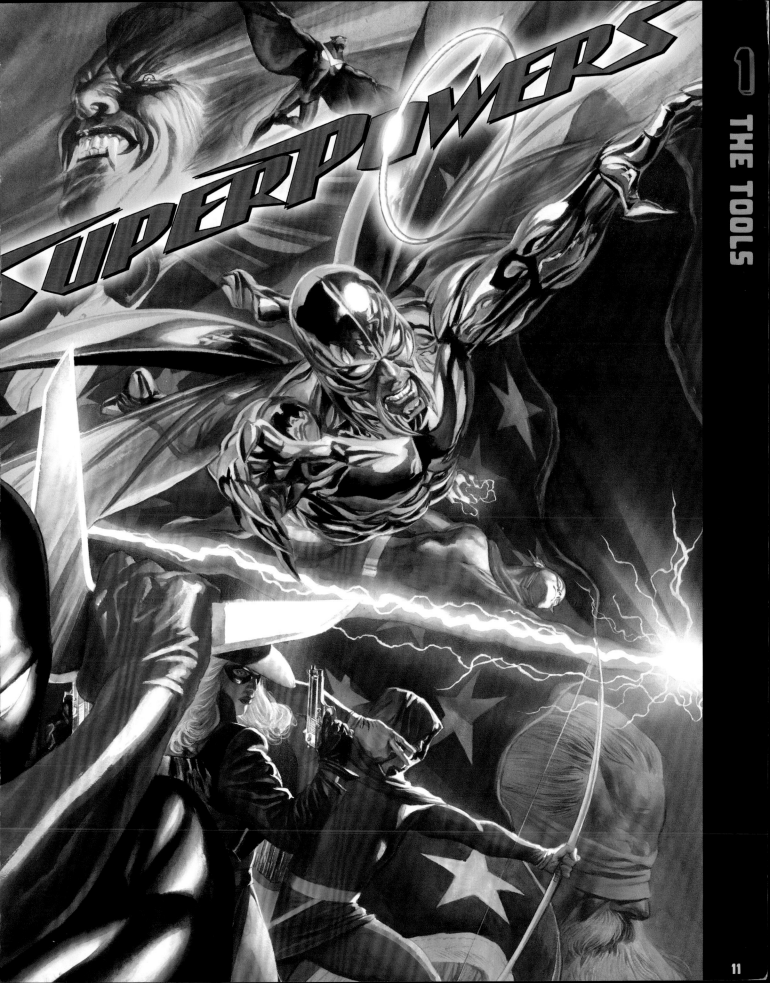

As you probably know, I've been in the comic book business for many, many years. The number of wonderfully talented artists I've had the pleasure of working with is too many to count. One thing that strikes me about artists, though, is how differently they all work. For instance, some artists like to get up at the crack of dawn and start sketching. They don't even wait for breakfast! Other artists like to burn the midnight oil, drawing away when everyone else, especially yours truly, is fast asleep! Some artists like to talk on the telephone or listen to music while they work. Others need complete silence to concentrate. I tell you, no two artists seem to work in the same way.

This maxim holds true for the tools that artists use as well. By tools, I mean the things artists actually use to create art! Some artists have a favorite pencil they draw with—no other pencil will do. Don't even think about showing them a different pencil! Other artists have no problem switching pencils, especially if they feel they need a different "look" for the comic book they're working on at that moment. Some artists only feel comfortable penciling their artwork, and they want someone else—a different artist—to handle the inking. Other artists want to do it all by themselves. They'll do the pencil work, the ink work, and sometimes even the coloring work!

Let's not forget this is the twenty-first century. Everyone uses a computer! Even me! And you better believe the use of the computer has become widespread within the comic book industry. Just about every professional uses a computer for one part of the art process or another. I know many artists who draw their layouts and then scan them in order to continue the process on the computer. Heck, I even know artists who do all of their artwork on a computer! They don't even use a pencil or paper. What an age we live in!

However, just because some artists do all their work on a computer doesn't mean you have to as well. It's important to remember that professional comic book artists have spent years figuring out what process, what work schedule, and what tools will give them the best results. It's up to you to figure that out for yourself! Don't buy the same tools or use the same computer software just because your favorite artist uses them. What works for them might not work for you! Experiment! Try out different techniques. Go to the art supply store and buy different pencils, paper, brushes, inks, and so on. Only by sampling everything that is available will you be able to figure out what works best for you.

That said, if you're just starting out and would rather not spend a lot of money right away, stick with the basics. The beauty of creating comics is that you really only need two items: a pencil and a piece of paper. So, as I describe all the different tools a comic artist uses, let's start with those.

The art store: Emporium for an artist's gadgets.

PENCILS

There's nothing wrong with starting off with the standard #2 pencil that you used in school. However, before too long, you will want to head over to your local art supply store to get your hands on pencils that have specific HB grades. HB is a measure of a pencil's lead weight. "H" stands for "hardness," and "B" stands for "blackness." A pencil with a high H value will leave lighter, finer lines on the paper. A pencil with a high B value, on the other hand, will leave heavier, darker lines (which will be more likely to smudge). Buy some pencils with different HB values and give them a try to see how the texture of your artwork changes depending on the pencil you use.

Pencils: The most common and necessary tool of a comic artist's tools.

You can also choose to use mechanical pencils. Unlike regular pencils, you never need to sharpen mechanical pencils. You just press the button to push out more lead. Just so you know, though, the points of many mechanical pencils are so sharp that they can puncture the paper you're drawing on if you're not careful! Unlike your #2 or HB, mechanical pencils come with different casings, and you should experiment to find the one that feels right in your mighty grip. Consider an anti-slip finish along with a solid grip along the case (too rubbery and your fingers might slip). Unlike the sturdy wooden casing

around the lead of regular pencils, these mechanical marvels come in a variety of widths, so make sure it feels absolutely comfortable in your hand.

Mechanical pencil: Handy for artists who always need a fine line without using a pencil sharpener.

PAPER

Speaking of paper, you might think one sheet of blank paper is the same as another, but try to draw on different kinds of paper and see what happens. Take a pencil and draw a figure on a sheet of paper that you use for the printer. Using the same pencil, next draw that same figure on a sheet of "fancy" paper, like the kind that you might use for printing your résumé. Just for good measure, draw the same figure on a thin piece of cardboard. Now place all three of your sketches side by side and examine them. See any differences? Without even looking that hard, you should be able to

Paper: Bristol board paper is the most common for the comic artist.

notice how the texture of your artwork changes according to the paper on which you draw.

Naturally, you're about to ask, "What paper is best for a comic book artist?" Just about every professional I know uses Bristol board. You can buy it at art supply stores or online. It comes in pads of twenty sheets of paper. Bristol board is a heavier, sturdier, oversized kind of paper than what you might use in your printer. Heavier paper better absorbs ink, which is good because a comic book artist can end up using a lot of ink, and the last thing he wants to see is ink bleeding all over his paper!

In general, there are two types of Bristol board: smooth and rough. You should try drawing on both types to see how it affects your artwork. Smooth Bristol board tends to capture details better, but only with the right pencil. For instance, drawing on smooth Bristol board with a mechanical pencil can be very tough. One artist told me it's like trying to draw on the hood of a car! Rougher Bristol board can be easier to draw on with a softer B pencil and is great for creating tonal effects.

Both kinds of paper have strengths and weaknesses for inking as well. The smooth Bristol board is perfect for using markers and other kinds

of pens, but ink dries more slowly on it (making accidental smudging more likely), whereas ink dries more quickly on the rough boards, but it can be a little harder to get very pure, unbroken lines.

It used to be that the major publishers would privately produce paper for their artists, adding the rules in non-reproducing blue ink to show where the art had to reside in order to be seen on the printed page. Since then, several art supply companies have produced preprinted artboards in a variety of finishes so you don't have to start by ruling the pages. Talk about a timesaving service!

That's why I keep suggesting to try out different tools before settling on anything. Some practitioners of the craft settled on a set of tools and never changed during their careers, while others constantly experimented with different pencils, brushes, inks, and paper stocks. You have to find the materials that you feel will bring out the best of your talent.

Erasers: There are many types for removing mistakes, such as pink, acrylic, and kneaded.

ERASERS

Believe it or not, besides buying different types of pencils and paper, you will also want to buy different kinds of erasers. You're probably most familiar with the pink rubber variety of erasers. Those are very effective, perhaps too effective. You can rub off the surface of the paper if you rub too hard with them! For that reason, you will also want to

buy white plastic erasers, as well as gray kneaded erasers. You can mold kneaded erasers into different shapes to allow for very precise erasing. Let's say you only want to erase a very small line of your artwork. You can shape your kneaded eraser into a small point so it will only erase that line and nothing else. On larger areas, the best approach is probably to use a kneaded eraser to take the top layer of graphite off, then gently go in again with the white to take off the rest without rubbing too hard on the surface of the paper.

Of course, you can only use erasers on penciled artwork. Even I understand that you can't use an eraser on inked artwork! Nothing can erase ink lines. Many artists correct an inking mistake by going over it with correction fluid (also known as Wite-Out or Liquid Paper) and trying again. Any professional artist will tell you if you plan on drawing with ink, have plenty of bottles of correction fluid handy. Some artists also use a white paint, usually gouache, which you can then ink over with a brush, though it is harder to work on with a pen.

INK

While I'm on the subject of ink—if you think I'm talking about drawing with a ballpoint pen, think again. I'm talking about dipping brushes or quills into bottles of ink and then employing techniques such as feathering and cross-hatching to make your drawing look truly magnificent! Artists can also use ink to show shadows or to give their artwork a sense of depth and weight. As you'll see when you shop online or go to your local art supply store, there are many different brands of ink. As a result, it might take you a while to figure out which brand you like the best. Whatever brand you choose, make sure it's labeled

Ink: Used for dipping a brush or quill.

"waterproof India." That's the most durable kind of ink, and it won't smudge once it has dried.

As far as brush and quill selection goes, you will want to have a

Quill or pen: for dipping into a bottle.

variety of them on hand, as each one will produce a different kind of line. Many artists prefer red sable brushes, but others use watercolor or acrylic brushes.

I could probably write an entire book on the pens and brushes artists use to create their magic, but let me just give you the basics. This is another case where experimentation is vital. You want to hold the brushes in your hands, use them on your paper of

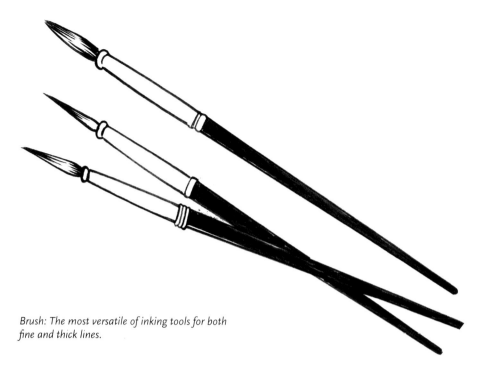

Brush: The most versatile of inking tools for both fine and thick lines.

choice, and get a feel.

Going back to when I first began working in this wacky world of comics, Winsor & Newton have been the most popular brand of brushes, but they are by far from alone. They're numbered like the HB pencils, so the lower the number, the thinner the line. A number 2, for example, will give you a very thin line for texture, while a number 7 provides a thicker line for outlining figures.

Among the pen nibs, the Hunt brand remains the most enduring and popular. Each quill nib has a number as well, ranging from 99 to 108, but most artists start and stop with a 102, with 107 being the second most popular.

If you would rather not handle bottles of ink, you can use inking pens instead. Many artists like to sketch with Micron pens. These produce very fine lines and are more precise than Sharpie markers. Best of all, these pens are not very expensive! However, if you can afford to spend more money,

you should also buy a set of technical pens. Rapidograph pens are arguably the best around and they have the added bonus of having refillable cartridges. This way you get to keep each pen's high quality point. On the other hand, with Micron pens, the whole

thing needs to be replaced after it runs out of ink.

One interesting difference between these pens is that the Rapidograph ink lays on top of the art and the page, while the Micron pen ink gets absorbed into the paper.

RULERS

I don't care how steady your hand is: You are going to need to use rulers, not only to draw a perfectly straight line, but for other purposes as well. For instance, a T-square is invaluable for drawing a series of parallel lines (which are, in turn, very helpful for constructing your panel borders). French curves enable you to draw accurate arcs and seamless sweeps. Need a circle? Use a circle stencil! Want to get angular? You'll need a 30-60-90 set square. Get your hands on as many different kinds of rulers as possible—long rulers, short rulers, see-through rulers, raised rulers, triangles, and so on. You will soon learn that rulers are the best friends a comic book artist can have.

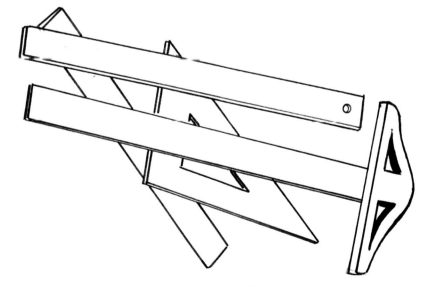

Rulers: All types are beneficial for one reason or another in drawing.

DRAFTING TABLE

Some professionals consider a drafting table a must-have tool. Others consider it a luxury that artists should get only if they have the money to buy it and the space to fit it. If you haven't seen them before, drafting tables have surfaces that you can tilt upward. This feature allows artists to draw in a more comfortable position. Of course, there's nothing wrong with using your desk or kitchen table to draw your comic books. It's just that when you use a standard desk or kitchen table, you have to hunch over your artwork. Sitting in that position puts a strain on your body. It won't take long for your neck to get sore and for your back to ache. An artist using the tilted surface of a drafting table, however, sits with better posture. With a drafting table, you can draw for longer hours than you can at a standard desk or kitchen table. It's like the difference between a cushioned recliner and a steel chair. You can sit in both, but which one feels better?

Some drafting tables have glass-top surfaces. You can put a light underneath the table to create a "light box" effect; that is, when one page is placed over the other, the light shines through both, allowing the artist to see the image underneath. Many people use this technique to trace through the key elements of a rough layout onto the final sheet of paper, or to copy reference photos. It also allows you to see perspective grids or layouts when you place them underneath your drawing paper or art board.

A cheaper alternative to both is a small tabletop board with adjustable legs which sits on top of any table and allows for a degree of adjustability in how flat or vertical you want it to be. This won't be as big as a drafting table, but it will certainly be cheaper! You can also use it as a lapboard for when you're drawing away from home. My old pal Vinnie Colletta was known to use a lapboard as he inked while floating in his pool—not something I would recommend to beginners.

COMPUTER

If all this talk about drafting tables, Rapidograph pens, and Bristol board starts to intimidate you, then allow me to repeat something I said at the beginning of this chapter: The beauty of creating comics is that you really only need a pencil and a piece of paper. With just those two things and your imagination, you can create comic book magic!

All of those tools have been around in one form or another for the last century, leading to some of the finest comic art you can imagine. But times change and for the last thirty years or so, new tools have been added to an artist's arsenal.

Having said that, I know many of you aspire to become professional artists or to show your comic books to someone other than your parents and friends. In that case, you simply must own a computer. Only with a computer can you create the kind of visual effects that you often see in professional comic book art. Only with a computer can you connect with other comic book creators, from around the world! Thanks to the internet and email, a writer in England can get in touch with an artist in Argentina, and the comic book that the two of them create together can be sent to a publisher in the United States. (And none of these people ever have to get on a plane in order to meet each other.) Heck, with a computer, you really don't need a publisher to bring your comic book to the masses. You can post it online yourself!

The kind of computer you should buy depends on your personal preference and your budget. It wasn't too long ago that every professional comic book artist worked on an Apple Mac computer. That's because the specific software programs that the artists typically used ran best on Mac computers.

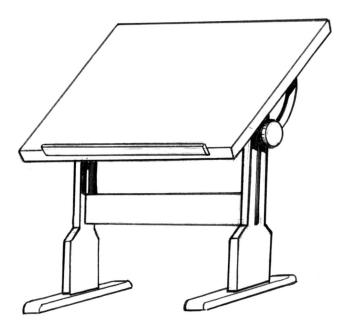

Drafting table: If possible, get one with an adjustable surface.

Computers: The computer has evolved into one of the most versatile tools for the comic creator, not only for adding color, but for both drawing, painting, and lettering as well.

Adobe Photoshop: the most common software used for coloring and other aspects of comic creation.

Adobe Illustrator: the letterer's choice for all dialogue and narration on the comic book page.

But now those programs are fully functional for Windows-based computers. As a result, more and more artists use PCs manufactured by Dell, HP, Lenovo, and so on. Generally speaking, Mac computers are more graphic-oriented and "user friendly" (they're also better at avoiding computer viruses). Windows-based PCs, on the other hand, are more affordable—up to three times less expensive than Apple computers.

So again, the computer you should buy depends on which brand you prefer and how much money you can spend. Both a Mac and a Windows-based PC will handle the tasks that you need your computer to do—as long as it is a relatively new model. I can certainly understand the desire to save some bucks and use a computer that is a few years old. The problem with older computers is that they may not have the necessary processing speeds to run the software programs you will need to use. You will end up wasting a lot of precious time waiting for your old computer to execute a task (and that's assuming your old computer can even run the software in the first place).

SOFTWARE

What particular software programs might you want to use? Three in particular come to mind: Adobe Illustrator, Adobe Photoshop, and Clip Studio Paint. While none of these programs will do the drawing for you, they can dramatically enhance your artwork. Adobe Illustrator is used mainly by professional letterers to create logos, fonts, sound effects, and word balloons. Adobe Photoshop is more versatile and is used by artists for many purposes, like altering their artwork (without having to redraw it),

Clip Studio Paint: a popular digital tool for the creator.

inserting visual effects, cleaning up scans, and so on. Most colorists prefer to work with Photoshop. The program easily allows them to add lighting effects, change hues, or even swap out one color for a completely different color. Clip Studio Paint is a more recent program, and it has become very popular among comic book artists. Unlike Photoshop and Illustrator, Clip Studio Paint was specifically designed for the digital creation of comic books. As a result, it is better equipped to format illustrations and it has tools and features aimed to speed up the art process. For instance, one Clip Studio Paint tool allows you to take a line that you drew and make it thicker or thinner. Another tool helps you create an accurate perspective for your drawing. I'll describe other neat Clip Studio Paint features in greater detail in Chapter 10.

Digital tablet: Many creators gravitate toward creating art digitally, and this is the most common tool for freehand drawing.

DIGITAL TABLET

Since I'm talking about the digital creation of comic books, I might as well mention the option of purchasing a digital tablet for drawing. Think about it: All the materials I've just spent so much space describing to you (pencils, paper, ink, erasers, and so on) can all be replaced with a single tablet that syncs with your computer. You can create artwork on a tablet with a pressure-sensitive pen and save it as a digital file to print out or share online whenever you want. Drawing on a tablet, though, takes a lot of practice. Several artists have told me that they have never been satisfied with the drawings they produce on tablets. They much prefer to draw on paper with pencils and pens. To be fair, several other artists have also told me that they will never go back to drawing on paper because they love how their art looks on a tablet.

Remember, the tablet is a drawing surface, so you will also need a monitor. While size matters, consider the sharpness and resolution and then the size for the space you have reserved for creation. The size issue also matters for the surface area of your tablet; the larger the surface, the freer you will feel to move your hand. The sensitivity of the surface is measured as pressure levels, with basic models having 1024 levels of sensitivity and higher-end models having 2048 levels, capturing your subtlest moves. Some models will have function keys, which you can customize once you figure out what you need. It's sort of like your game controller, but more productive.

As I told you before, you need to figure out for yourself what tools and methods work best for you. A drawing tablet will cost you between fifty dollars and several hundred bucks. Some of the more expensive tablets will have larger drawing surfaces as well as better features.

SCANNER

Even if you want to stick with paper, pencils, and pens, you will still need something that can scan your artwork and convert it into a high-resolution image that you can post online, email to someone else, or alter with one of the software programs previously mentioned.

The higher the resolution, the more accurately the scan will capture the subtlety and line quality of the original page. There are literally hundreds of types of scanners to choose from. Make sure to choose a flatbed scanner, which requires you to lay your artwork flat on a glass surface. You don't want your artwork ruined by a scanner that uses rollers. Additionally, if you intend on drawing on the same kind of artboard that comic book professionals use, make sure to buy a scanner with at least an 11 × 14-inch surface so that your artwork will fit on it. Otherwise, you will have to scan your artwork in separate halves and connect them through Photoshop. Believe me, that extra work can give you a headache. And if there's one lesson I hope you learn from reading this book, it's that creating comic books should not be a chore. It should be fun!

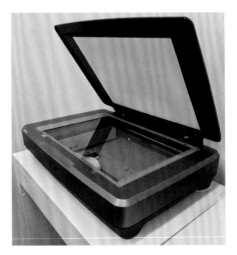

Scanner: Enables the artist to digitize their artwork for production purposes.

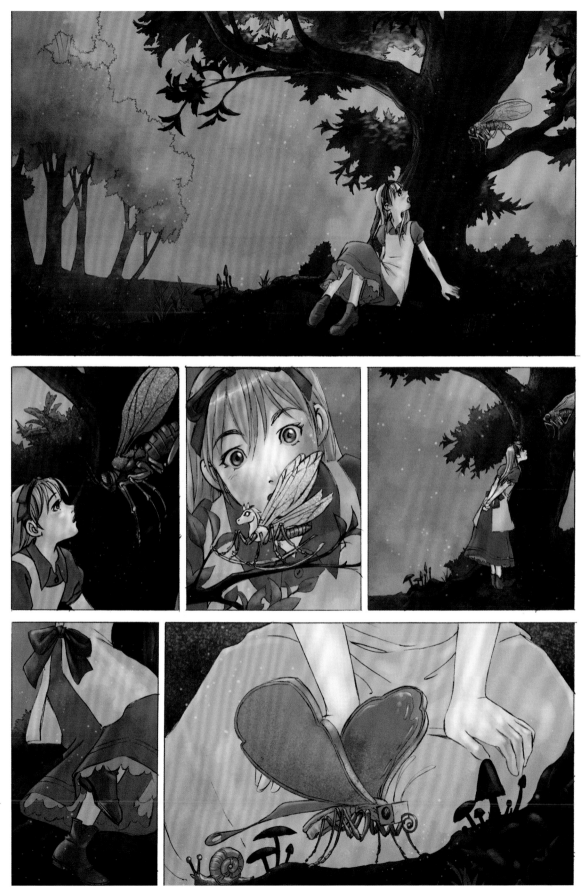

From a penciled page to being scanned then inked and colored all on the computer. This shows the powerful combination of tradition and technology evoking watercolor illustrations in a book. Art by Erica Awano and color by PC Siqueira.

DEFINING TERMS

Before I go any further, I want to familiarize you with the lingo of the comic book industry. By that, I mean the common terms that every professional comic book creator knows and uses. As you read through this book, you will see these words used over and over again. It's important for you to learn their meanings now. That way, you'll have no problems understanding the lessons ahead in the book. Besides that, once you become acquainted with common comic book terms, you will be able to properly communicate with other comic book writers and artists.

Some of these terms might already look familiar to you, especially if you already read *Stan Lee's How to Draw Comics*, so why make you go through them all? It's important because they might mean something different to comic book creators than to others. For example, when a comic book creator hears the word "balloon," the first thing he thinks of is not a small bag that gets inflated with air. Likewise, to a comic book artist a "gutter" is neither part of a bowling alley nor the part of the street that collects rainwater. Do you think the words "plot" and "script" mean the same thing? Not to a comic book writer! Not even close!

So without further ado, here are some common comic book industry terms that you need to recognize and understand:

ART BOARD

Thick oversized paper (usually 11 × 17-inch Bristol board) used by artists to draw comic book pages.

BALLOON

A bubble that surrounds words indicating a character's dialogue or thoughts.

BREAKDOWNS

Preliminary pencil work that establishes the panel layout for a page as well as character positions within panels. Breakdown artwork is rough and undetailed.

The sketch above shows how an artist can figure out composition before focusing on the details.

11 x 17-inch art board: usually provided by the comic publisher and has guides printed in blue on the page.

CAPTION

A text box that may indicate setting, time, a narrator's commentary, or even a character's thoughts (in lieu of thought balloons).

COLORIST

The artist who applies color to a comic book page after it has been inked. For years, artists used special dyes to color comics books. Today, coloring work is performed digitally, usually through the use of software like Adobe Photoshop.

COVER

The first image we see on the outside of the issue, and arguably the most important part of a comic book. A successful cover provides an image that not only encapsulates the issue's story, but also compels the reader to buy the comic book.

CREDITS

The names of the people who collaboratively produced the comic book, usually listed in this order: writer, artist (penciler/inker), colorist, letterer, and editor.

EDITOR

The person who manages the creation of the comic book by assigning tasks, setting deadlines, and overseeing work accomplished by the writers and artists.

FILE TRANSFER PROTOCOL (FTP)

A method for transferring large files via a computer network. Since scans of high-resolution artwork are too big to email, FTP becomes a convenient—and secure—way for comic book creators to share files. Current alternatives to FTP include websites like Box.com, Dropbox.com, and Wetransfer.com.

Now the most hated person in the world, Vampirella decided to take a nap after defeating Lucifer and his off-brand Heaven. Her dream became a first year psych student's...ummm...dream come true when Vampi runs into her animus, Vampirello, and then a room full of her past iterations who seem to have just been waiting around to work some stuff out. Jeez...most people's stress dreams just involve being late for class.

Writers
Paul Cornell
Jeremy Whitley

Artist
Andy Belanger

Colorist
Lee Loughridge

Letterer
Travis Lanham

Cover A
Philp Tan & Elmer Santos
Cover B
Andy Belanger
Cover C
Cosplay Photo Variant
Cover D
Jimmy Broxton

DYNAMITE.

Nick Barrucci, CEO / Publisher
Juan Collado, President / COO

Joe Rybandt, Executive Editor
Matt Idelson, Senior Editor
Anthony Marques, Associate Editor
Matt Humphreys, Assistant Editor
Kevin Ketner, Assistant Editor

Jason Ullmeyer, Art Director
Geoff Harkins, Senior Graphic Designer
Cathleen Heard, Graphic Designer
Alexis Persson, Graphic Designer
Chris Caniano, Digital Associate
Rachel Kilbury, Digital Assistant

Brandon Dante Primavera, V.P. of IT and Operations
Rich Young, Director of Business Development

Alan Payne, V.P. of Sales and Marketing
Janie Mackenzie, Marketing Coordinator
Pat O'Connell, Sales Manager

PEFC Certified
Printed on paper from sustainably managed forests and controlled sources
www.pefc.org
PEFC/01-31-106

Online at www.DYNAMITE.com
On Facebook /Dynamitecomics
On Instagram /Dynamitecomics
On Tumblr dynamitecomics.tumblr.com
On Twitter @dynamitecomics
On YouTube /Dynamitecomic

Credits page for Vampirella (2017) #7.

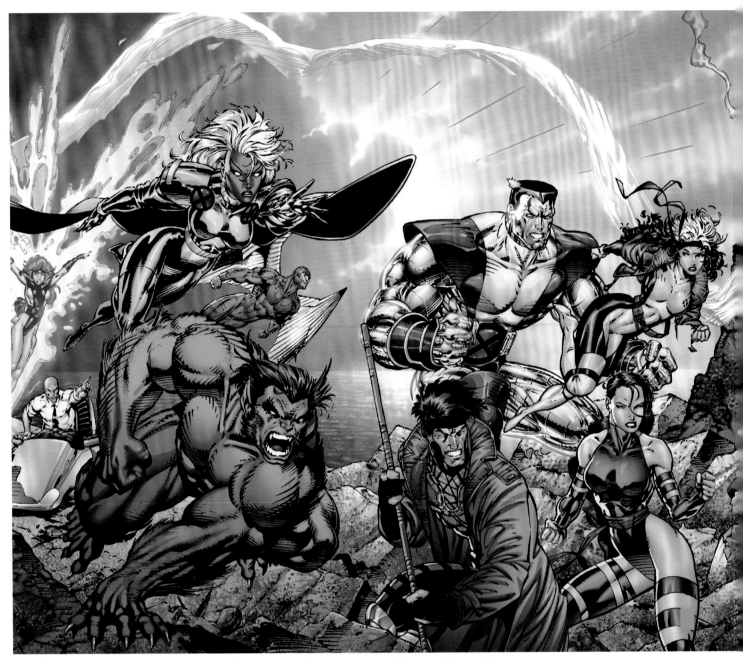

Remastered version of X-Men Vol. 2 #1 (1991) gatefold cover with art by Jim Lee, Scott Williams, and Thomas Mason.

FOLDOUT OR GATEFOLD

The paper is oversized and folded to fit within the size of the rest of the publication but can be opened up to continue the reading experience. "Gatefold" tends to be applied to covers employing this technique, while "foldout" tends to mean an interior page. This became used in comics in the 1980s.

GENRE

The type of story a comic book provides. Genres are differentiated from each other through their own unique characteristics. Typical comic book genres include crime, fantasy, horror, science fiction, superhero, war, and so on.

GUTTER

The space between panels. Gutters help readers distinguish one panel from another.

INDICIA

Text within a comic book that lists information like date of publication, copyright and trademark notices, legal disclaimers, the publisher's address, and so on. It traditionally appears on

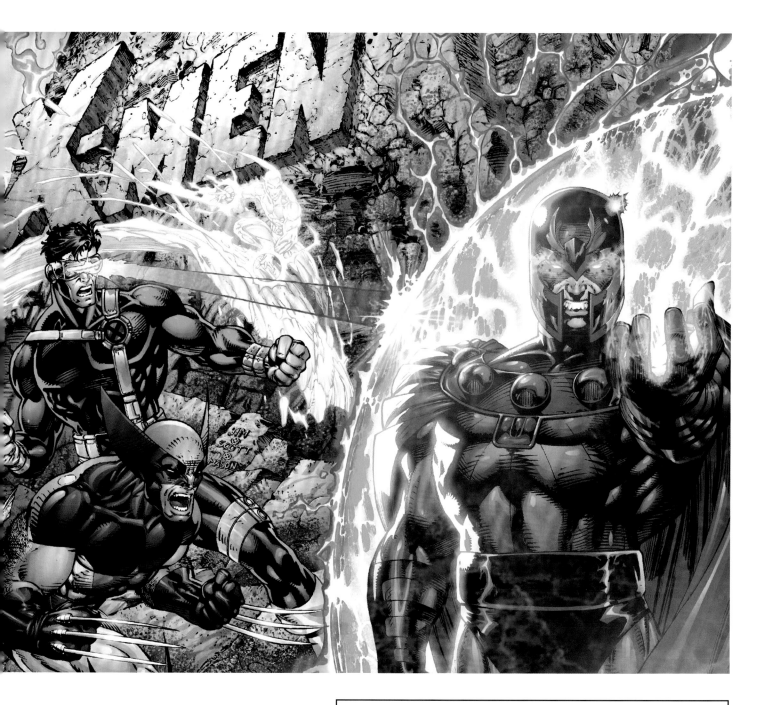

the inside front cover, at the bottom of the first story page, or on the last page of a comic book.

INKER

The artist who "finishes" the artwork of a comic book by drawing over a penciler's lines with ink, providing a more polished, cleaner final image. Depending on the amount of work done, an inker may also be known as a finisher or embellisher.

An example of an indicia from Dynamite's Vampirella comic.

LAYOUT

The arrangement of panels on a comic book page. Layouts need to be carefully selected for maximum storytelling effectiveness (see Chapter 7). Layouts are often drawn at a smaller size than the actual page.

LETTERER

Not to be confused with a comic book's writer, the letterer is responsible for setting a comic book's text on the page by placing balloons, captions, and the words that appear within them. Rather than using handwritten text as in the past, most comic book letterers today accomplish their work digitally, usually using software like Adobe Illustrator. Letterers may also be responsible for designing a comic book's logo.

LOGO

The title of a comic book presented in a specific style. The logo captures the essence of a comic book and, as a result, is one of its most important features.

MANGA

The term used to describe comics created in Japan or those created in the Japanese cartoon style. (In Japanese, "manga" means comics.)

PANEL

A border-enclosed illustration. A comic book page is typically composed of several panels that tell a story when placed in sequential order.

PENCILER

The artist who draws with a pencil. The penciler works from either a script, a plot, or breakdowns, and draws all the visual imagery of a comic book.

PERSPECTIVE GRIDS

Paper ruled in one-, two-, or three-point perspective that helps artists create depth in their work (see Chapter 4).

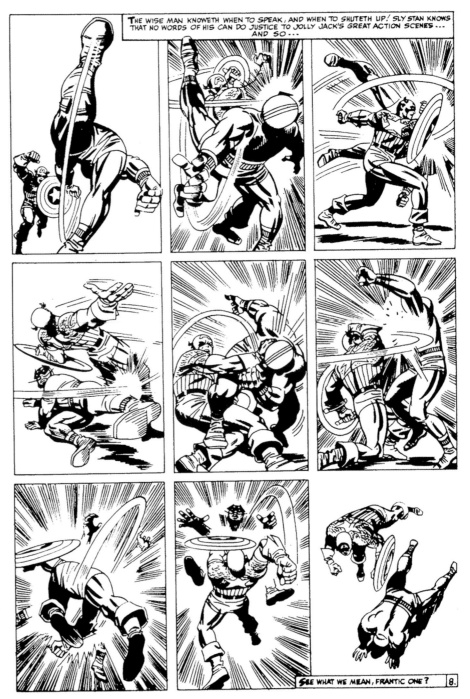

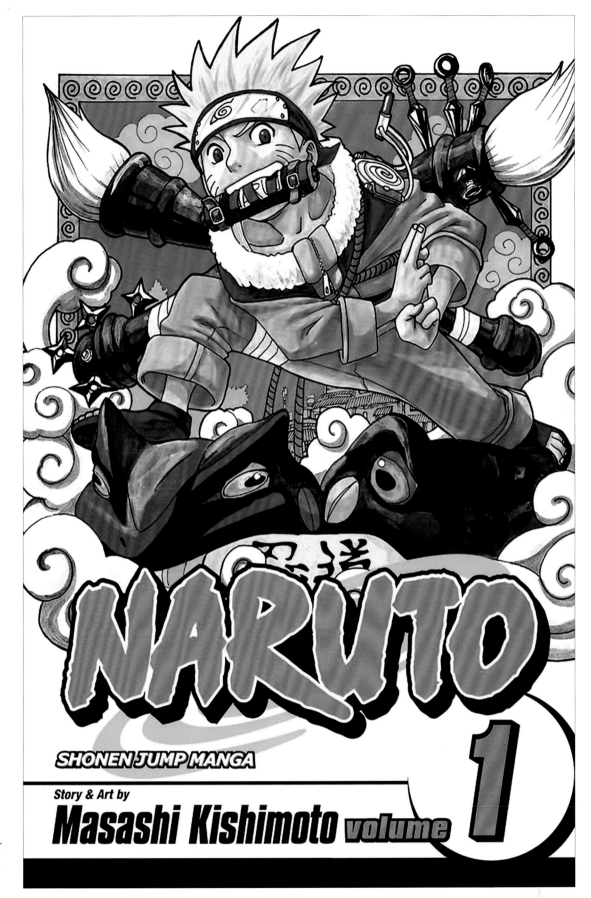

Created, written, and drawn by Masashi Kishimoto, Naruto is one of the many popular manga titles both popular in Japan as well as in the west.

PLOT

A general description of a comic book issue that the writer provides to an artist. Plots summarize an issue's events, allowing the artist to tell the story as she sees fit. In plot writing style, dialogue, captions, and sound effects are written after the artist has drawn the pages. By contrast, full script writing style will include the dialogue for each character before the artist has planned out any imagery.

PUBLISHER

The company (or person) responsible for hiring creators and printing the comic book. Some companies (such as Marvel or DC) have a team of editors who are responsible for the publication of dozens of comic books every month. Other companies (such as Dave Sim's Aardvark-Vanaheim or Terry Moore's Abstract Studios) might not have an editorial staff because they only publish one comic book on an infrequent schedule. Comic books tend to be released on a monthly schedule, although some smaller publishers will skip a month or release their titles on bimonthly, quarterly, or annual schedules.

SCRIPT

A detailed description of a comic book issue that the writer provides to an artist. A typical script describes every panel on every page in as much detail as the writer thinks the artist needs. In addition to providing dialogue, captions and sound effects, scripts often suggest specific points of view for the artist to draw.

SOUND EFFECTS

Words that mimic sounds and appear in a panel. Sound effects are not placed in balloons.

SPLASH PAGE

A full-page illustration in a comic book. Comic books often begin with a splash page that includes credits and the story title. Creators also use splash pages for important story moments.

SPREAD

An illustration that spans more than one page. Spreads are usually two pages but can be increased to three or more pages through the use of a foldout or gatefold. Given how comic books are printed, spreads have to start on a left-hand or even-numbered page.

A Splash page from Vampirella: Morning in America *#1. Art by Louis LaChance.*

TIER

A singular row with one or several panels. Comic books traditionally have three tiers.

THUMBNAIL

Similar to a layout, thumbnails tend to be drawn on 8.5 x 11-inch paper, simulating the printed comic book page with rough drawings to indicate panel layout and figure placement. Often, artists thumbnail for writer and/ or editor approval prior to producing finished artwork.

WRITER

The person who relates the events of a comic book to the artist through either a script or a plot. The writer is usually responsible for all the text (dialogue and captions) that appears in a comic book.

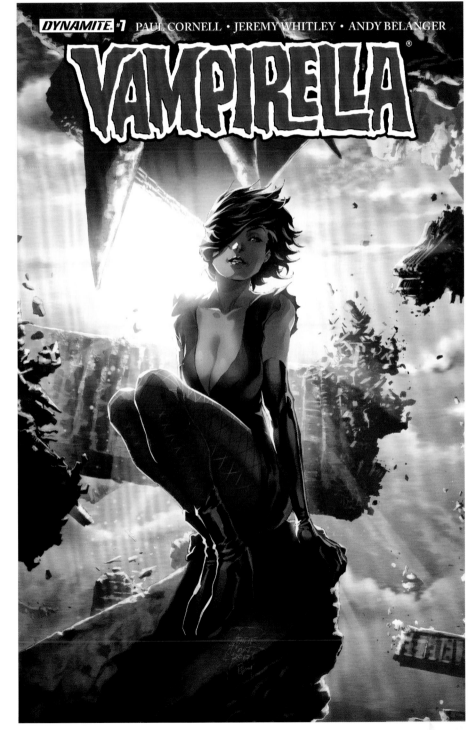

Vampirella (2017) #7 cover with art by Philip Tan and Elmer Santos.

In superhero comics, the muscular physique is usually standard practice for figure construction.

Anatomy is the basic building block that an artist has to work with in shaping a character. It refers to a character's bodily structure. Whether you're drawing heroes or villains, criminals, sidekicks, or regular Joes and Janes, it's your job as the artist to depict accurately who these people are and what they look like. Especially in a storytelling format like comics, it's important to remember that the most important features of a character often come through in the expressiveness of anatomy. This includes a character's attitude, gestures, and presence. Let's start with the basics!

FACE GRID

In these examples, you see a fairly standard depiction of a certain male superhero's facial features, achieved with the help of a useful tool called a grid. By drawing a set of equally spaced lines onto your drawing paper, you can lay out the features of your character's face in a balanced and symmetrical fashion. Not all faces are symmetrical, of course. But even if you're drawing a face that isn't symmetrical—think Batman's nemesis Two-Face—starting with a grid will help ensure that you draw, what you mean to draw, where you mean to draw it.

Typically, faces start in the shape of an oval, and the face grid begins with a vertical line drawn straight down the middle, bisecting the face. From there, you can add a line just above the center (this is where the eyes will go), then two equally spaced lines below that (for the nose and mouth, respectively).

The head starts with a basic circle.

Add a curve below the circle to construct the jaw.

Now it takes on the shape of an egg.

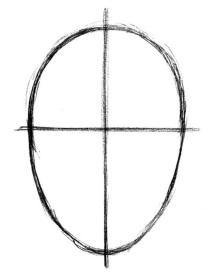

Start to place guidelines for the features starting with a horizontal center line for the eyes and a vertical line for measuring the nose and lips.

ADDING CHARACTER TO CHARACTERS!

As a rule of thumb for many decades, comic book artists have turned to the famous faces of Hollywood when seeking inspiration for creating appealing characters. Stories are often populated with contemporary-looking faces that are easily recognizable and relatable for readers. At the same time, most popular actors are so well-known that their faces can conjure up associations for readers that you might not intend. It is also not unknown for stars to sue if they see their image being used without permission! So before you make every man in your comic look like Chris Pratt or Denzel Washington, play around a bit with features and do something distinctive with each face. A safer alternative is to use friends or family to pose for photos, giving you an infinite range of possible expressions to choose from without the threat of legal action!

It's up to you—the artist—to ensure that each character in a story is distinct and recognizable from scene to scene, regardless of the action or emotion they're expressing. Whether your lead character is angry or elated, you need to make sure they look like the same lead character that appears in every other scene of your comic book.

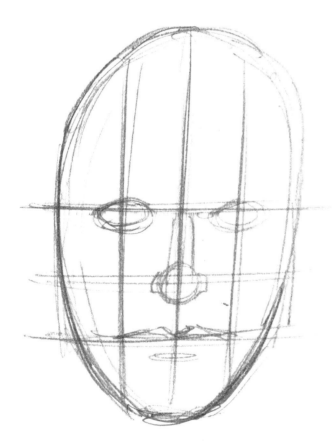 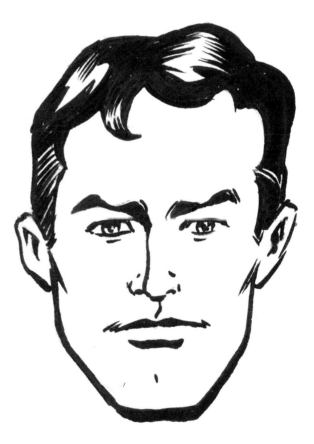

Here is the comparison for how the features of the face line up using the final drawing and facial grid.

EYES

Using your face grid, place the eyes at the top horizontal line of the grid—usually just above the center point of the oval. There's a reason people say, "The eyes are the window to the soul." It's because the eyes are the most expressive part of anyone's face, and they can and should reveal a lot about your character. With subtle adjustments to eye shape, positioning, and shading, you can portray your character as sincere or shifty, compassionate or calculating.

The eyes and eyebrows line up accordingly to horizontal center line.

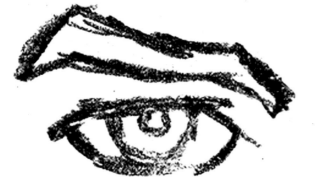
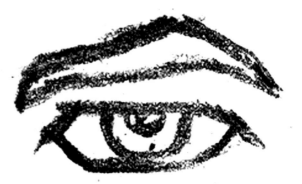

In the final step, the lines are removed.

A woman's eye takes on an almond shape and is more rounded for a softer, more pleasing look.

Here is the side view of a woman's eye with the top eyelid slightly overlapping the iris

Here is another example of a feminine eye with thicker, longer lashes.

Here we have an example of expressive eyes in conjunction with the eyebrows to convey an emotion.

FACIAL EXPRESSIONS

In these examples, you see a range of expressions modeled on a male face, but the basics of each look will work for any gender. A character's expression is a valuable tool for visual storytelling because it can convey a great deal of information very efficiently. It can show passion, tension, concern, or any other telling emotion. And emotion provides context! Consider things like the position of the eyebrows—are they raised or lowered?—and you'll soon see how useful the face grid recommended earlier can be.

This is a good place to remind you that closely reading the script you're working from is very important. If the writer indicates that a character is speaking in a panel, you'll need to depict that character's expression with an open mouth. A character who is angry might speak with a barely open, tensely pursed mouth, or she might be wide-mouthed and shouting furiously. Pay attention to what the script asks for, and find the best expression to fit that need. I'll go into more detail on this aspect in the next chapter.

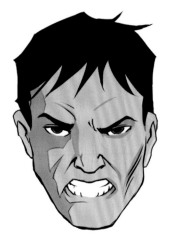

Here is the first example of the finished rendering of the male hero expressing anger.

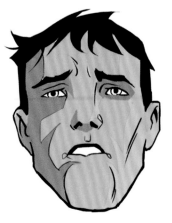

The final example of the finished rendering shows a drastically different emotion, which could be "defeat." The challenge for the artist is to maintain the general likeness of the character between so many varieties of emotions.

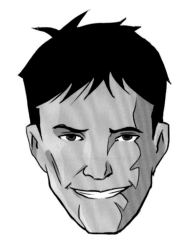

Here is the second example of the finished rendering, this time showing the hero expressing a happy look.

FEET

Many aspiring artists find feet just about the hardest things to draw. Whether in a shoe or boot or uncovered, these things are complicated, but as before, practice makes perfect. You should bear in mind that your figures will often be striking dramatic, exciting poses, so these feet will have to be dynamic. Along with drawing from life, it might be fun to study athletes or sports stars, maybe even freeze-framing recordings from TV or the internet, to see how feet can fold, twist, and extend as they run or jump. Remember, in superhero comics, the figure needs to be full of action from head to toe, so study those toes!

A rendering of the superheroine's feet, adorned with the standard "boots" look.

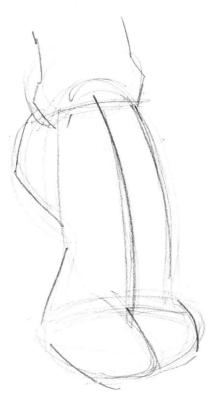

Starting out with the foot, you can think of the gesture it's making. A center line can be drawn how the arch is shaped. Add in basic forms for heel bone and where the toes are.

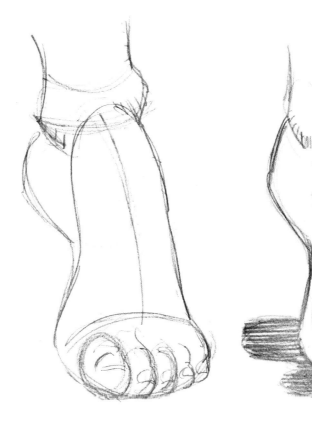

Gradually build up the details, adding in toes and also the structure of the ankle bone.

In the final step, we have all the necessary details and a finished pencil drawing showing completed structure of the foot.

NOSES

Add the nose at the second horizontal line on the face grid. Nose shapes and sizes vary widely among real-world humans. The same should be true for your fictional creations. Even minor adjustments in size, shape, and angle can have great effect on the look of a character. It's important to remember that how a nose looks from the side will affect how it's drawn from the front.

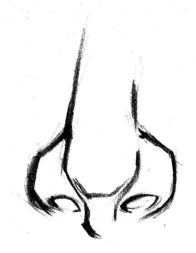

Here is an image of finished pencil drawing of the nose which shows the different planes.

Here is the side view of the nose.

This is one of the many variations of nose types on people.

Another variation of a nose type.

This shows the under plane of the nose and how the nostrils are aligned.

Another nose type with a slightly sloped bridge.

Alternate under plane of the nose showing the septum and nostrils for proper alignment.

MOUTHS

On the bottom line of your face grid, draw your character's mouth. Aside from the eyes, the mouth is a person's next most expressive feature. Keep that in mind when designing your character's face and thinking about the personality and emotions you want to convey.

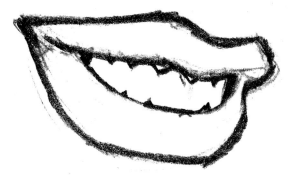

This is an example of a feminine mouth with full lips.

The masculine mouth tends to have thinner lips, which gives it a harsher look.

Observe this example of the masculine mouth smiling.

Here is a drawing of a mouth agape and how it is drawn to provide dialogue in a scene.

An alternative render of the mouth with a stern expression.

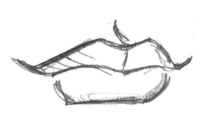

This image shows a female's lips slightly puckered for a seductive look.

MALE FIGURE

In general, the male torso is broad at the top and narrows toward the hips. This tendency is exaggerated—often greatly—when it comes to superheroes. The shoulders, chest, and abdomen should be positioned in alignment with the (usually not visible) spine, and the amount of muscle definition you depict will depend on the character.

Legs and arms should be proportionate to the size and suggested weight of the torso. A big, strong upper body requires strong legs to carry it;

however, the exact length and muscle makeup should be specific to the kind of character you're drawing. Here's a neat rule for drawing arms: a person's arm span is usually roughly the same as their height.

This is a good place to mention the incredible benefits of drawing from a live model—whether using your own reflection in a mirror or having a friend or professional model pose while you draw. Understanding how a person's anatomy works and seeing it being used by a real, living body are

vastly different experiences. Equally important—even if you're not able to find a live model, don't limit yourself to only drawing from other comics! You can use fashion magazines, art textbooks, and the endless resources available for finding images online. Attending a local life drawing class can be an invaluable source of practice and potential models, and many artists find that regularly drawing from life improves their knowledge of anatomy enormously.

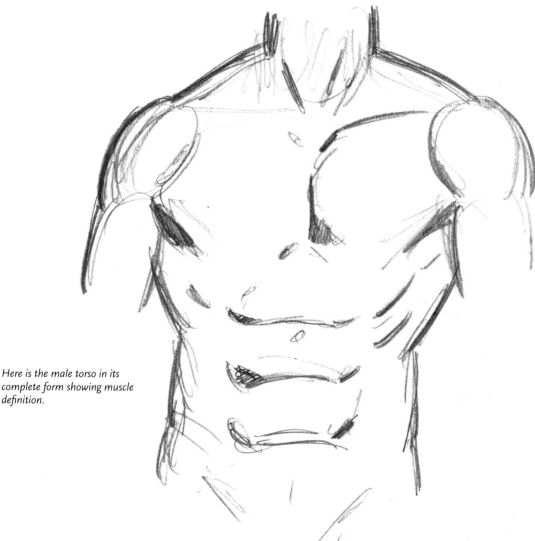

Here is the male torso in its complete form showing muscle definition.

This is the basic construction of the male torso.

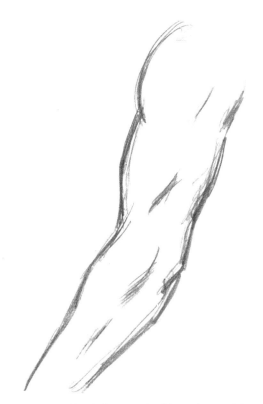

Here is the example of the male arm with muscle definition.

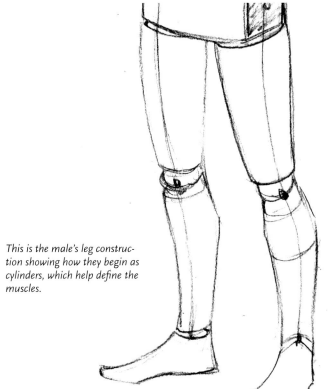

This is the male's leg construction showing how they begin as cylinders, which help define the muscles.

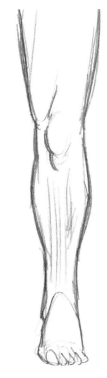

This is an example of the male leg with muscle definition added to it.

FEMALE FIGURE

While men's bodies tend to be broader at the top and narrower toward the middle—like a V-shape—women's bodies tend to have some additional curves, resulting in what we call "an hourglass shape". Physiologically, women's bodies tend to be smaller, shorter, and less bulky than men's, but of course this varies from individual to individual. That is especially true in the many worlds of make-believe that comprise the comics medium. Again, working from friends, models, or photos will be enormously useful in understanding how the female body works, how it can twist, stretch, and compress. Women's bodies can often be softer and curvier than men's, so study how movement and gravity can affect the shape of torsos, breasts, and limbs. These are bodies made out of flesh and bones, not rock or steel (usually), and they should not look stiff or hard.

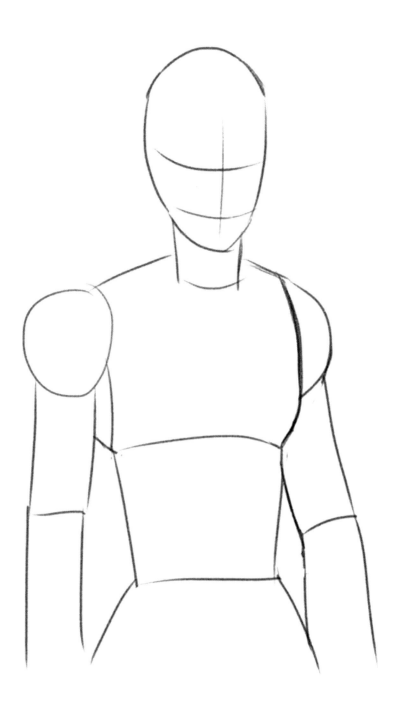

Here we have the underlying construction of the female hero, mapped out with cylinders and circles for proper anatomical placement.

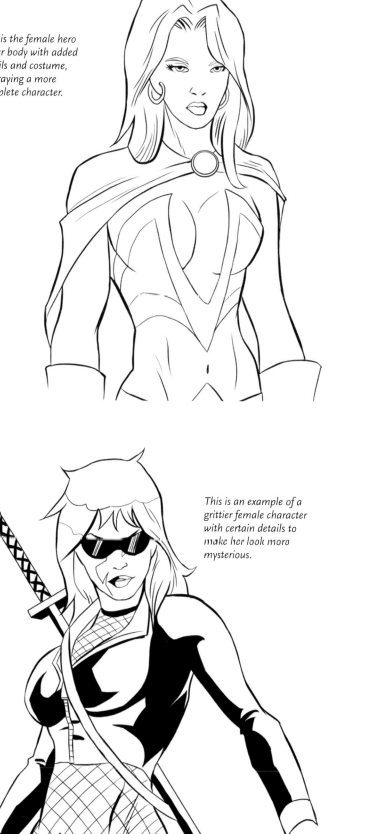

This is the female hero upper body with added details and costume, portraying a more complete character.

Here the female's arm is more slender than the male counterpart.

This is an example of a grittier female character with certain details to make her look more mysterious.

HANDS

Hands are notoriously difficult to draw. For most artists, they prove challenging even after other difficult anatomy lessons have been mastered. Nevertheless, hands play a key role in capturing the gestures and expressiveness of a character, so do your due diligence and get those hands right. One useful tip is to take a photo of your own hands on a mobile phone or camera, adopting the pose or motion your characters in the comic strip are doing. Presto, instant reference!

In superhero comics in particular, hands (or more often fists) can appear to really be coming out of the panel— straight at the reader—and this can be quite demanding to draw. It is particularly useful to practice drawing hands in different perspectives, coming at us or away from us in all sorts of different arrangements, such as fists, open hands with fingers splayed out, or at rest. Practice from photos, friends, models, or your own hands and build up a repertoire of hands you can use when the script demands them. Study how the great masters of comics have created dynamic, interesting hands. In drawing hands, Gil Kane, José Luis García-López, and newspaper artist Leonard Starr are particularly skilled.

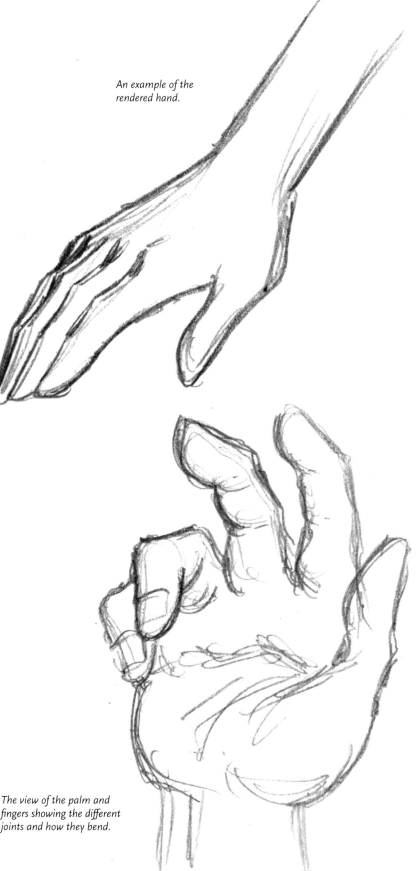

An example of the rendered hand.

The view of the palm and fingers showing the different joints and how they bend.

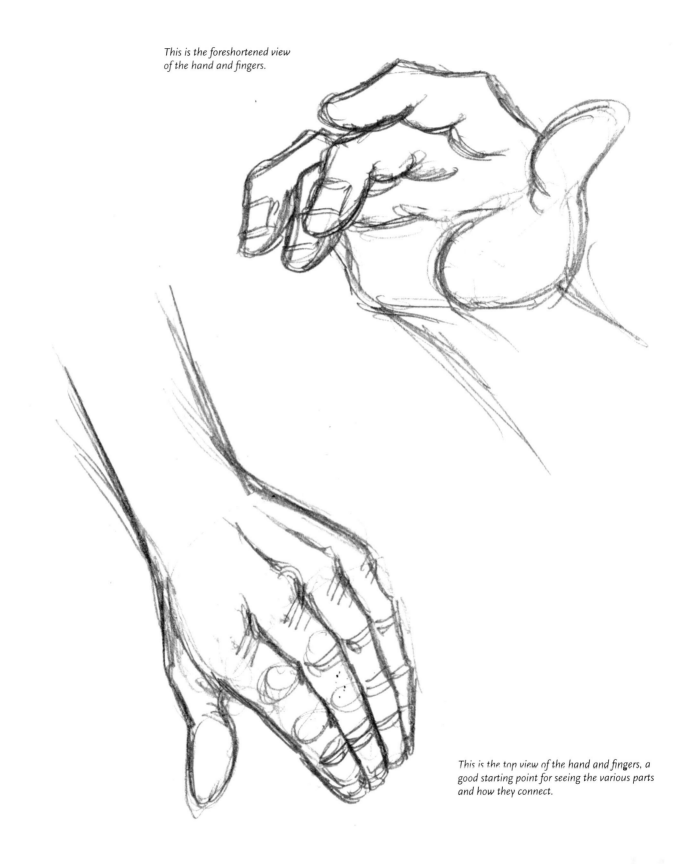

This is the foreshortened view of the hand and fingers.

This is the top view of the hand and fingers, a good starting point for seeing the various parts and how they connect.

DIVERSITY

When comic books were merely an American product, they tended to feature white Anglo-Saxon characters, but with time and greater appreciation for the world's diversity, the population of comic books has grown increasingly diverse. Just as we're not all the same size and shape, we dont share one ethnicity. Think about where you your story is set, and who is populating that world, and fill it with interesting-looking people. That goes beyond skin color, and includes how they dress, their hairstyles, jewelry, and so on. It's a bright, big, varied world we live in, and that has to be seen on the printed page, too.

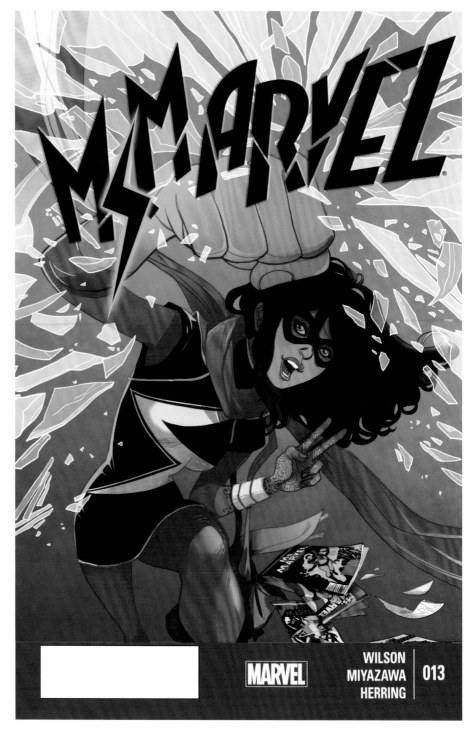

Kamala Khan was introduced to take the mantle of Ms. Marvel in 2013, and was the first Muslim character to star in her own series. Art by Marguerite Sauvage.

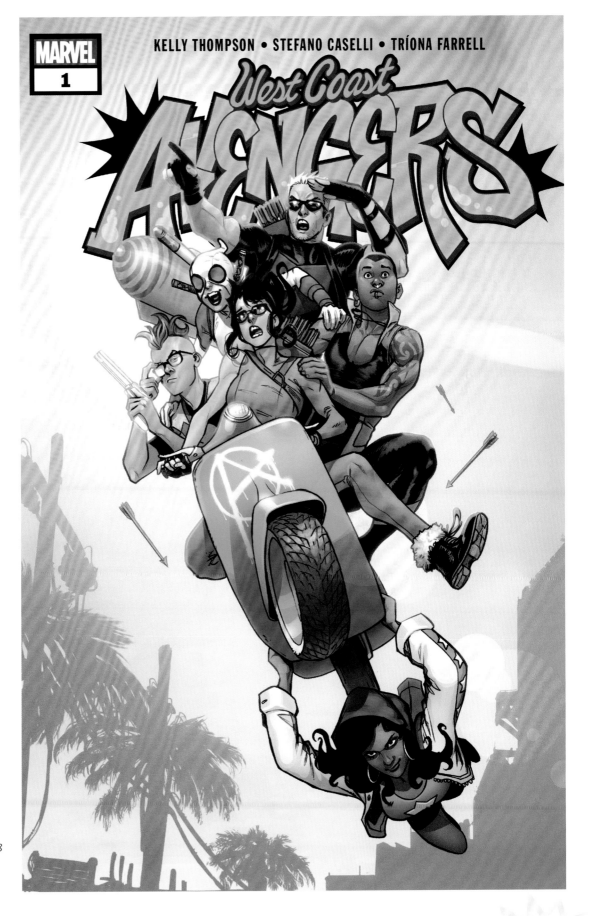

West Coast Avengers 2018 reboot features an all-star cast of diverse characters. Art by Stefano Caselli.

This dynamic double page spread of all-out action carefully guides the eye through different elements of the page. Art from Project Superpowers: Hero Killers #1 by Pete Woods.

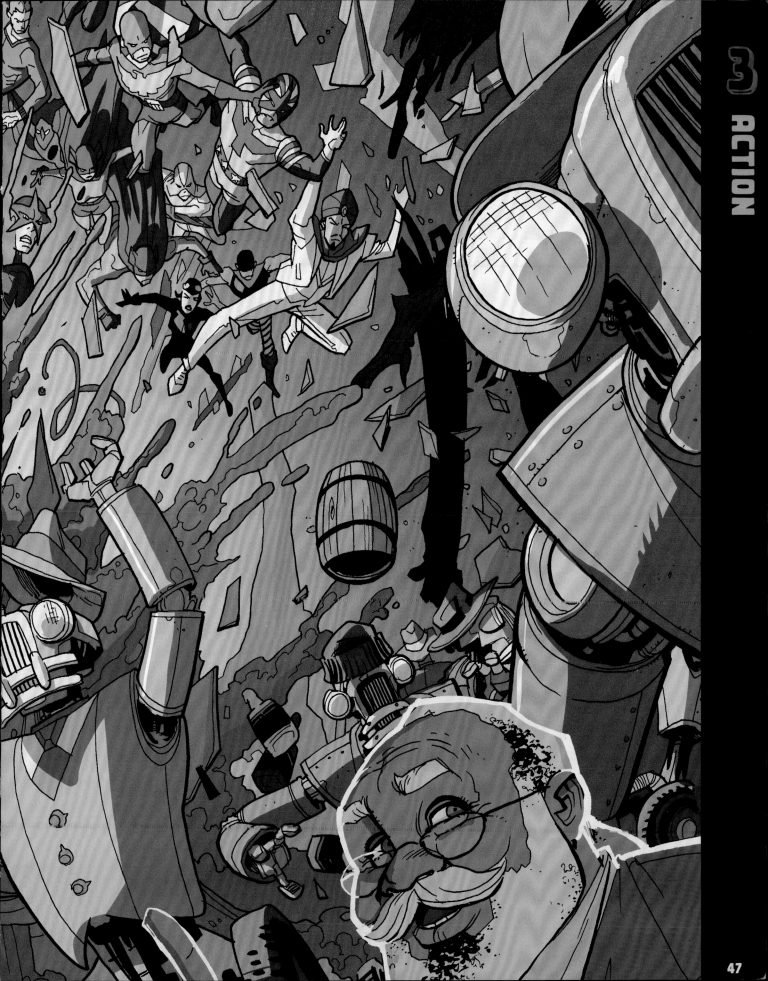

While comic books are often about overly muscled men and women in skin-tight, brightly colored costumes attempting to take over the world and wrap I-beams around each other's heads, there is so much more to them than just this. Comic books are a visual medium, and it is entirely possible to build a superbly crafted and well-written story that is chock-a-block full of suspense and tension without having people get dressed up and repeatedly hit each other. These are illustrated stories, and the artist will be called upon to draw an enormously varied number of things while always moving the narrative forward.

One of the things that separates the greats from the also-rans is the ability to make anything visually interesting, from characters chatting in a bar to an all-out superhero slugfest on an alien world. Make it interesting, inventive, and creative—a feast for the eyes. It's action that we're all here to see, in all its varied forms.

Come on! It's okay to admit it—we're the only ones here at the moment! We all totally love it when Thor brings the hammer down on a Frost Giant or when the Hulk mops the floor with Loki—smashing him around like a sad rag doll. We just love it when Superman lands a mighty haymaker on Doomsday or Darkseid. We wait for the moment when Daredevil comes careening through the skylight to whale on a bunch of thugs or when Iron Man, Firestorm, or Phoenix unleash a massive energy blast against some foe. We speed through the "talkie" parts of *The Walking Dead* in search of the zombie attacks. We relish the moment when Conan or Red Sonja unleashes hell on the sinister Thulsa Doom. The precise moment when Captain America, wrapped in the red, white, and blue of the American flag, unwinds and plants one on Hitler or the Red Skull.

Be honest, what could be better than gazing at a fully rendered page of art, illustrated by the likes of Jack Kirby, Jim Steranko, Wally Wood, Gray Morrow, Alex Toth, José Luis García-López, John Buscema, Gene Colan, Steve Ditko, Neal Adams, Jerry Ordway, Curt Swan, John Romita, Jim Lee, Brian Bolland, John Byrne, or countless others? These are but a few of the iconic artists whose work has not only caused generations of fans to go "Wow!" but who also inspired many of them to enter this field and continue in their stead.

In this chapter, I want to talk about action. I'll show you more body shapes, movements, proportions, foreshortening, and yes, action scenes. We'll cover about a dozen different and useful body poses, including fighting and action as well as sitting and standing—because as I said earlier, everything doesn't involve tossing an M1 Abrams tank through a window or dropping a building on someone.

Red Sonja delivers a flying kick to a group of thugs. Art by Carlos Gomez and Mohan from Red Sonja (2017) #3.

SCULPTING THE ACTION

In the last chapter, I covered how sculpting a character's face can help you convey emotion, context, and passion, thus helping evoke a specific mood. The same can (obviously) be done through in-panel action. That is to say, the way you block the action within each panel, the way you lay the panels out on the page, and the way each of those panels interlocks with each other helps to form the mosaic of the tapestry that is your illustrated epic. There are many different ways of doing this, from the epic, page-filling panels of Jack Kirby, to the more subtle, multi-paneled strips of modern master Chris Samnee and the psychedelic jumble of overlapping panels of Gene Colan. As long as the reader's eye can follow the action from panel to panel, anything goes. Working from your script, you are going to want to plan out your pages, how the panels work from tier to tier, how the action within each panel occurs. You do this so that the reader's eye flows along a natural arc, helping the story to be read smoothly.

Alex Ross masterfully captures emotion with skill in design and painting from this cover to Project Superpowers #2.

Close up of Red
Sonja thrusting
her sword into
a monstrous
demon. Art by
Carlos Gomez
and Mohan
from Red Sonja
(2017) #6

BODY LANGUAGE

Your characters should stand and move the way "real" people stand and move. Few things will disrupt the flow of your story more than showing someone contorted in a way that is all but impossible for a human, or for a character to have impossibly exaggerated musculature, or simply not appear proportional.

To achieve this sort of realism, it is very important that you observe how actual people move. One of the tricks that all the great artists I've ever worked with have told me is that they often have their friends and family act out the action they want to draw in their comics. That way, these artists can better see how bodies move when in action. (Hey, back in the dawning days of the Marvel Bullpen, I was known to climb up on desks and jump around the office as I acted out scripts while working with my artists.)

Get people to act out the action sequences for you, and then take plenty of pictures so that you can look at them over and over again. Build up a visual reference library of people running, jumping, hitting, and flying. (For the record, you really shouldn't hit other people, and unless you can actually fly, I don't recommend practicing it, but, hopefully, you know what I mean.)

Once upon a time, artists would pull pictures out of newspapers and magazines for any reference they thought might be useful. They'd buy photo books of military gear and

There's a lot going on here, but Kevin Lau makes no mistake in placing the Green Hornet and Kato as the central focus while they eradicate the hordes of enemies around them in this cliffhanger final page from Green Hornet Vol. 1 #1.

ancient weapons. Carefully, they'd build up their collection, known as the *morgue*, so that depending on the needs of the story, they could rifle their files and bookshelves and find the proper reference. Today, searching for images online makes it easier, especially with the Library of Congress leading the way with digitizing and making their collections available online—for free!

The lesson here is that doing your homework makes for a more successful finished story, and doing it is not as painful as you might think it is.

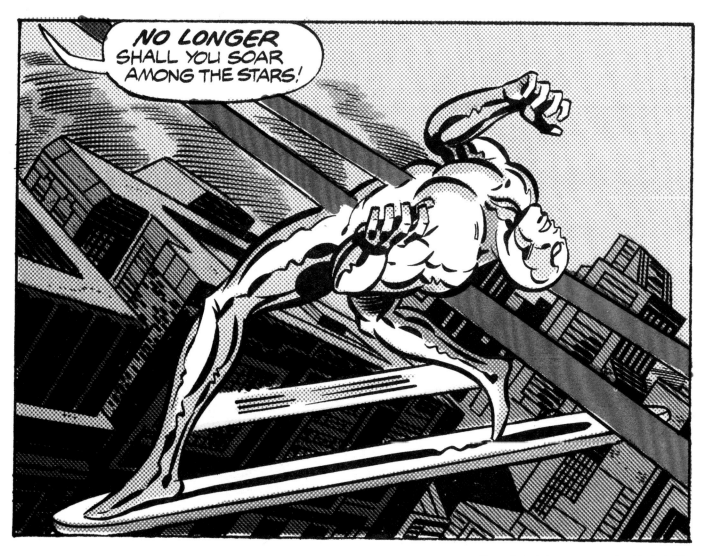

Dramatic body language as rendered by Jack "The King" Kirby only can. From Silver Surfer #1.

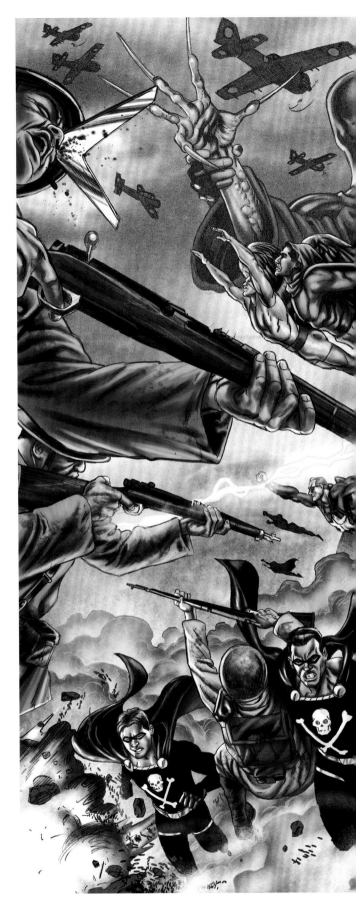

Various characters are on the march, showcasing an epic sequence between the heroes and their enemies in the foreground while the background has a view of simultaneous action between the main villain and other heroes. This combination of action helps keep the viewer up to date on both plot lines simultaneously while providing an eye-catching image. Art from Project Superpowers #0 by Stephen Sadowski and Doug Klauba.

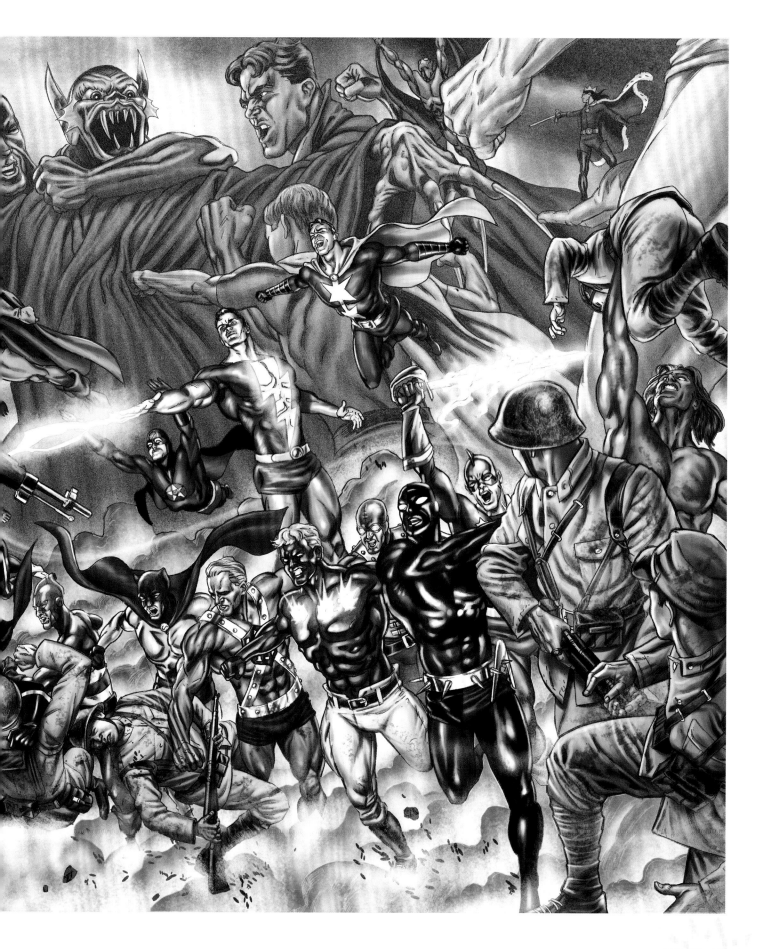

I DRAW THE BODY ELECTRIC

Human anatomy is fluid. The human body tends to look one way when at rest and different when in motion. Let's start with a character who is sitting down. You need to look at not only what the character is actually doing, but why they are doing what they are doing and what else is going on in the panel. Who is the person sitting? Is it Ben Urich or Lois Lane at their desk in the middle of the night banging out a story to make a midnight deadline for the morning's paper? Is it Perry White or J. Jonah Jameson the following day, going over the headlines? Or is it Loki, regally astride the throne of Odin that he covets? Is it Vampirella reclining on a couch? Tars Tarkas or Red Sonja sitting at the edge of a bluff overlooking a valley? Is it Captain America sitting ramrod straight in a meeting with General Thunderbolt Ross? Or Tony Stark, back in his drinking days, slouched over a bar, tying one on?

In any drawing, there will be numerous aspects to remember, from the characters personality and mood to the atmosphere you're trying to convey, and the particular point you're trying to make with the illustration. Is this a moment of quiet reflection or a sudden revelation? Is the scene trying to be sad, funny, scary or romantic? Whichever it is, you need to take all of these decisions into account, as each evokes not only a different image, but involves a totally different character posture. Another thing to consider is whether the character in question is facing toward the camera, away from it, or seen from a side view. How is the person dressed? All of these questions matter and play into how your scene is set, and how each character conducts him or herself within that scene.

Was Tars Tarkas scoping out an enemy's position from that ledge, causing him to appear tense and alert, observing his enemy's position while attempting to remain unobserved? Is it Queen Sonja gazing out across her kingdom after taking a nighttime stroll? Or is she resting up after besting another band of brigands who tried to waylay her on her journey? Think about what your character is doing and how that would best be reflected in their poses and body language. Has Captain America been called into a meeting with the Joint Chiefs to consult on a new threat by the Sons of the Serpent? Are the Avengers sitting around a table, going over plans to take down a Hydra base, or are they simply relaxing over drinks and a pizza? Okay kids, enough with the sitting and standing—I'm thinking you're getting my point. Now you need to inject some superlative action into your comic to make it soar and sing!

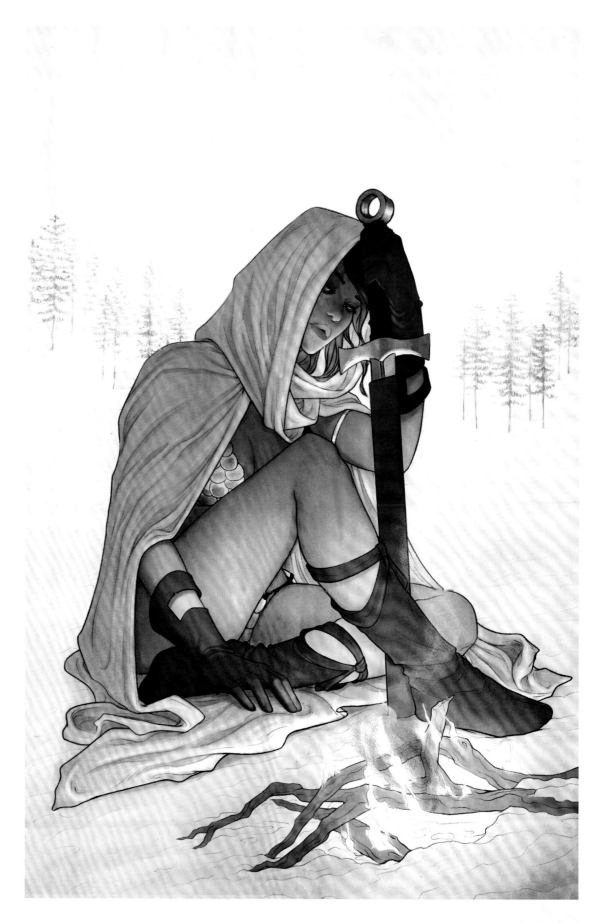

In this image from Red Sonja Vol. 2 #17, the use of color provides a balance between the frigid surroundings and warmth of the fire.

PACING THE ACTION

Tell me, friends, what is the most action-packed scene you can imagine? Check out panels from a page out of *Peter Cannon: Thunderbolt* #3, where the title character uses some very cool battle maneuvers. Note how the artist depicts the characters clashing and bashing, twisting and turning, with movements sweeping across—and through—each other. By showing quick slices of action in a succession of small, thin panels, the artist builds up a fast, staccato rhythm, which propels the action with momentum and immediacy. A sudden close-up of the villain's face interrupts the flow of the action, signaling something momentous is about to happen. The combat then explodes in a large final panel spreading across the width of the page, showing us the fight-stopping blow delivered by the hero to his opponent! We get a sense of the speed and momentum of the action scene, and the large climactic panel conveys the power and impact of Thunderbolt's deadly karate chop.

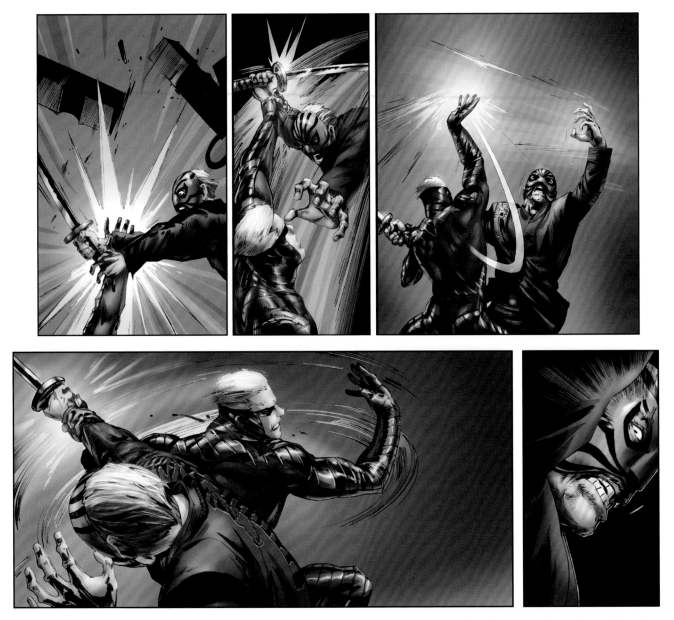

Art by Kevin Lau from Peter Cannon: Thunderbolt *#3.*

By contrast, the double-page spread from *John Carter: Warlord of Mars* explodes into action across both pages, as the formidable warrior leaps into a fray of fiendish foes. Carter is a dynamic figure, forever frozen in the moment, his finely tuned muscles straining as he launches himself at the alien assassins. By drawing him with his body facing three-quarters towards us (rather than with his back to the reader), as in a stage play or a telefilm, the artist gives us a much stronger and more powerful image.

In issue #12 of *Project Superpowers: Chapter Two*, the supremely talented artist Edgar Salazar uses a similarly fractured two-page spread to show an equally dramatic moment as the superheroic President of the United States engages with his caped cabinet in an all-out battle against a hellish creature. The angular slice of the splash adds urgency to the action. The perspective focuses the reader's attention at the spot right in front of the terrifying invader. All of this works to heighten the reader's awareness of the stakes of the fight.

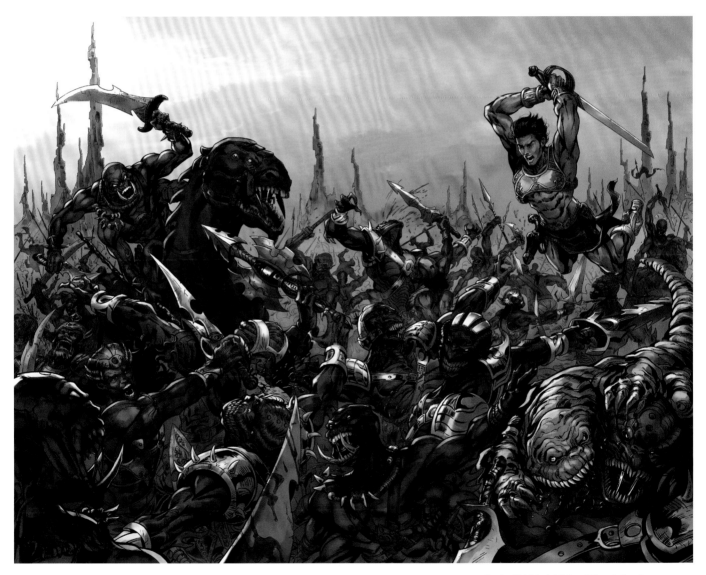

Art by Abhishek Malsuni from John Carter: Warlord of Mars *#1.*

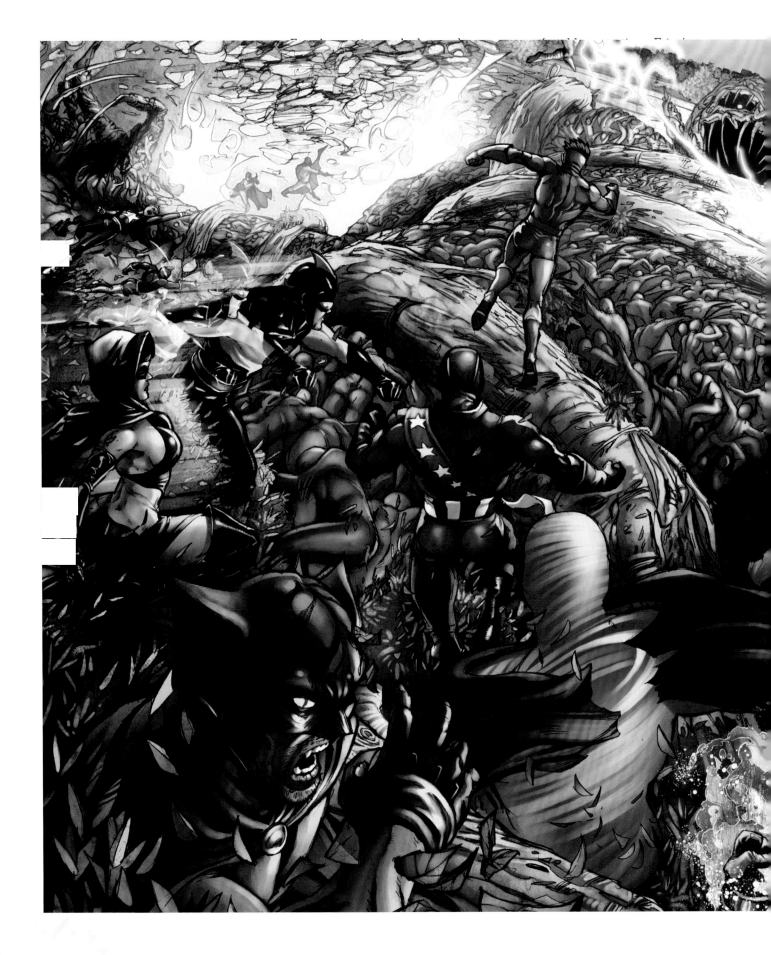

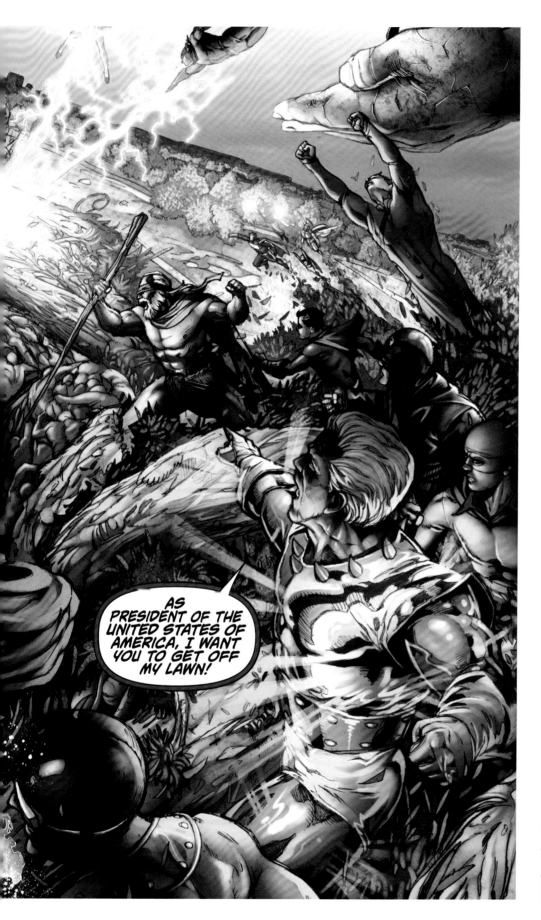

In this double page spread, the artist provides a clear overview of all the action taking place while the super heroic POTUS provides the battle cry. From Project Superpowers: Chapter Two #12. Art by Edgar Salazar.

An innovative panel set plays up Alice's understandable claustrophobia as she quickly grows. Art by Erica Awano from The Complete Alice in Wonderland #1.

For a less action-packed or explosive sequence, let's look at the unique page layout at left from *The Complete Alice in Wonderland #1*, where artist Erica Awano uses an innovative panel set at the top of the page to play up Alice's understandable claustrophobia as she quickly grows in size after unwisely imbibing strange edibles.

As a reader, you can all but actually feel the tremendous pressure as Alice is pushed and folded into increasingly uncomfortable contortions. Erica's choice of viewing Alice from a spot close to the floor on which she sits increases the reader's sense that the poor, discombobulated girl is now looming over us as well as her swiftly shrinking surroundings. By dividing one illustration into three panels, she slows the momentum down, and then switches her focus to outside, where we see the hidden part of Alice's body—her other arm, flailing around through the window.

This sequence is less about movement or dynamism, but about slowly revealing a dramatic moment in time. It is a perfect example of how you can visually control the passing of time and gradually reveal the full extent of a character's predicament. As an artist, you can control how fast or slowly your readers follow the story.

Another powerful moment that captures heightened tension is seen on the page from *Legendary Tailspinners #2*, drawn by Grant Bond. With each panel, the glowing eyes of unknown creatures lurk ever closer to the characters in the foreground. As the tension escalates, the panels each take a slightly different view from the camera, cutting from view to view as the ghostly eyes close in on our scrappy band of protagonists.

Let's talk about that camera for a moment. A comic book panel is similar to a singular frame of film. You're not only the artist, but you're the cinematographer, director of lighting, and film director. You will be selecting the angles and shots to create the appropriate mood for your scene. Tiny panels can create the illusion of speed, but tilted angles and panel shapes can also be used to throw your characters and reader off-kilter, adding tension to the moment.

Alfred Hitchcock was the master of creating tension among his viewers by showing us things his characters didn't know or see. He showed the audience where the bomb was and they squirmed in their seat wondering if the hero would find it before it detonated. In comics, you can frame a moment such that the reader sees a street light glint off the knife of a common thief before Thomas and Martha Wayne notice him in that dark alley. A close up of the knife tip toying with Martha's string of pearls makes you wonder what happens next.

There are many great action sequences that have taken place in modern-day comics, but these are just but a few of the great moments that I believe clearly demonstrate how the use of physique, angle, and setting help the artist illustrate action, motion, and even static imagery in comics.

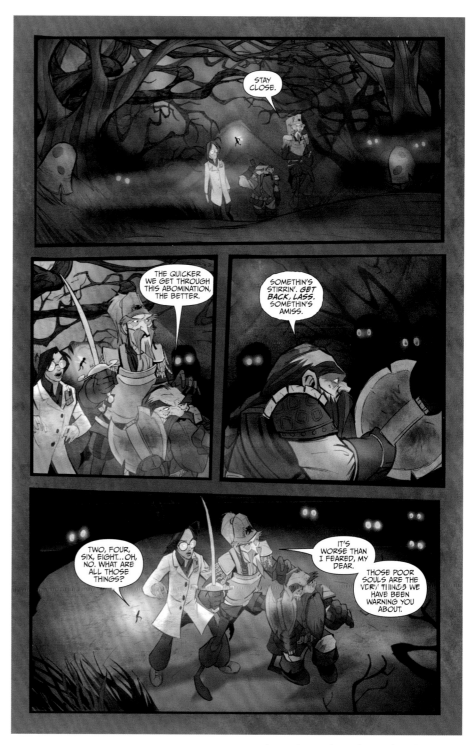

As the tension escalates, the panels each take a slightly different view from the camera in this art. Art by Grant Bond from Legendary Talespinners #2.

Dramatic bird's-eye view perspective is being presented to show the whole city covered in a lush jungle ecosystem as the Dynamic Family take to the air from Project Superpowers #4 with art by Carlos Paul and Debora Carita.

Typically, we see with two eyes. This practice is called binocular vision. Each eye receives a slightly different image, and the brain processes both of the images into a single 3-D image, generating a sensation of depth. This ability allows us to see flat images and process them as 3-D. With this three-dimensional sight, you clearly understand (and see) objects as existing in 3-D, whether they are in the real world or on a flat surface, such as on a comic book page.

Unless your comic book is rendered in 3-D (by the late and great Ray Zone or some other talented 3-D artist), your art will be confined to the flatness of the printed page or screen. However, as I pointed out in the previous chapter, a truly talented artist can make art come alive and all but leap off the page. In this chapter, I'll teach you about perspective and how you can make it work for you by providing depth and dimensionality to your art. We'll explore one-, two-, and three-point perspectives, as well as curvilinear perspective. Needless to say, proper perspective is truly one of the hardest artistic techniques for most artists to master, but it is an indispensable technique for creating a believable setting in which your characters can live.

Unfortunately, many art teachers explain perspective in ways that are confusing and complicated, but I'm going to simplify all of that and show its application to drawing comics in a way that should be easy to follow. With this technique, you will be able to understand and use the various types of perspective and make the world of your comic book really come to life.

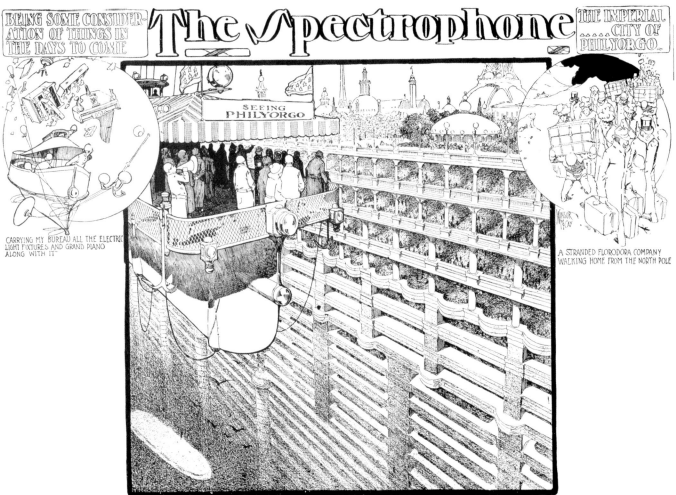

Winsor McCay, the master of perspective, as evidenced in this art from The Spectrophone: The Imperial City of Philyorgo, *from the* Los Angeles Herald *(1904).*

ON THE HORIZON

Perspective is a technique that tries to recreate the sense of depth experienced when looking at an object or a scene in real life. It is based on the sensation that objects appear to get smaller as they recede into the distance, vanishing to a dot. Any straight lines will appear to recede to this point as well; this is called the vanishing point. Typically, perspective starts with the horizon line (sometimes called a *camera line* or eye level), that is, the height in any composition at which your eyes would be if you were actually in that setting. In comic books you can choose to use one-, two-, or three-point perspective to achieve different types of depth where necessary. Don't be alarmed—it's not nearly as complex as it sounds! For simple one-point perspective, pick the first point at which you wish to start. This should usually be where you want the focus in the background to be, or where all the action is going to be heading toward or coming from. Draw a series of lines all coming from that point, add vertical and horizontal lines to them, and you can create a simple grid on which to construct your street, building, or alien metropolis. This can create dramatic, simple backgrounds for your action with a very definite direction of action; your eye will be almost sucked in to the flow of lines toward that single vanishing point which can make for a very dynamic composition.

To create a setting with a more complex, realistic illusion of depth, you will need to use two-point perspective. First, you decide on one vanishing point, let's say on the left of the drawing, then on the horizon line, about two feet away on the physical drawing board or table, add the second point on the right. It's usually not even on the page. Many artists just guess at

An example of one-point perspective is shown here, where the vanishing point was placed on the side of the composition. Art by José Luis García-López.

it. But, the first few times you do it, you may want to use a yardstick as your camera line. Go out two feet and then sketch in the diagonal lines from there. It will take you some practice to do this correctly, and you'll be able to tell when you do because it will look off when it's wrong. To be sure, this is not an exact science. Essentially, what you are attempting to do is to hint at real life, not actually capture it. Once you've accomplished this, you'll see

how the crossing lines from the vanishing points form a grid. Anything you draw on this grid will appear to recede to two points, which is typically how we experience the world around us.

For an even more dramatic setting, you might sometimes want to use three-point perspective to create the appearance of looking up or down at a scene. Imagine you are looking up at a skyscraper, to recreate that vertiginous sense of scale, you can

use vanishing points to the left and right of the horizon, as well as a third point way above, possibly off the page itself. Your grid will look like a pyramid rising up above your horizon line. To create the sense of something receding beneath you, simply place the third vanishing point beneath your horizon line. However, if all this sounds kind of complicated, let's see these ideas in practice and everything should become clear.

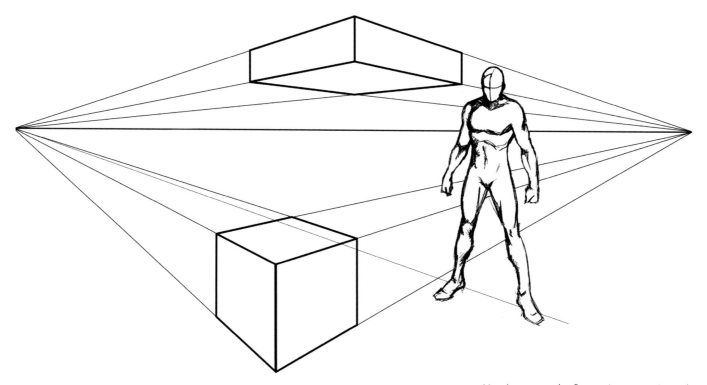

Here is an example of two-point perspective and how the human figure looks standing within the picture plane.

VANISHING POINT

Perspective books always talk about the vanishing point, which is the point of convergence, the spot on the horizon that all lines are drawn to like a black hole. While that's important, if you want your perspective to be bang-on perfect, what I find is more useful is just worrying about whether things go basically up or down as they recede into the distance. If an object is above the horizon line (eye level, remember), the object will angle downward as it recedes. If your object is below the horizon line, it goes up. It may sound odd on the printed page, but try drawing it and you'll see what I mean.

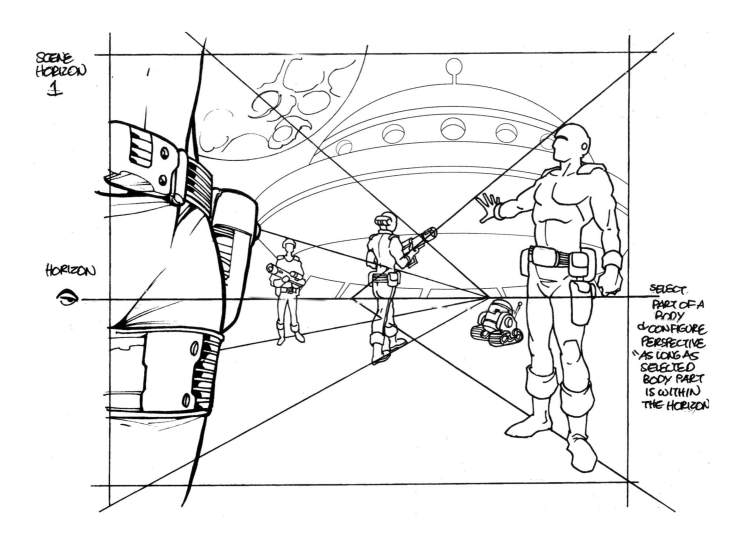

The horizon line placed in the center of this drawing is where the vanishing points are being placed. As you can see, whatever is above the line will angle downward and below the line objects will angle upward. This is what provides a sense of scale to the viewer to differentiate sizes of objects and people.

ONE-POINT PERSPECTIVE

In the panel from *Legenderry: Vampirella #1*, you can see how one-point perspective comes into play as the magnificent airship looms out of the drawing towards us and the buildings seem to go way back into the distance. It is also worth noting that visually, the ship travels from left to right, as do the dialogue balloons. In this fashion, both the dialogue and the action travel in the same direction.

For another example of one-point perspective, look at the panel from *Legenderry: Red Sonja #1*. As you can see, the ship is stretched from the lower left to the upper right of the panel. The lines of the ship and mast, and even the poses of the characters, are stretched towards the same vanishing point. The artist has also tilted the horizon line to create more of a sense of being out at sea on the choppy waves!

A dramatic one-point perspective shot with elements converging to the vanishing point is placed on the bottom left corner of the page at a "worm's eye" view. Used to show the turbulence of the sea and boat. Art by Igor Lima from Legenderry: Red Sonja #1.

A simple one-point perspective image can be just as dramatic if handled correctly, like this image of the Zeppelin flying within the city skyline. From Legenderry: Vampirella #1. Art by David Cabrera.

TWO-POINT PERSPECTIVE

Now that I've dealt with one-point perspective, let's take a look at what two-point perspective looks like. For that, we are going to drop in this dazzling example by Ross Andru. He uses two-point perspective to establish that dastardly Yandroth's maniacal machination—the Omegatron! Its scale is heightened by making the figure small below the horizon line, which separates the panel evenly.

You can use two-point perspective to draw the same objects as one-point perspective, but rotated. Look at the corner of a house or look at two forked roads shrinking into the distance, for example. One point represents one set of parallel lines, the other point represents the other. Looking at a house from the corner, one wall recedes toward one vanishing point, the other wall recedes toward the opposite vanishing point.

If the reader views a scene that consists solely of a cylinder sitting on a horizontal plane, no difference exists in the image of the cylinder between a one-point and two-point perspective view. Two-point perspective has one set of lines parallel to the picture plane and two sets oblique to it. Parallel lines oblique to the picture plane converge to a vanishing point, which means that this setup will require two vanishing points.

Ross Andru provides an exquisite example of two-point perspective in this panel from Marvel Feature #1.

Here's an example of clear and compelling yet dramatic two-point perspective in a classic team-up with Batman and The Hulk featuring art by José Luis García-López from DC Special Series (1981 Treasury) #27.

THREE-POINT PERSPECTIVE

Now, let's ratchet things up a level. Let's talk about three-point perspective. It is essentially two-point perspective with the addition of another vanishing point off the horizon line. What's that you say—another vanishing point that's not even on the horizon line? How is this even possible?

When you view an object—like a cube—in one-point perspective, you see it head-on. Your attention is focused on one side of the cube. When the cube gets rotated, you can then see it in two-point perspective. Now your focus covers two sides of the cube. You consistently see two sides regardless of where the cube is placed. When you twist the cube, you can see three sides of it. You'll notice that the lines which once ran parallel up and down now recede and become foreshortened (that is, the parts of the cube closer to us appear to be bigger than the parts further away, which look smaller). The cube has been moved above the viewer's eye level.

You can carry that effect even further with three-point perspective. Artists use it to create impressive visual effects, such as a view from a skyscraper. This technique is most commonly used when drawing buildings viewed from a low or high eye-level.

All of this, as you can see, adds depth to the image itself, giving the illusion of three dimensions without the need for 3-D glasses.

So, whether you chose to use one-, two-, or three-point perspectives, you are now armed with all the tools you need to create the world your heroes will have adventures in. What will it look like?

Ross Andru shows complete mastery of three-point perspective from the splash page of Giant Size Spider-Man *(1974) #3.*

Another example of three-point perspective by José Luis García-López from Atari Force #3.

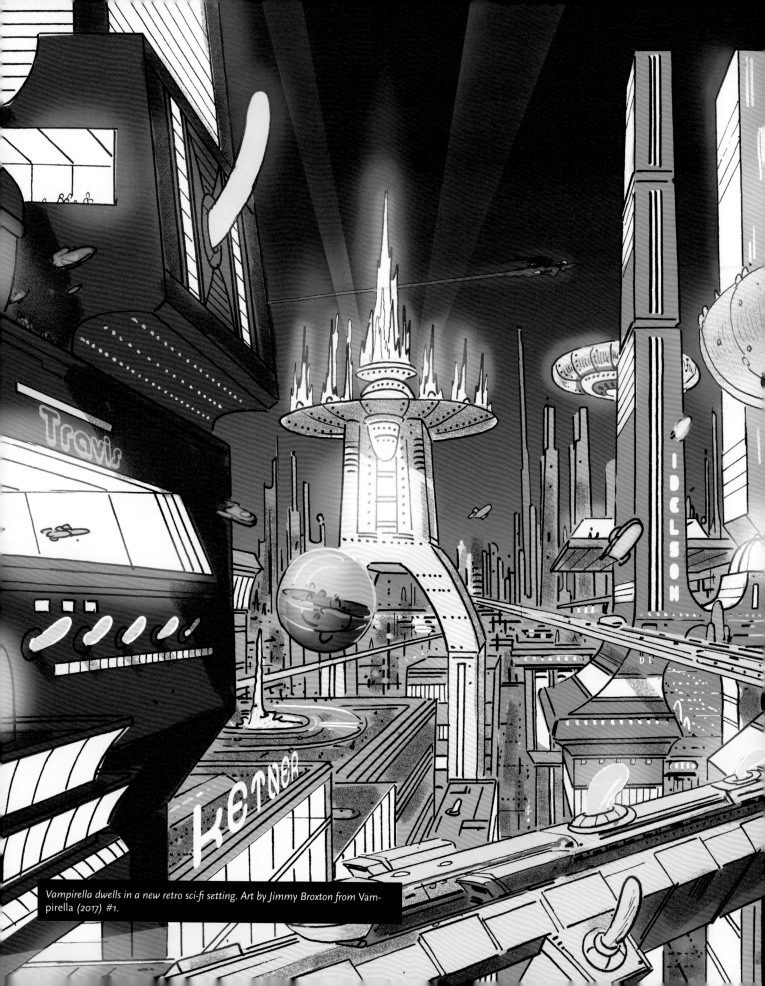

Vampirella dwells in a new retro sci-fi setting. Art by Jimmy Broxton from Vampirella (2017) #1.

Creating a new world is a godlike task and I'll be using this to share some advanced tricks, tips, and secrets to help you make those worlds live and breathe. If you are creating your own world in comics, here are three simple elements to focus your efforts on: landscape, tools and transportation, and creatures.

LANDSCAPE

You know, our world is a visually fascinating place to live. I should know, having been all around the world meeting fans and spreading the gospel. I've seen beautiful vistas, gorgeous sunsets, glorious sunrises, majestic mountains, ancient temples, amazing architecture, and so much more.

As an artist, you should use your imagination and the world you live in for inspiration. Use good old Earth for inspiration, as a launching pad to propel you into worlds of your own. First, of course, you need to determine exactly what you need to draw for your setting.

What kind of scenery—city, rural, or otherwise—are you depicting? Whether you're setting your story in the gritty desert of nineteenth-century Deadwood or on the desert planet of Tatooine in a galaxy far, far away, your world will need intriguing, yet familiar, features. The most other-worldly landscape becomes instantly relatable when it's shown to feature houses, schools, and places for people to gather, eat, and drink. Don't be afraid to look online or in books on landscapes, underwater photography, or foreign countries for interesting pictures that might inspire you to create something new and fantastic. See a gothic cathedral you like? Double its size—go ahead and triple it! Add gargoyles, armaments, towers, and moats of molten lava. Presto! You have a nightmarish fortress from the under-world. Maybe take a fascinating rock from one photo, a twisted tree from another, some wild vegetation, add a

crazy constellation in the background, and you have the basis of an alien world. Cities like Tokyo and Singapore look pretty futuristic already, perhaps they could inspire you to build your own city of the future. Whatever works to spark off your imagination is fine. And of course, artists like Jack Kirby, Moebius, Alex Niño, Stuart Immonen, Geof Darrow, Walt Simonson, Michael Kaluta, and Todd McFarlane (and if you don't know these comic titans already, Google is your friend!), among many others, can lead to interesting places which can help inspire you to great things.

Whenever I am at a convention and we get to tour the area, if there's an artist on hand, you can bet that they're taking pictures. Lots of pictures. Maybe even sketching if they have a book with them.

But remember, the world has to make sense. Imagine that the gravity of your world will have an impact on the architecture, the growth of the flora, and development of the fauna. Is it a desert world? If so, what sort of plant life is there? Where are the water sources? Even if it's a fantastic, supernatural setting, it has to have an internal logic so that when your characters are moving in this world, it feels right.

If you're creating your own realm, world, or even just a city, you might want to sketch it out from different angles, playing with how the sun casts its shadows at different times of day or night. You could always scan your image and use Photoshop to create different lighting effects. A map is not out of the question, so you know how to get from the waterfall to the castle or from the coast to the hidden caves.

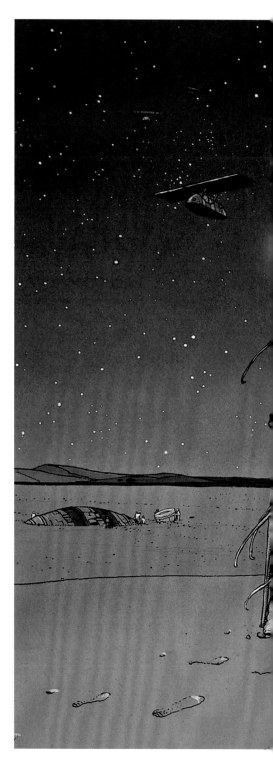

Moebius provides the most believable of alien landscapes. Art by Moebius from Arzach graphic novel.

TOOLS A D TRANSPORTATIO

You will need believable, yet fantastic, vehicles, whether they're for the world outside your window or a far-out cosmic realm. And the kind of transportation you select should match the general technology contemporary to your story. A science fiction story set in Victorian times might feature cool, steam-powered vehicles, for instance. Again, take from the past or present, update, mutate, and augment and you'll have something fabulous for your characters to travel about in. As always, the incredible imagination of Jack Kirby can be a great source of inspiration for the craziest vehicles. Check out the Whiz Wagon from *Jimmy Olsen* for a start! Most artists I know love *Blade Runner* (both films, in fact), and Syd Mead's flying car designs still look wonderful today. (Let me pause and point out that Mead has enjoyed a reputation as a futurist for the last thirty years, taking where we are today and projecting what our world will be like. It's one reason why the film resonates so well with viewers.) The trick here is to take a basic design we can recognize today, twist it just a little, stick on some cool bits here and there—maybe a dashing fin, or some menacing spikes, or chains— add some shiny chrome effects, or maybe make it broken up, grimy, and dirty, and chances are you'll have something no one's ever seen before, but looks like it might just exist sometime in the future.

Colin Gibson designed about 150 imaginative vehicles to populate *Mad Max: Fury Road*, and he explained how each one had a personality, but they were all mashed up from familiar vehicles we drive today. They were

Here is an assortment of various vehicles from the past, to the future, to out of this world.

Jack Kirby's production art for an unmade film called Lord of Light.

fearsome and loud and ferocious, and very, very distinctive and memorable. That's what you want for your own story.

While you don't need a degree in physics to design a spaceship, you do need to think about the basic concepts of traveling through the vacuum of space and being able to enter an atmosphere. Fins help with aerodynamics, so they're great for flying around your planet, but to get from planet to planet without worrying about things like air and gravity, you must unleash that fertile imagination of yours.

Now, apply that same thinking to the tools you want your characters to use. Jack Kirby made certain Reed Richards was building phenomenal machines with things that looked like spanners and wrenches and soldering irons, but they were tricked out to be futuristic. You can do the same with your hardware.

How can your flora be weaponized? How can animal avian or aquatic bones from your landscape be applied as tools to carve, cook, hunt, or defend? What natural materials does your world possess that can become magic wands or power a laser pistol? By asking yourself these questions (and tons more), your world is slowly taking shape and becoming a coherent whole.

One of Jack Kirby's masterful renditions of a highly-stylized vehicle called "The Whiz Wagon" from The Forever People #1.

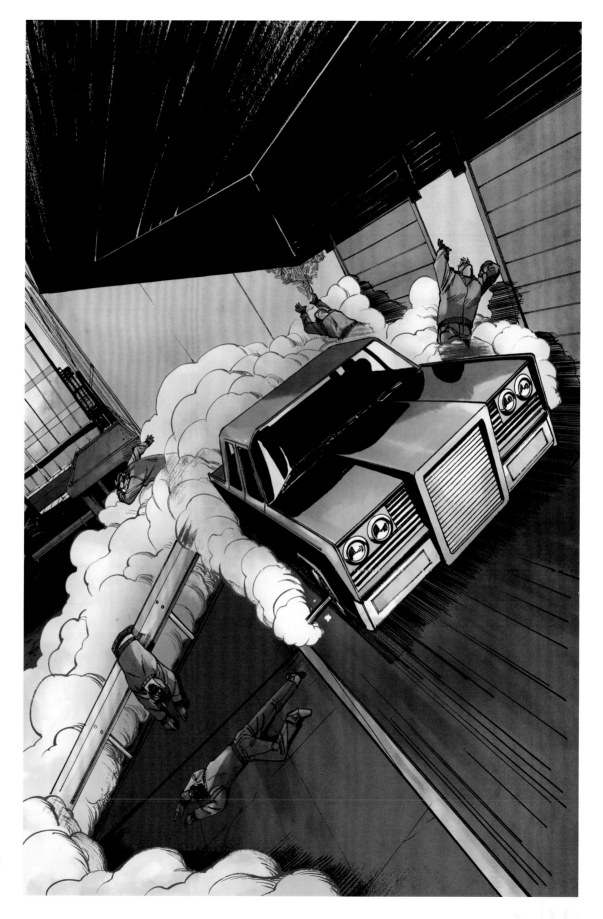

Green Hornet and Kato's mode of transportation is based on a classic 1965 Chrysler Imperial Crown car but enhanced with all sorts of gadgets.

CREATURES

However fantastic or mundane the world you're creating is, the beings that populate that world should be well-suited to live in it. Equally important, they need to be a good match—or foil—for your main characters. We're surrounded by creatures, big and small, and we've all grown up with monster movies, sci-fi spectaculars, and (of course) brilliant comic books, so take bits from here and there and really let your imagination go wild. Is there such a thing as a monster that's too far-out? I don't think so. Comics have some amazing creature makers out there to inspire you, such as Arthur Adams, Mike Mignola, Walter Simonson, Bernie Wrightson, and Jack Kirby (What? That guy again?), so dig out your collection and settle down for some fun research in how the masters go about dreaming up their wildest creations. Please note: While monsters and similar creatures are often hostile, meaning the good guys no good, they can often be conflicted— or even be good guys themselves. Think of the Hulk—well-intentioned, conflicted—yet seen by most of the world (including his friends) as a potential menace. And even the most dangerous villains have moments of relative kindness or joy. So we will see how to draw creatures with a variety of moods and attitudes to make them fully realized characters.

I've said it before, and I'll keep saying it—when it comes to monsters, the best, most effective ones reflect the fears and anxiety of the times. Capture in physical form the essence of something that people find ter-rifying in real life, and you'll have yourself a monster! Here are just some of the different creatures you might want to include in your comic strip.

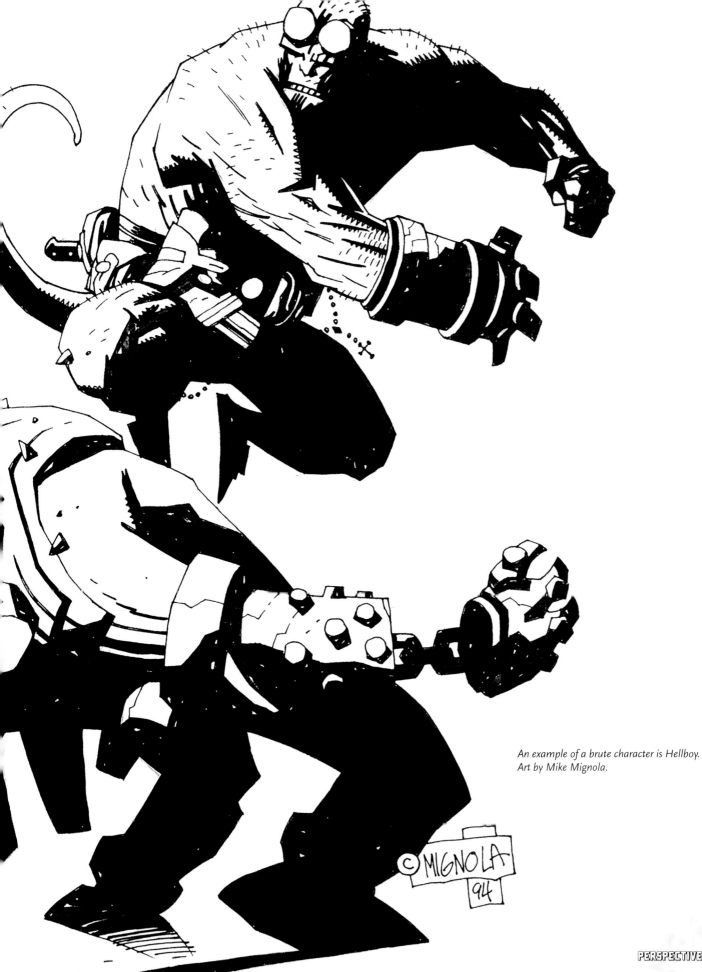

An example of a brute character is Hellboy.
Art by Mike Mignola.

©MIGNOLA
'94

BRUTES

Big, boisterous behemoths have always had a place in storytelling, and they always will. Whether your hero is battling a massive manmade mechanical menace, or a more organic, humanoid hulk, playing up the significant size difference between the main character and an enormous enemy adds thrilling drama to a story. Just think how awe-inspiring villains like Thanos are, looming over our heroes with a glint of pure evil in their eyes. If you can capture that feeling, then you're off to a great start.

Most of these brutish behemoths are massively muscled (you know alliteration is my thing!), which will impact how they move and how they run and fight. Once you design your character, try them out, make them try to sit down, or pick an apple, or pet a dog. See how they fill your panel. Which reminds me, body language for all your creations is essential, not just your human heroes and supporting players. Bring your beasts to life by figuring out which ones pick their teeth with the bones of their prey, or which one is always buffing his talons, or which limps because of an old injury.

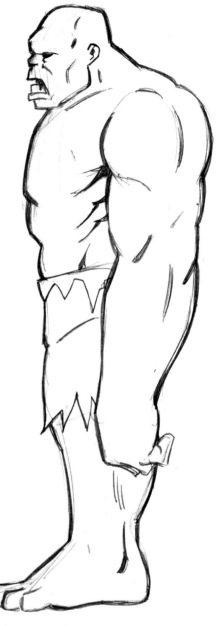

The side view of the character shows the oversized arm proportions.

The character in full figure shows proportions that make the character a "brute."

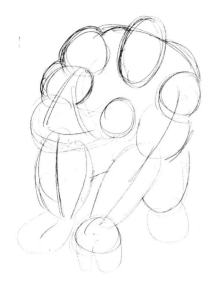

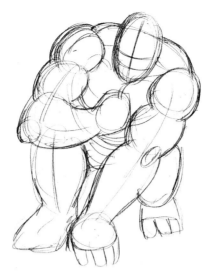

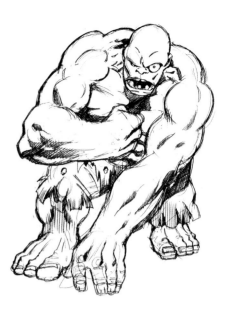

In step one, we start out with a crouching pose, adding circles that match the size of the head or bigger.

Step two has a more refined look to see the proportions of the character's muscles.

Step three has tight pencil art and features that are clearly defined.

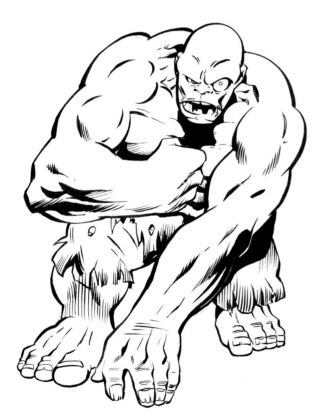

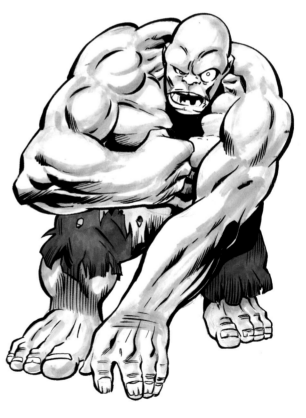

In step four, the final inks are added.

The final step has the fully-colored character in his menacing pose.

ALIENS

Creating aliens offers an artist (and a writer, for that matter), a great deal of imaginative leeway for one simple reason—they're not based on reality! The more bizarre and fascinating you can make your alien creations, the better. And this is one case where the notion of realism and proportion go out the window—you're free to put together your creature in any way that works for you. A head that is too big or arms that are too long might be just the thing to ratchet up the fear factor! Don't limit yourself to entirely human bodies either; why not add tentacles, claws, extra limbs, scales, and so on. The only limit is your own imagination.

Depending on your setting, the aliens you design need to work with your world, so a tall, willowy alien makes no sense on a world with the gravity of Jupiter. Don't give an alien gills if he's operating in the atmosphere. Remember, the nature of your landscape will dictate how your people, animals, birds, insects, and fish will (or won't) develop.

If you create a plethora of species for your world, are there similarities or contrasts? For example, if you have three species on a world, what does that mean for the tables and chairs that accommodate each type? Does a chair have a space for a tail? Does the bathroom need a variety of commodes?

As you design your aliens, think again about their transportation and tools, their clothing, and so on. When we populated Wakanda, we were inspired by African tribal designs which would look out of place in Namor's Atlantis, while the armored Norse gods would certainly be challenged (as they were) on the wind-swept, icy terrain of the Frost Giants who had no need for armor.

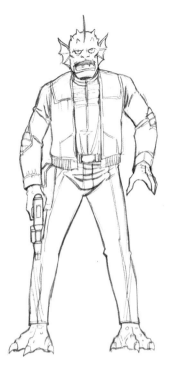

A less human-looking alien character that still has a humanoid form.

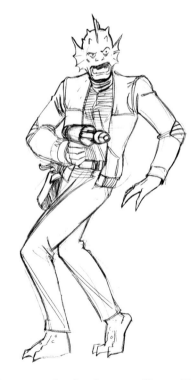

Here you see the alien character pulling out his weapon.

Here you see the side view and posture of the character to demonstrate how it resembles a human.

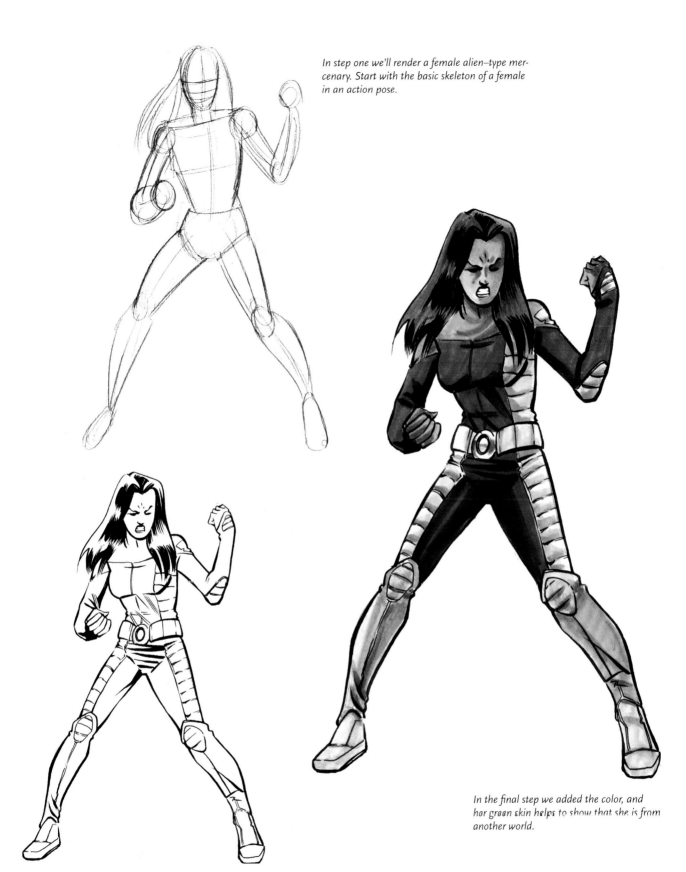

In step one we'll render a female alien-type mercenary. Start with the basic skeleton of a female in an action pose.

In the final step we added the color, and her green skin helps to show that she is from another world.

In this step we have the refined figure inked and ready to be colored.

GIANTS

Even larger than the standard brutes I mentioned earlier, giants bring distinctly surreal imagery to the comics page, and drawing them provides some unique challenges. For one thing, depending on the size of your gargantuan guy or gal, fitting other characters into a panel with them usually requires a heavy reliance on perspective. But, big characters are big fun, so don't be afraid to take a giant risk.

The size of your characters can not only provide nice visual variety, but allow you to play off contrasts. You pair someone like jolly Jim Shooter, well over six-feet tall, with the more diminutive Roy Thomas, and you get a nice study in contrasts.

The giant character is in a heroic pose with slight worm's eye view to convey size.

Using the side view helps show the proportions of the character still resemble that of a normal-sized human.

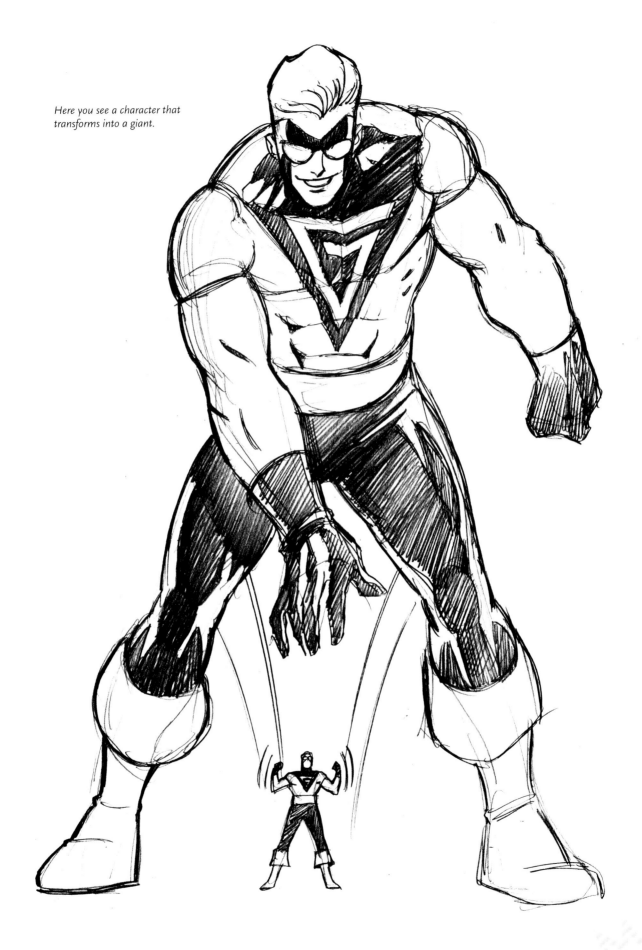

Here you see a character that transforms into a giant.

ZOMBIES

It's safe to say that zombies are as relentless a force in pop culture as they are on their never-ending quest for flesh. Here's a zombie-specific challenge for you—find a way to present zombies that feel, for lack of a better word, fresh. Whether it's a new approach to how they move, or capturing just the right grisly details to delight the most die-hard zombie fan, drawing zombies should be as fun as it is gruesome. And if a certain comic book–based hit TV show has taught us anything, it's that half a zombie can be as terrifying as a whole gang of them.

The zombie hails from Haitian legend, and since the 1970s has been a comic book staple. The rules for zombies have varied, so maybe go back to the ancient tales and use them for inspiration, and to find a way to twist them into something new.

If we're reanimating the dead, think about how dead you want them to be. Freshly dead will be almost identical to a human, but someone dead a year or more has been decomposing, and someone dead for centuries will be a skeleton, perhaps missing a few pieces. Again, think about your visuals and your need for variety.

A standard look for a zombie involves missing teeth and/or a missing eye to show that it's decomposing.

Another portrait view shows sunken cheek bones and a missing nose.

Now he's very hungry! Here is the zombie getting ready to take a chomp out of his victim.

ROBOTS

It seems as if the heyday of science fiction might never end—the modern world seems more sci-fi every day! One of the keystone concepts of great sci-fi storytelling is the robot. Not to be confused with their android cousins (see below), robots are intended to be completely mechanical. A robot's design might try to emulate the general shape of a human, but they are clearly machines, in many cases designed for a very specific purpose. Robots are often depicted as shiny and metallic, so color can be an important element in capturing the exact look of the robot you're drawing.

Now challenge yourself. You've created a new world populated with not-quite-human people. What do their robots look like?

Anyone who has grown up with such Japanese creations as Transformers, Evangelion, BattleTech, or Shogun Warriors knows just how much variety you can have in robot design, and really the sky's the limit!

The robot's head has very human features, which help make a connection to it.

The features can be distorted to show various emotions like anger.

Here is another emotion being shown by the robot character.

Here is a robot character in full view. You can reference all sorts of machinery that can add details to make your character look authentic.

Here's a side view showing various gears and joints, which give it movement.

Now the robot is rendered in motion to feel almost human.

VAMPIRES

For a vampire, body language is everything. Often vampires are considered suave—even sexy—but their bloodthirsty intentions are hinted at in subtle ways. Hunched shoulders, an odd tilt of the head, and any unusual appearance of the mouth—physical markers like these will help bridge the gap between comely and creepy. Don't just limit yourself to a traditional Dracula-type vampire. In comics, there is a long tradition of alluring female vampires like Vampirella or Lilith, and don't forget the vampire hunter Blade, armed with his array of wooden stakes. Try to show us a sort of vampire we've never seen before.

Vampires were born out of Eastern European folklore, so if you go back to the original source material, you can see how they were described and build from there. If your vampire is a soulless, mindless creature, signal that with how it's drawn. A smooth operator in a nightclub might turn out to be picking up a woman not for sex, but for dinner, a surprise to reader and victim alike.

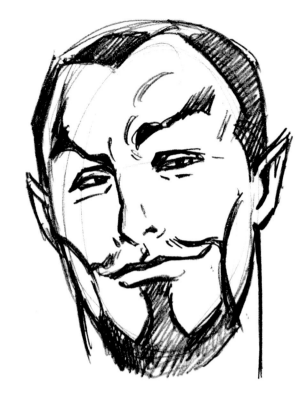

Here's a close-up view of the vampire character. It all starts the same as with any head. Refine your pencils to show sharp features and bone structure. A touch of facial hair makes him look more sleek and mysterious as well.

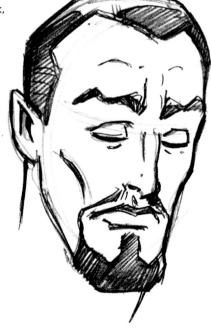

Here's a different expression showing a more sorrowful look.

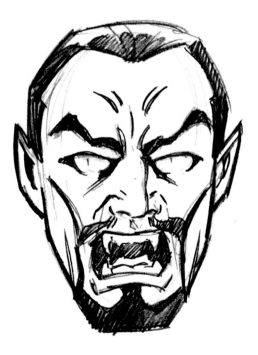

And now we show complete blood-lust raging in the eyes and fangs. Notice the small pupils that add a more sinister look. And most important are the vampire's fangs, too.

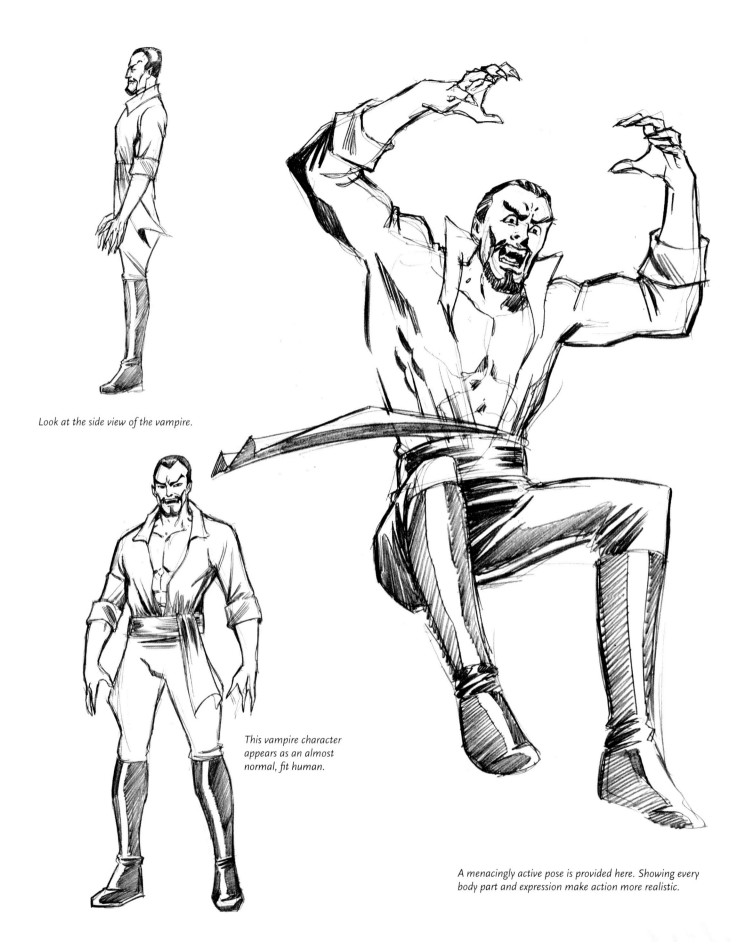

Look at the side view of the vampire.

This vampire character appears as an almost normal, fit human.

A menacingly active pose is provided here. Showing every body part and expression make action more realistic.

ANDROIDS

Like robots, androids are a form of mechanical artificial being, but androids bear the added burden of being created to resemble—or perhaps even attempt to become—a human being. Does your android look convincingly human? Then maybe play around with exposing the mechanical skeleton underneath to create something visually striking?

When Roy Thomas rascally created an android, The Vision, he dubbed it a synthezoid, something unique to help people stop confusing androids and robots. Since then, we have seen androids infiltrate society through the *Terminator* films or TV's *Battlestar Galactica*. As a result, they've been dubbed "toasters", "skin jobs", and worse. The key is: an android resembles a human being but is entirely mechanically or synthetic (clones need not apply).

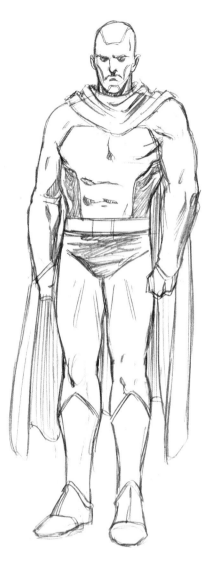

Here's an android character—still a robot on the inside but more human in appearance.

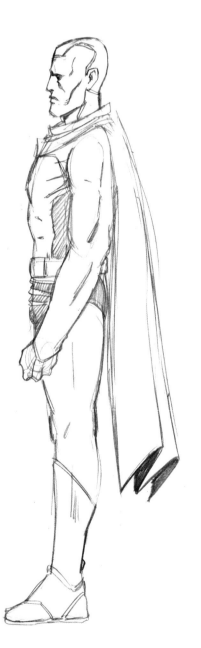

Here's the side view of the android.

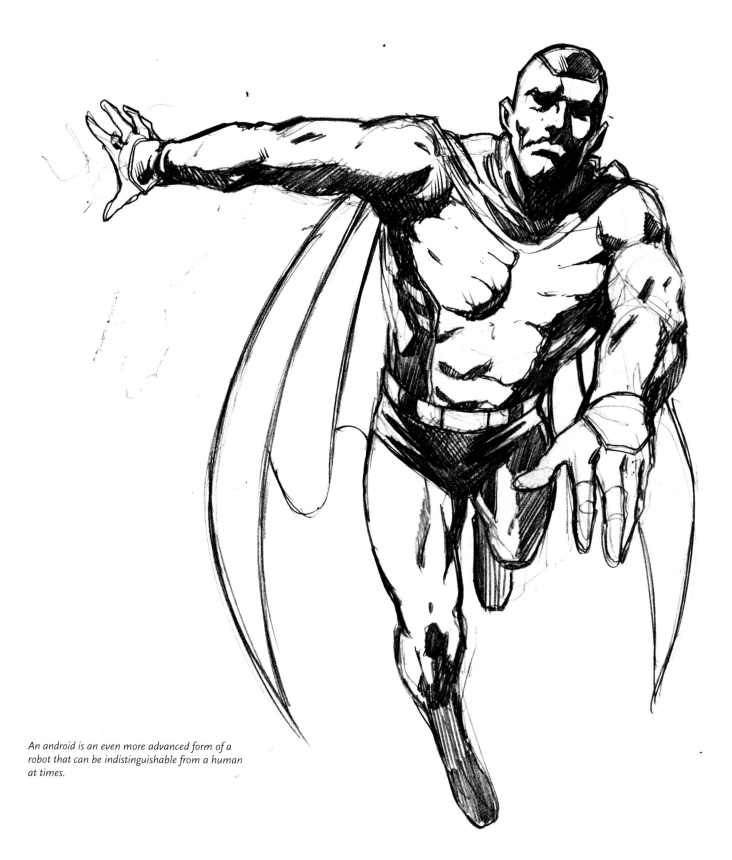

An android is an even more advanced form of a robot that can be indistinguishable from a human at times.

CYBORGS

It's probably been a while since you've thought of the phrase "cybernetic organism," but that's where the word cyborg originates. While they're often mistaken as being a specific kind of robot, cyborgs are people with tech-based mechanical enhancements. The combination of human flesh and cold, hard technology could be quite striking to draw, so feel free to mix and match.

We could go all the way back to Edgar Allan Poe to see the use of pre-mechanical cyborgs in an 1843 short story. Science fiction and comic book writer Edmond Hamilton had space-exploring cyborgs back in 1928, but really, we all know about cyborgs thanks to Martin Caidin's novel of the same name, although you probably know it best from *The Six Million Dollar Man*.

Marvel's legendary Deathlok is a fine example of how to dream up an unforgettable-looking cyborg, with scarred, burnt human skin combined with a hard metal exoskeleton and a robotic eye. Not to be outdone, the great George Pérez drafted a less threatening-looking figure in his new Teen Titans cyborg.

In our world, ever since pacemakers and similar devices have been inserted into human beings, the line between science fiction and reality has grown ever thinner. Artificial joints, tech to help sight and hearing, and miraculous inventions still on the drawing board make creating interesting cyborgs challenging, but it can be done. You just need to see where we are today and take it a few steps further and think of how we would appear to one another. How fashion and cosmetics evolve to hide or enhance the cybernetic touches.

Here is a cyborg character with robotic limbs but still human underneath.

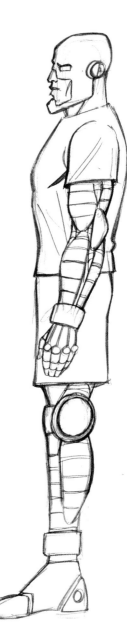

This is the side view of the cyborg showing he is robotic.

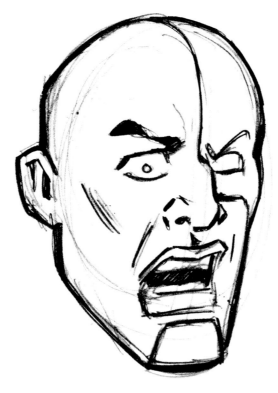

The cyborg character here has an aghast expression.

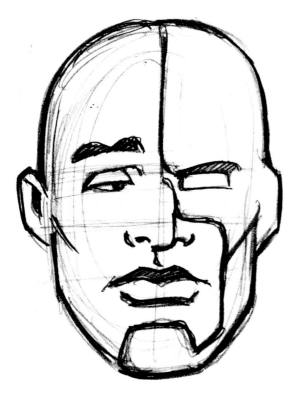

This cyborg also has robotic facial parts, as shown around the left side of his face.

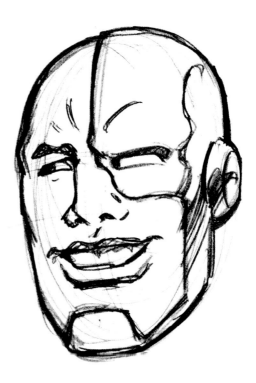

The cyborg character, smiling.

WEREWOLVES

The beastly brutes whose wolfen forms emerge with the glow of the moon populate many classic horror tales, and some of the best ones are found in comic books. From Marvel's *Werewolf by Night* to DC's *Fables* and even *Jughead: The Hunger* (really!), artists have found interesting ways to draw their own vision of the age-old myth. Does your lycanthrope completely change into a wolf, in which case you'll need to surround yourself with photos of the real creatures and even watch some films to study how they move? Or maybe your creation is some strange animal/human hybrid, possibly walking on two legs but covered in fur and with sinews, claws, and teeth stretched and pointed? For a different take on the old legends, check out Marvel's Tigra, an altogether more modern, light-hearted lycanthrope. There is great scope to express yourself as an artist here.

Also, don't forget to consider the transformation itself, which can be visually compelling, frightening, or make your character sympathetic by showing how painful it is to go from human to wolf.

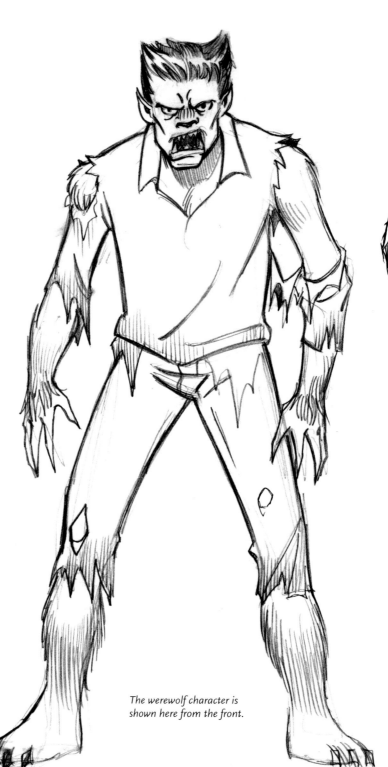

The werewolf character is shown here from the front.

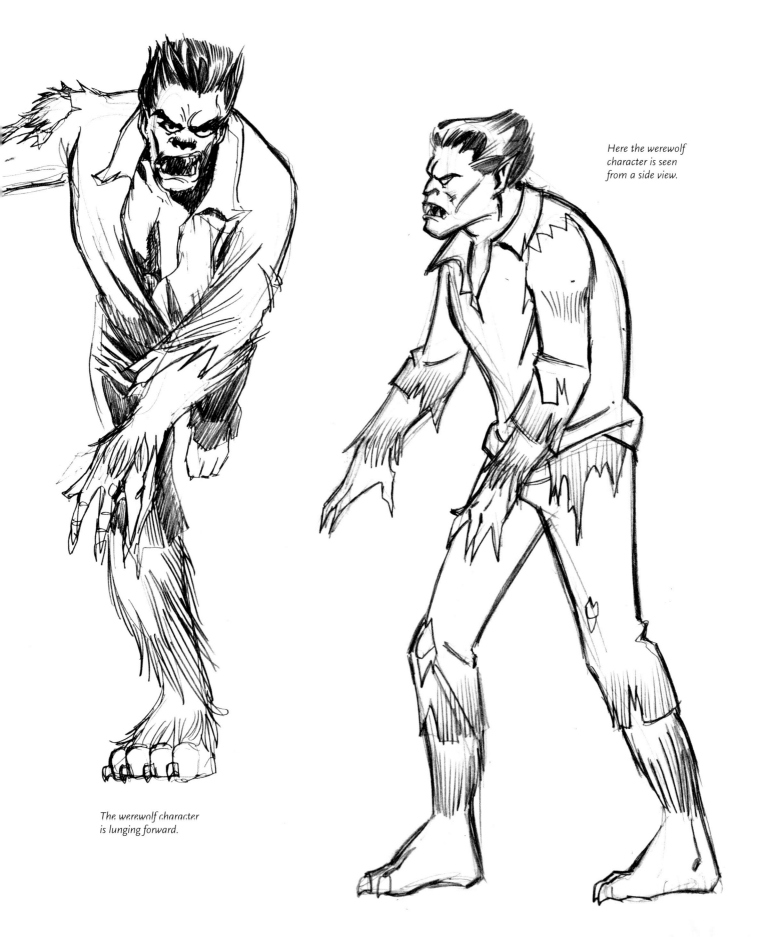

Here the werewolf character is seen from a side view.

The werewolf character is lunging forward.

The werewolf character with a smug expression.

This time the werewolf character has an angry expression.

Now the werewolf character looks sorrowful.

A lycanthrope made popular by Marvel in the 1970s can be seen in Werewolf by Night #1. Art by Mike Ploog.

ANTHROPOMORPHIC

Think back to your English classes where you were taught to identify anthropomorphism in your literature and poetry (well, I was!). Throughout human history, storytellers have assigned human attributes to non-human things. By making these things—the moon, a cloud, a white rabbit, and so on—act like humans, they become more relatable. They have been a part of storytelling since the first story was told around a campfire and remain a popular aspect in literature to this day. While relegated these days largely to children's literature, it hasn't always been that way.

While anthropomorphic characters are typically based on the concept of an existing object or animal becoming personified, these characters can have some of the most wildly original and imaginative personalities you'll ever meet. If you've seen the *Guardians of the Galaxy* movies (and if you haven't, what planet have you been hiding on?), you'll know how entertaining Rocket Raccoon is. But who'd have thought a talking raccoon could be cool? Or that Groot could be so adorable?

Just about any animal can become a memorable comic book character. Who could forget the Teenage Mutant Ninja Turtles; what sort of crazy imagination thought of turning an unassuming group of turtles with the names of the great painters into fearless, deadly martial arts fighters? It's crazy, but it worked. Or for a beautifully drawn, gentler type of animal hero, check out Archaia's *Mouse Guard* comic strip. And what about Howard the Duck? Or the great French cat detective Blacksad? There are still lots of animals that nobody's used yet (is the world ready for a talking anteater?), so go for it!

Drawing such creations requires you to alter the anatomy of your subject since, last time I checked, we were the only ones to walk on two legs as our primary form of motion and have opposable thumbs. Giving those aspects to animals or birds or inanimate objects automatically alters them. You need to determine what you want or need these beings to do in your story, and which human attributes are the right ones to provide them. Then consider which parts don't change and why. Then you can choreograph your story so a walking, talking bear might crowd an aisle at the supermarket while your office chair might hug you each morning when you arrive for work.

Not only do you need to consider anatomy, but also proportions. A kangaroo, for example, wouldn't be able to stretch its short arms up to pluck an apple from a tree. As you consider your anthropomorphic creation, start with a skeletal structure. Draw a few poses to get a feel for how the creature would move, sit, stride, and run.

Once you're happy with that, go on and add in the muscle mass, bringing out new dimensions to your amazing animal. Then go in and add the details: hands or paws, fur or feathers, clothing or not? After all, you're adding this creature to your story. So is it civilized, and if so, how does it dress? Does it wear jewelry and if so, what sort?

You need to pay particular attention to the head and figure out how the creature expresses itself. Twitching ears or bearing its fangs? Is the emotion in the eyes or eyebrows? Do some studies to get comfortable and adjust until the character is ready to make its entrance in your newly created reality.

Another anthropomorphic character series is Mouse Guard, *created, written, and drawn by David Petersen.*

Howard the Duck is a perfect example of an anthropomorphic character that is in a class of its own. Art by Gene Colan from Howard the Duck *#6.*

The strangest things can be given a personality in the world of comics, such as this character example.

The anthropomorphic character is shown here in side view.

Now the anthropomorphic character appears in attack mode

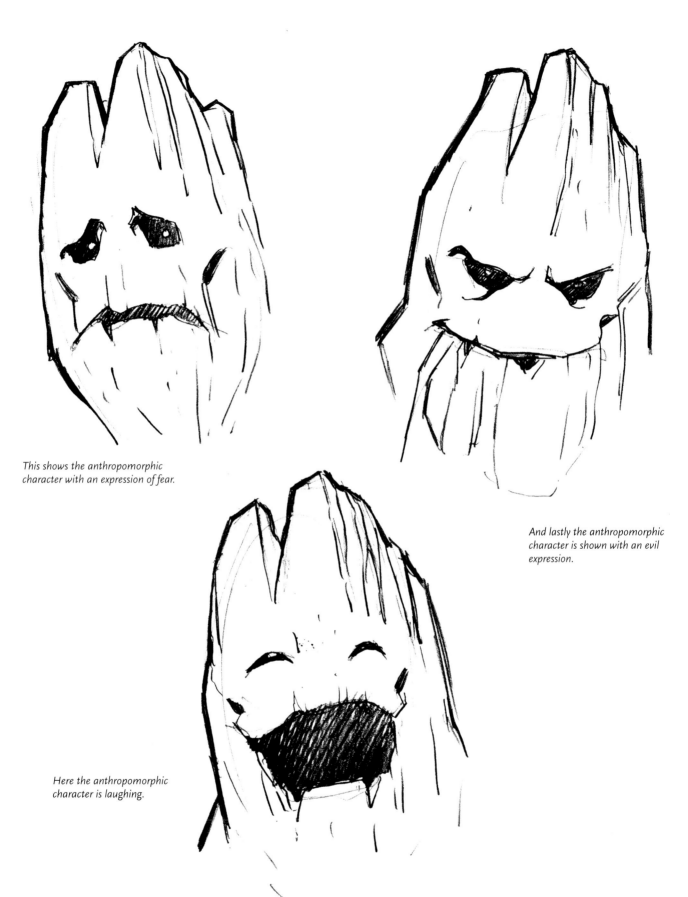

This shows the anthropomorphic character with an expression of fear.

And lastly the anthropomorphic character is shown with an evil expression.

Here the anthropomorphic character is laughing.

The Mighty Samson observes the horrors of a city destroyed from
The Sovereigns #0. Art by Johnny Desjardins.

It's all well and good to know and master art technique, but here's where we discuss how to put these techniques to use. Comics are all about telling a story—how things develop from one event to another, the building of suspense and drama, the creation of characters that readers will love or hate, and so on. As important as words are in this process, comics are primarily a visual medium.

While comics may give specific credits for writer and artist, the fact is that comics are a combination of words and images that work together to tell a story. Unlike with movies or TV, comics are made up of two-dimensional images that don't move and are silent. The job of the writer, artist, letterer, and colorist is to draw with words and write with pictures—to make the reader forget he or she is looking at static images combined with lettered text. In other words, you're telling a story that—like all great stories—takes the reader to a world of imagination.

For this chapter, let's talk about visual storytelling—what the artist needs to draw to tell a tale in the most effective possible way. Of all the considerations you need to keep in mind before you draw and while you're drawing, knowing what a story is and how it works is the big one.

Dramatically drawn gestures and expressions add to the urgency of the words being spoken in these panels. Art by Jose Gonzalez.

PANELS AND PICTURES

What is a story? We all know from grade school that a story has a beginning, middle, and an end. If you can tell a joke, you can tell a story. Stories are made up of a series of events—featuring different characters, settings, plots and conflicts—and it is your job as an artist to most effectively convey these events visually.

Storytelling in comics means creating pictures to work alongside the writer's words, which combine together to tell the story. As a comic artist, there are so many different tools at your disposal to carry the reader through a story, and it's important to learn basic storytelling techniques if you intend to keep a reader's interest. Of course you'll need to keep your characters—their costumes, accessories, and settings—looking consistent in scene after scene, but once you've mastered that there are so many more things to think about as you construct your story.

FLOW OF ACTION

To make the act of reading a comic as effortless as possible, its action must flow smoothly from one panel to the next. In order to achieve that, pacing your storytelling is an absolute necessity. How much room you have for a scene determines how much of the action you can show. No scene exists on its own—every scene is part of the overall structure of a story.

Typically, you will be given a script or plot which covers an entire story or episode. Some scripts can include extremely detailed breakdowns of the whole story right down to the number of panels on each page, exactly what's going on in each panel, along with full dialogue and captions. Others can be much looser, leaving the precise pacing and distribution of panels on each page up to the artist, in which case the artist has much more control in how the story is told—this is usually known as the "Marvel style."

However, even when working from a very detailed script, you might want to add extra panels, or use fewer than suggested to tell a particular sequence in your own way. The writer and editor who assigned you the story may have a different sense of timing and pacing than what you feel is best for the scene, and sometimes you can convince them that your idea will work better. But, remember: Everything you add or subtract from one scene will impact the pacing of the rest of the story, especially if the story has a specific page length, which most of them do.

The evenness of the panel placement helps guide the viewer through this solemn scene. Art by Stephen Sadowski from Project Superpowers *#0.*

You're never just drawing a single panel—even if it's a full splash page. Everything has to fit into the overall flow of the story. The reader will see each page of the story as a complete unit before they focus on a specific panel. Each panel should lead the reader to the one that follows it. The reader's eyes should effortlessly be taken from left to right and top to bottom as they follow the action across the page. Back in the earliest days, we'd number the panels because readers were still getting the hang of how to read the page. Later, the numbers were dropped, but arrows were often included if the page construction might be in any way confusing. Thankfully, you've all grown into sophisticated readers, able to read most page configurations without such aids.

The placement of the panels, figures, objects, word balloons and sound effects—all of these help carry the reader through a story. Be aware of the need for clarity in visual information as you draw each panel and build up each page.

Regardless of the volume of information the writer has provided you, make sure you understand the story. If you can't follow the action or plot, your reader will be even more lost. Lots of artists I know will doodle as they read, going through a script once, marking things up such as a list of required references or questions for the editor or writer. More than a few will complete a read of the script, and then either on the script itself (if still on good old-fashioned paper), or on blank printer paper, begin roughing out what the page construction should be, getting a feeling for the pacing. This is where you may decide you need to add or subtract panels, adjusting the pacing of the story to build up the tension to the climax or cliffhanger.

Many use those thumbnails and scan them in, enlarging them on their computers, and begin digitally turning those rough figures into finished artwork, layer by layer. Others will send the layouts to the writer or editor for comment before committing to the artwork. And then there are those who read and absorb the script, gather their references, refill their coffee, put on some music, and just begin drawing. You'll experiment before you find a routine that works for you.

What you can't do is read the script and then play video games for a week. The script will always arrive with a deadline and you need to make certain you can meet that date. This is, after all, your business. It's also your reputation. If you blow the deadline, you may not get another chance with that editor or that company. Should you need to allocate time to pull all the references you need, do so. Also, communicate with your editor. If you have questions or think there may be a problem meeting the deadline, the sooner you share that news, the better the odds are that together you can find a solution or two.

If you write and draw your own story, then you have complete freedom in deciding how long each scene should be, how many panels should be on each page, and, of course, what appears in each panel. With great power comes great responsibility (now where have I heard that before?), and you really do need to remember not to get carried away with self-indulgent techniques or needless padding out of scenes. Always tell the whole story! But, whether you're working for hire for a top publisher or creating your own comics, you'll need to examine your work critically to determine how much the page, panel, or scene you've created advances the story and reveals character.

UNDERSTANDING YOUR CHARACTERS

In comics, characters are arguably the medium's number one attraction. Getting them right is a comic creator's most important job. Your story's characters—whether superheroes or civilians—will have defining features and tendencies that impact your story. How does Superman stand differently than Batman? How does a skinny guy like your friendly neighborhood Spider-Man move differently to a colossus like the Hulk? How would a Jane Foster stand differently than J. Jonah Jameson? It's important to study body language and observe how different body types look in action or at rest to bring out each character's individuality visually. Small, tall, thin or chunky, young or old—we all move differently. In superhero comics you'll want your heroes to be imposing, imperious, and impressive. Great artists of the past like Neal Adams and John Buscema were masters at dreaming up unforgettable, iconic poses, and current stars like Jim Lee, Adam Hughes, and Alex Ross are no slouches either. Always keep in mind how these different characters act, move, and stand, and your artwork will really come to life.

COMPOSITION

Most of the time (even in a detailed script), the artist will have a certain amount of freedom regarding the panel's point of view, closeness or nearness of the action, and so on. Some writers (and Alan Moore is one who's notorious for this) will tell their artists exactly how each panel should look, right down to the smallest background detail, light source, and character poses. However, most writers like to give their artists a lot more

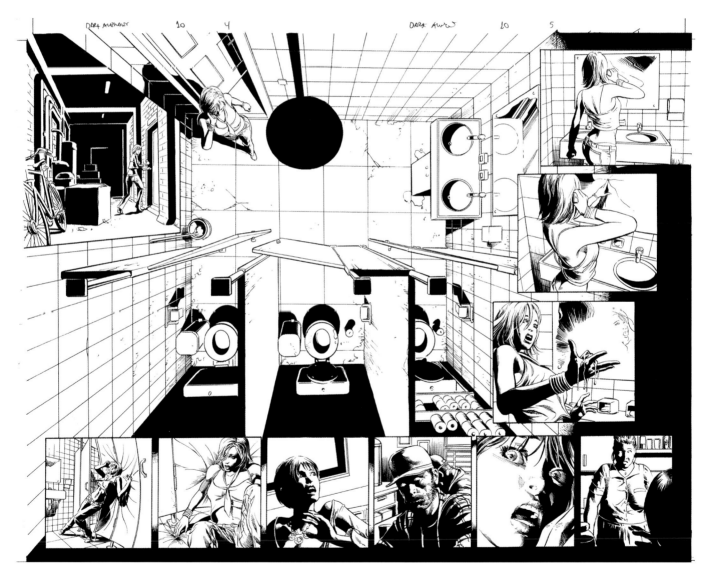

Effective use of lighting enhances the creepiness of your everyday, mundane public bathroom.
From Dark Avengers #10. Art by Mike Deodato.

freedom to interpret the script. As a writer myself, I feel that the writer is responsible for framing the actual storytelling, and there are a couple of necessary rules I keep in mind while doing this.

First, every scene should start into the action as late as possible and end as soon as possible, especially in comics, where your space is limited. I want to leap straight into the heart of every scene, and I expect my artists to fill each panel with all the information my readers need to lose themselves completely in the story. For example, you want two people to have an argument over the man they love. You don't need to show them drive to the bar, park, order a drink, and then start the dialogue. Cut right to the two women bellying up to the bar, ordering their drinks while sniping at one another. You can then have the argument and end the scene as one throws her drink in the face of the other. We don't need to watch her pay, walk out, and drive off.

Second, each scene should achieve at least one storytelling goal, and ideally more than one, including advancing and explaining the plot, giving information about characters, setting up the next panel, deepening the conflict, and so on. Rather than show the hero spotting the villain, advancing towards him, throwing a punch, the villain flying towards a wall, crashing into it, and his cronies rushing in through a nearby door, the best artists can fit all that into one exciting panel. Hey, whoever said this was going to be easy? But with practice you can get there!

CAPTURE THE EMOTION

As Will Eisner, Alan Moore, and many other comic book creators have shown, you can use comics to tell any kind of story: action-adventure, science fiction, drama, comedy, memoir, horror, and so on. For the sake of this book, I'm mostly talking about a classic type of superhero story, one that's mostly dramatic and serious in nature, but that you leaven with humor, romance, and personal conflicts.

A story that showcases only one mood is likely to be pretty dull. As in real life, the most tragic situation often has some humor, the most hilarious comedy often is laced with tragedy, and romance can be awkward and funny even while it's also tender and intimate. You'll want your readers to connect with the emotional undercurrents of each scene. Make sure your serious scenes are serious, romantic scenes romantic, and so on. I always loved collaborating with my good buddy John Buscema, and in this page from *Silver Surfer* #11, you can see how he gives each panel an emotional charge. The Surfer's mood changes from anger to concern and then to rage, and his mustachioed quarry looks back in terror at him. Finally, in the last panel, two soldiers look on at their fallen dictator with looks of shock and awe. It's a powerful mix of emotions, and this is the type of roller coaster the best artists can take you on.

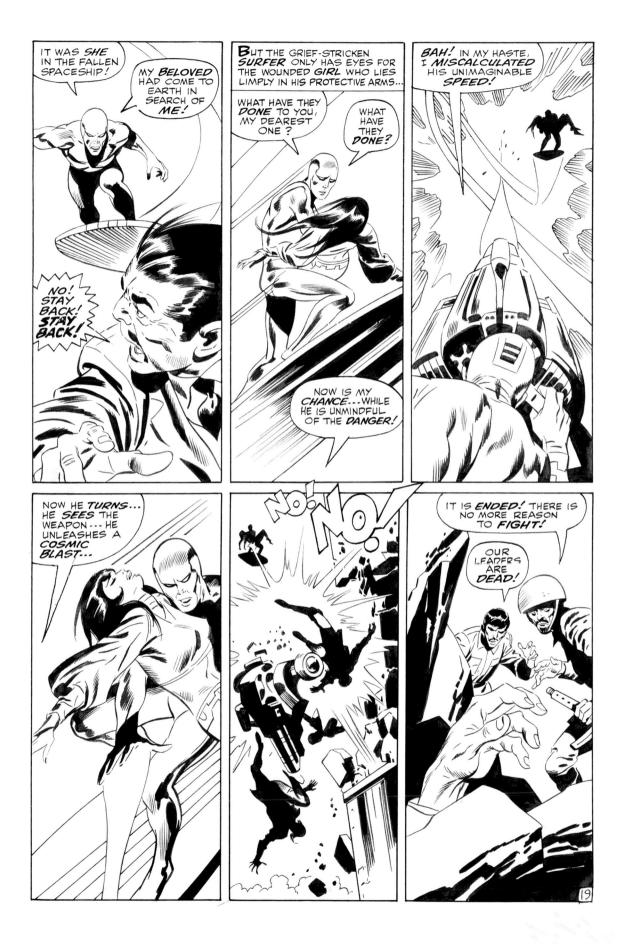

A dramatic sequence of events from Silver Surfer #11. Art by John Buscema and Dan Adkins.

DRAMATIC TENSION

Dramatic tension is one element that can greatly enhance the emotional impact of a story. In a fight scene, creating dramatic tension is a relatively straightforward process. You have two superhuman characters and have them whale on each other with fists, feet, eyebeams, hammers—whatever makes the most sense for each character.

But comics also contain quieter scenes of people in conversation or events building up to important story turning points, when key plot points are revealed. Paced and presented correctly, these scenes can be as powerful or even more impactful than action scenes. Pacing is a vital component of any scene—from the quiet and serious to the driving and explosive. The pace at which the action unfolds brings the reader into the rhythm of your story. In the scene from *Sherlock Holmes*, the artist keeps moving our point of view. After establishing who is standing where, he has the freedom to concentrate on a curious and puzzled Dr. Watson. By splitting the sequence into lots of small panels, this small scene takes a while to read, making us take in the sense of foreboding. Dr. Watson can tell that something is about to happen—but what?

Since the script dictates the pacing, you might consider it more of a writing topic, but it's useful to consider for writer-artists, or for someone working "Marvel style," who will have the responsibility of setting the pace while laying out a story from only a plot with little detail and direction.

Using the number of panels and their size to dictate pacing can be traced back to my old pal Will Eisner, who mastered that with his eight-page

The Spirit stories. During the first Marvel Age, Jim Steranko did the same brilliantly while producing *Nick Fury, Agent of S.H.I.E.L.D*, while Frank Miller went further with his groundbreaking work on *Daredevil* during the second Marvel Age.

Effective panel placement and character actions from Sherlock Holmes *#1 with Art by Aaron Campbell*

SETTINGS

Every scene happens somewhere. It may seem ridiculously obvious, but it's true. Your job is to make each setting feel believable to the reader. Even the wildest surreal dimension or futuristic city has to feel as real as a street in New York City or a forest in Oregon. If there's anything that drives me crazy looking at today's comics, it's how often the artist barely establishes a location, then skimps on backgrounds for the rest of the scene or the whole story.

Thanks to the internet, you can find photos of pretty much every place on Earth—as well as every vehicle, device, and garment. All of this reference material is at your fingertips. Readers will know if you get something wrong, so make sure your reference is correct. For *Dark Avengers*, Mike Deodato (page 115) chose an unsettlingly high angle to look down on a creepy bathroom, but filled it with all sorts of realistically grungy details so that you really believed in it. Likewise, Francesco Francavilla in *The Spirit* summons up an incredibly atmospheric shot of a rain-drenched subway train trundling over the rickety rail tracks. You don't need to read the scream of horror to understand that something bad is going to happen tonight, but you instinctively feel it because the setting is so believably and atmospherically drawn.

As I mentioned a few paragraphs earlier, figure out what kind of reference materials you'll need before you start to draw your story. Sometimes your writer or editor will supply some, but there may be more you need. Hunt down the appropriate images online to create a reference library for your story. There are wonderful collection

An urban setting with impressive lighting effects highlights a person's scream. Art by Francesco Francavilla from Will Eisner's The Spirit *#1.*

programs such as Microsoft OneNote, Google Keep, and so on where you can create story- or title-specific sections where all the reference material can be collected, organized, and reused. This way you'll have everything ready, and you won't be tempted to distract yourself by searching for reference materials or becoming overwhelmed by choices while you're focusing on drawing.

Even if your setting is some bizarre dream dimension, you still have the responsibility to make it consistent from panel to panel and scene to scene. The second your reader is pulled out of the flow of the story by some inconsistency in the art, there's the chance that reader will be lost for the rest of the issue and will avoid your work in the future.

Joe Jusko's beautifully painted alien landscapes from *Vampirella: Blood Lust* are wildly imaginative but somehow feel believable. Even though the flora and fauna of the far-off planet Drakulon are brightly colored and strangely twisted, they still have echoes of the world we recognize and are rendered with enough detail, depth, and structure that we can believe they might just exist.

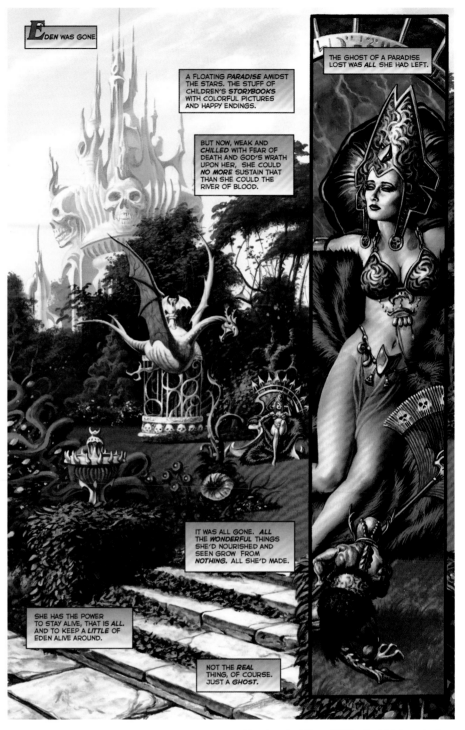

Here is a depiction of "Eden," which is part of Vampirella's home world, Drakulon, from Vampirella: Blood Lust #1 with art by Joe Jusko.

An intense tank battle during WW2 in the frozen tundra makes the situation all the more bleak. Art from Black Terror #5.

BACKGROUNDS

For a comic book artist, backgrounds refer not just to the setting for your story but also to the specific physical environment shown in each scene drawn. As mentioned earlier, once you establish the backgrounds in a scene, you can then focus in on certain parts or merely hint at them as the story goes on, but remember to always establish your settings on each page. You can render backgrounds in exhausting detail or simply suggest them with subtle strokes of the brush. Whatever the exact aesthetic of your background, the guiding principle is that the reader must always be aware of where the scene is taking place.

A fully realized background can be vital in telling the story, and a perfect example is the panel from master craftsman Alex Toth, which manages to sum up a whole scene in just one drawing. As you can see, the panel shows a cluttered 1930s style office with three levels of depth to it, each of which tells us more of the story. In the foreground, we can see a slightly slumped figure—is he dead or just asleep? We can't tell just yet. In the middle stands a hoodlum with a smoking gun; it looks like foul play has been afoot this night. But, behind him in the background are two open doors giving us a preview of what's coming next: On the right, two of New York's finest with guns at the ready; on the left, the cloaked figure of the Shadow ready to mete out his own form of vigilante justice. All chaos is about to break out! It's a whole story in one drawing and drawn with such realism and intelligence that you completely believe in it.

Alex Toth and his uncanny knack for creating lively backgrounds from the most pedestrian of objects. Cover art from Alex Toth *published by Kitchen Sink Press.*

LIGHT AND SHADOWS

The use of shadows, or the placing of solid black areas, in a comic story can do several things—it can create a particular atmosphere, give the impression of weight or solidity to something, help make figures or certain pictorial elements stand out in a panel, and make a page look visually more interesting. How you light a scene depends on the direction and strength of the light and what is creating that light. In other words, what is your light source? Is it the sun, or the moon at night; is it a light in a room, or maybe just the outline of a figure illuminated by a torch in the darkness? When drawing a comic, paying attention to light sources is not only important because of the need for visual consistency and believability, but also because it can play a major role in establishing the atmosphere and mood for a story. The more shadows in a scene, the more dramatic it will be perceived as being.

Will Eisner is widely celebrated for his use of shadows, and in the page from *The Spirit*, you can see him using them to do lots of different things, from throwing shadows over figures to obscure their identities and emphasize other characters, to placing a shadow behind the tiny figure of the Spirit in panel five, which gives him just enough weight to make him look believable. And importantly, the way the black is distributed around the page gives it a varied, interesting look.

A page from Will Eisner's The Spirit syndicated newspaper insert from 1945.

Jaime Hernandez is an indie artist drawing comics today who also has a great ability to work with shadows. At first glance this page from *Love and Rockets* might seem a bit simpler and more cartoony than the superhero comics you're used to, but take another look—this is no comedy strip! Here, he manages to draw a scene of genuine suspense and terror, created through a constantly changing point of view and a brilliant use of shadows that fall in almost every panel. Something that Hernandez is particularly good at is always zeroing in on the most important part of each panel, and he often uses shadows to do this. So in panels one, four, and six, he partly or completely covers the foreground figure in shadows so we concentrate on what she's looking at in the distance. In panels three, four, and five he throws a shadow behind the small figures in the background, which makes them feel more solid and really makes them zing out of the panel. And, as the sequence reaches its grisly conclusion, he surrounds the action with solid black so we can't look away; we focus in on the dead cat. Brrrrrrrrr!

While a colorist can add their own visual cues to the storytelling, do not count on them to give you the look you want when you can control the image with the presence or absence of light. All too often, in the haste to make the dreaded deadline, color notes can be misunderstood, or worse, overlooked entirely.

Interior art page from Love and Rockets *by Jaime Hernandez.*

NEGATIVE SPACE

You don't have to fill every square inch of a panel with drawing. In fact, sometimes—like the pauses in a piece of music—less is indeed more. Isolating a character or characters in a panel without showing the backgrounds, or framing a scene so there is a large amount of empty space can be as or more effective than drawing every nut and bolt in the background. The empty area of such a panel is known as negative space.

Judicious use of this technique can make your art more effective—and can save you valuable time. It can also enhance the placement of word balloons and captions when focusing on those elements might be particularly important. In the panel from *Jonah Hex*, José Luis García-López (an artist's artist and someone I regret never having worked with) has arranged a packed panel with three figures and a detailed background. But, rather than draw in the floor boards which would create a very cluttered drawing, he leaves that whole area white, even taking out the panel borders, so that our eyes are completely focused on the more important figures instead. The white area also acts as a sort of counterbalance to all the line work in the rest of the panel, creating a more harmonious picture. A page which mixes areas of negative space, solid black shadows, and different types of lines or cross-hatching is usually a very interesting page to look at indeed.

An interior panel from Jonah Hex #4 with art by José Luis García-López.

TWELVE USEFUL STORYTELLING TECHNIQUES

1. An extreme close-up will give more intensity to a panel. Just imagine the impact of standing close to someone's face—when used in a comic strip it can be equally startling.

2. In action scenes, it is often most effective to show the result of an action in the same panel as the action depicted. A punch thrown is usually more powerful when we see the effect on whomever the punch was aimed at.

3. Extreme action is usually best depicted with the lead-up and/or the follow-through. The moment of impact—a fist to a jaw, for instance—is often the least dramatic-looking point of a scene. Look at any Jack Kirby comic to see this principle in practice.

4. An upshot (that is, a composition taken from a low point of view, looking up at the subject) makes a character look large and imposing, even threatening.

5. A character drawn small with a lot of space around it will seem lonely and small in the universe.

6. Always remember: Leave room for word balloons, captions, and sound effects in each panel. Otherwise, the lettering will appear cramped and might even cover key parts of the art. It can be a good idea to loosely write in all the dialogue and captions on your page to be sure you've left enough room. These are as important as your figures and objects and should be designed as a whole.

7. Establish locations and characters at the beginning of your page, then you can use blank or simplified backgrounds and offbeat framing on the rest of the sequence.

8. People in Western cultures tend to read first left to right and top to bottom. Your panel layout, as well as the contents of the panel, should flow based on that arrangement.

9. If something in a panel is important later in a scene, set it up clearly, early in the scene. Your writer will usually call this out in the story, so make sure it's there!

10. Place the first person speaking in a panel on the left. Similarly, people shake hands with their right hands so position your figures appropriately.

11. Depending on the context, many small, thin panels next to each other can create the comics equivalent of slow motion. You can also use the same technique to create the effect of sped-up action. It all depends on the context.

12. Shadows tend to make a scene feel moody and dramatic. It's best to use them for serious scenes that require a sense of menace. Humorous scenes work best with fewer shadows, and with more space and room around the characters to emphasize the lighthearted atmosphere.

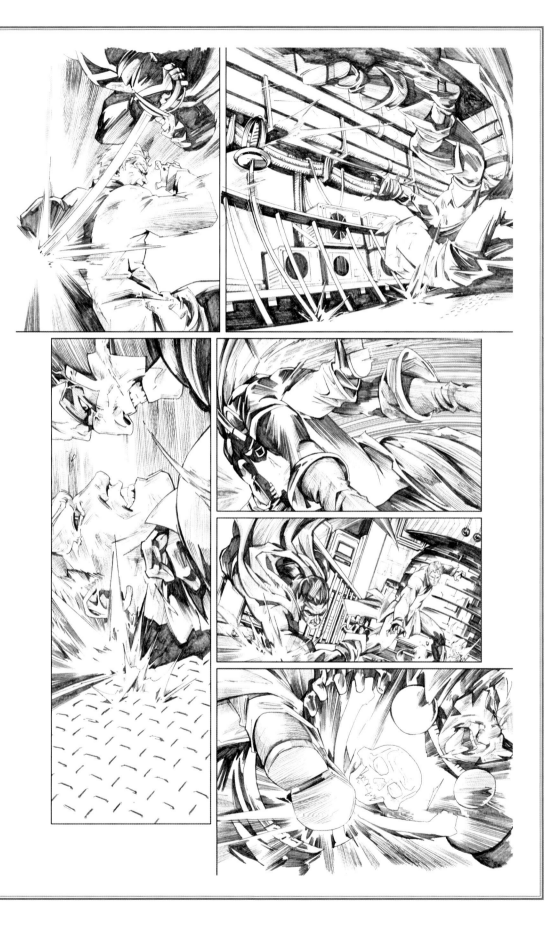

Tight panels around the action bring the viewer close in. Art by Stanley Lau from Black Terror #7.

THE SCRIPT

So far we've spoken about the different sorts of scripts you might be given to work from, and the various ways you can interpret them. But what does a furshlugginer comic script actually look like? (You mean you don't already own *Stan Lee's How to Write Comics*?)

Here is an example of the sort of script you could be given when you embark on your career as a comics pro—starring a couple of guys called Tarantula-Man and Killer Cyborg (Geez, who writes this stuff?)

In this example, you can see the first page of a scene. The scene might end on the next page or it could go on for pages—depending on where the story goes, of course. In some strips, this action might have been done in a much more straightforward manner, but in this story we're combining drama with humor. Tarantula-Man wants to have a quiet afternoon, sharing a pizza with his girlfriend. But what he gets is a super-villain nearly killing him, an unprovoked battle with that villain, and his nemesis having yet another reason to hate him.

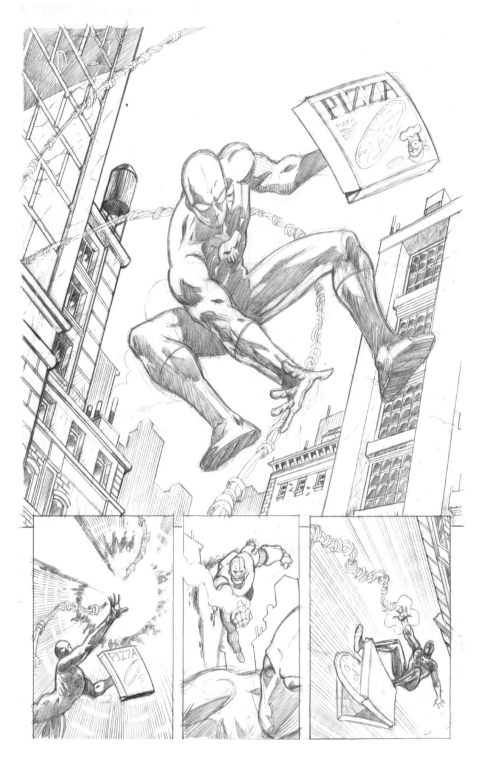

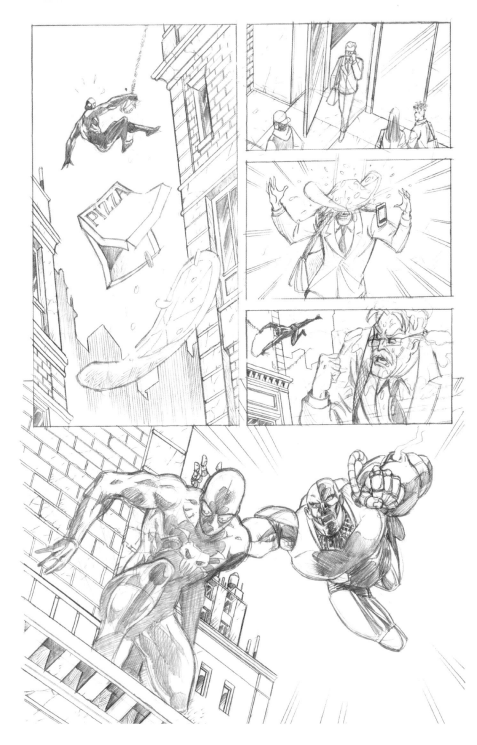

PANEL ONE: Tarantula-Man swings through the city, carrying a pizza box.

PANEL TWO: He's attacked by a ray blast, which severs his rope line.

PANEL THREE: The blast we saw was fired by Killer Cyborg, who is flying toward Tarantula-Man!

PANEL FOUR: Tarantula-Man falls through the air, past building windows. He's still holding the pizza box. He shoots out a web-line—

PANEL FIVE:—that saves him by adhering to the side of a building. But the pizza box goes flying and the pizza falling out of it.

PANEL SIX: We see Tarantula-Man's TV reporter nemesis leaving the building below—

PANEL SEVEN: —the pizza plops right onto his head!

PANEL EIGHT: Nemesis pulls the gooey pizza off his head while shaking a fist at Tarantula-Man.

PANEL NINE: Tarantula-Man, landing on the rooftop, regrets what happened—he's already hated by a large part of the populace—but he has no time to worry about that, since Killer Cyborg is jetting towards him, metallic fists aiming at Tarantula-Man's head!

THE ARTIST'S APPROACH

Let's examine the thought process that goes into drawing a scene like the ones in the previous section. The writer may have given stage directions, but the artist is the one who has to come up with the compositions, poses, body language, backgrounds, lighting, and the angle of what's depicted in each panel. In fact, as an artist, you design each panel—and the entire page—as a visual unit. Remember, you're not just making pretty pictures—you're telling a story and establishing its mood.

I realize this sounds ridiculously obvious, especially since I mentioned it earlier, but the first step of drawing a comic is reading its script— not simply a cursory glance—but really carefully so you grasp all the important elements.

Here are some questions to ask yourself as you're reading, to help you analyze how you will approach your drawing:

- Is the hero confident and assured or is he tired and bruised? Is the villain intent on hurting the hero because he hates him or because someone's making her do it?

- Why is each player in the story doing what they do and what is at stake for each person?

- Put yourself in the characters' shoes (the hero and villain, and even the bit players and bystanders) and think about what would should appear in each scene. Think also about what should not appear in each scene.

Remember also to vary each panel, mix close ups with long shots, place shadows where necessary to create a certain mood or visual depth, or to create a focus on something important in the panel. The writer is not necessarily trained to think in these visual ways, so it's up to you to consider all of this. You might want to look for reference material, or even take a peek at how your favorites have handled similar scenes in the past.

Each artist has a different approach to creating a comic book page. Some jump straight to drawing out the scene, but most will sketch out their ideas on a scrap of paper first, seeing which approaches work best to each sequence. Many read the script several times and let it percolate in their mind. You might want to go for a walk, or even take a shower(!) to give your mind a chance to come up with the best solutions to the problems of interpreting a script. All artists are different, and there is no single way to create a page, but in time, you'll find the method that works best, and then there'll be no stopping you!

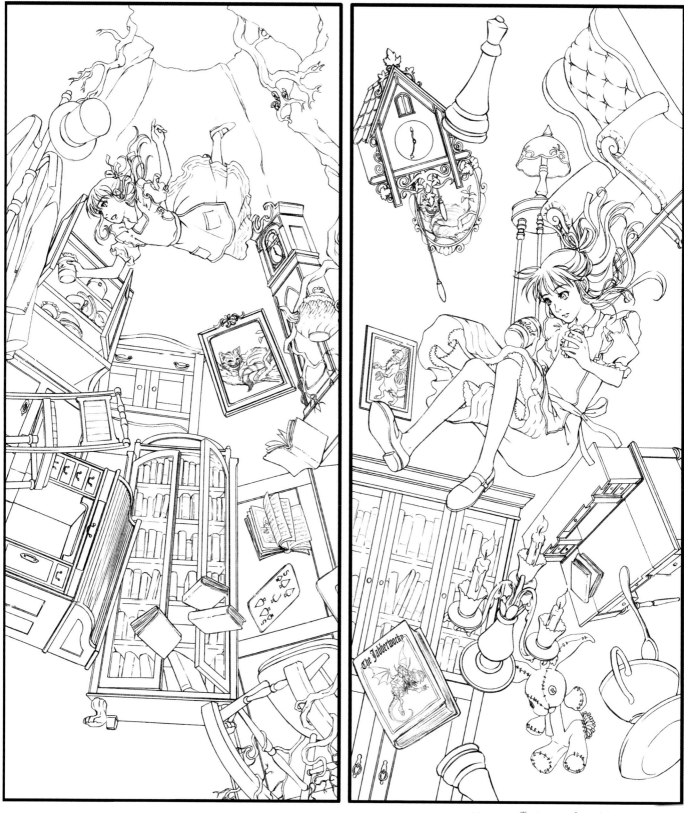

Here's an effective use of panel shape as chosen by the artist to include the main character and all the background elements needed for the image as instructed by the writer. Art by Erica Awano.

Series of various Vampirella scenes without the containment of panel borders in this double-page spread from Vampirella Vol. 4 #7

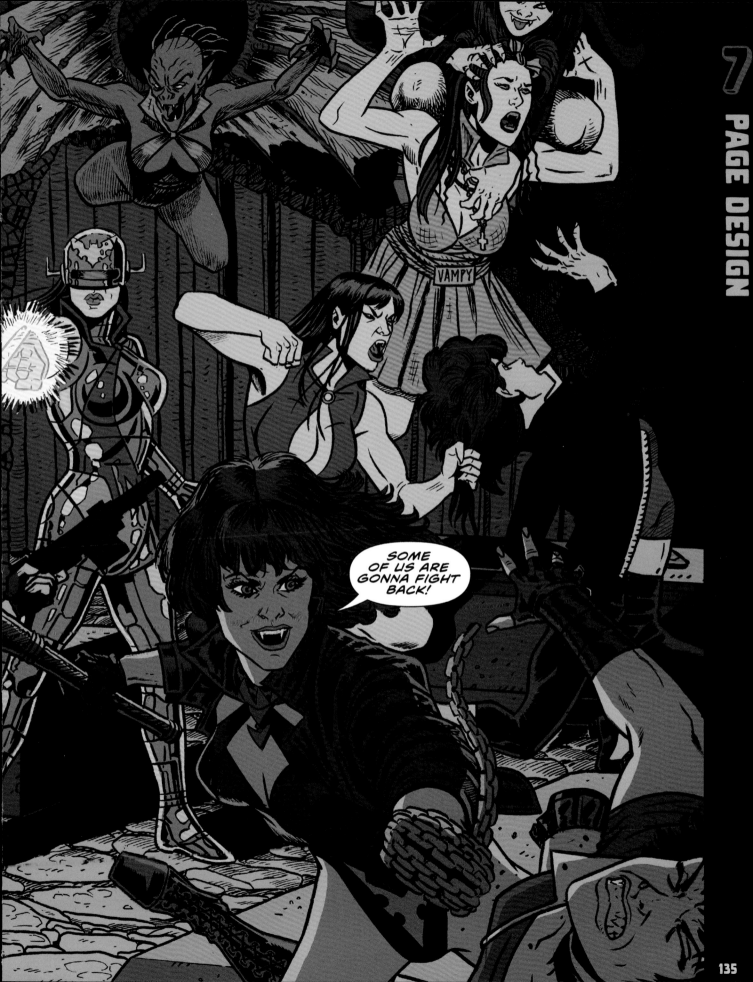

The blank page is literally and figuratively your tabula rasa (blank slate). It's an empty space on which you will use your art to magically convert it into a page of a comics story filled with drama and excitement.

While the script may give you directions, there is still a plethora of choices that are left up to you to resolve. Your skill and imagination will enable you to take the reader to amazing places that only you can take them to.

Remember, the art you create for a comic is in service to a story. While a quick look at the comics racks will tell you that there's more latitude these days than ever before in terms of what's acceptable to editors and publishers (and readers) on the design and layout fronts, there are still some basic guidelines for creating a comics story that people will be able to follow and enjoy. A comic book is not just a succession of pretty pictures, it is a sophisticated way of telling a story. I am going to show you how to guide the reader's eye where you want them to look, how to create drama, mood, and emphasis where the story needs it, and how to speed up or slow down your story.

Think of each page of as an invitation to the reader to continue reading the story. As a result, each page must be as pleasing to the eye as possible. The reader may not know he or she is responding to the page's design—all they want is to somehow feel reading the page is worth their time and effort. But you and I know that part of what attracts them to a page is how well it is designed. If that sounds vague—well, it's because there are many solutions to the challenge of creating pleasing page designs.

Some of the essential elements of page design include panel sequence, the location and size of figures within the panel, panel sizes, inset panels, and lining up storytelling beats to create a "page-turner" at the bottom. These various components work together to create the overall mechanics of the page, which heavily influence how the reader experiences the story.

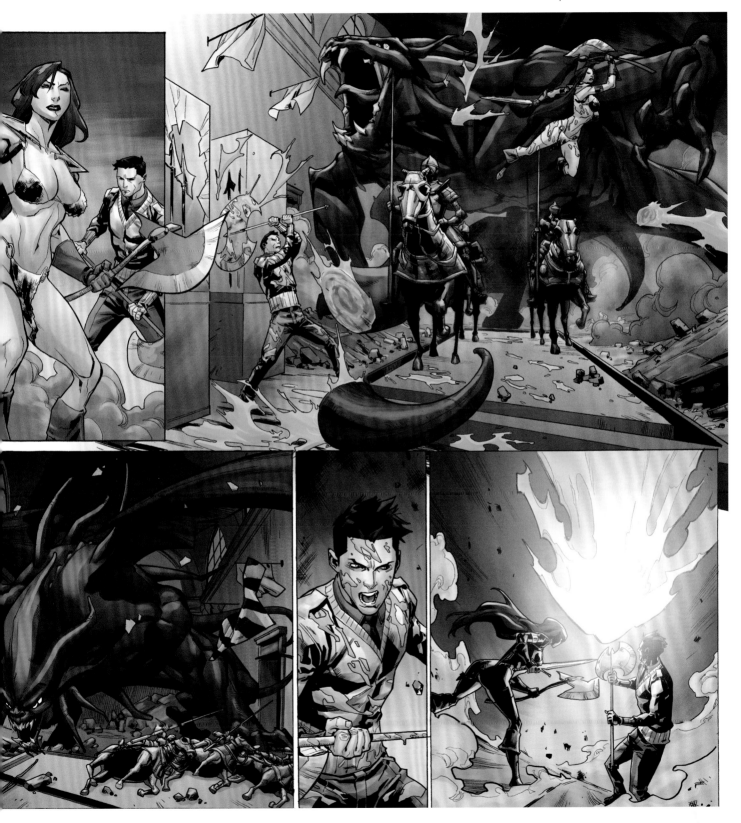

Interior double-page spread of chaotic yet effective battle sequence from Red Sonja Vol. 4 #4, with art by Carlos Gomez and Mohan.

PANEL SEQUENCE

This may seem rudimentary and basic, but its importance cannot be overstated: Panel sequences in English-language comics must run from left to right and top to bottom—unless the writer or artist is intentionally creating a sense of confusion or some other disordered notion in the story. The artist's job is to make your readers' eyes move the way you want them to move, following the action across and down the page and also within each panel. So, knowing that we naturally read from left to right can be used to your advantage when composing the page. It is also worth bearing in mind that you are trying to make your pages as attractive as possible, and sometimes it is fun to create a page made up of a jumble of differently shaped panels, possibly overlapping each other, or with the characters breaking out of the panel borders. In this double page spread from *Swords of Sorrow: Red Sonja vs. Jungle Girl*, the panels are arranged in a double bank of curves, which echoes our two heroines tumbling over each other. It works because the panel arrangement relates to the action we are reading, but it wouldn't be quite so appropriate if we were watching a couple of cops eating doughnuts!

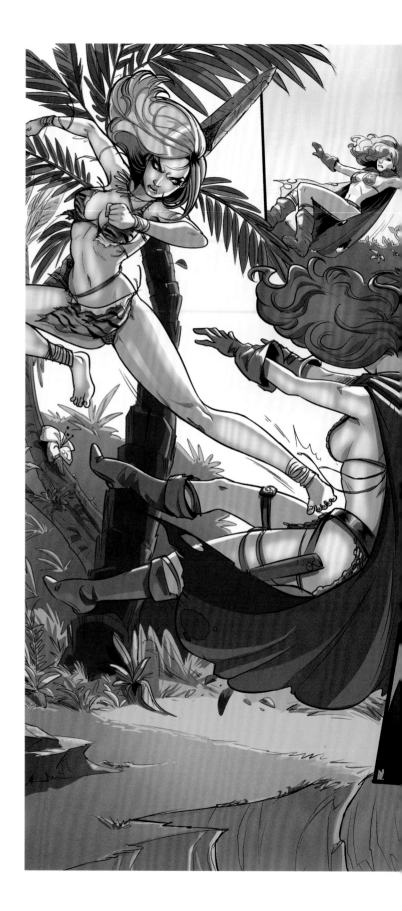

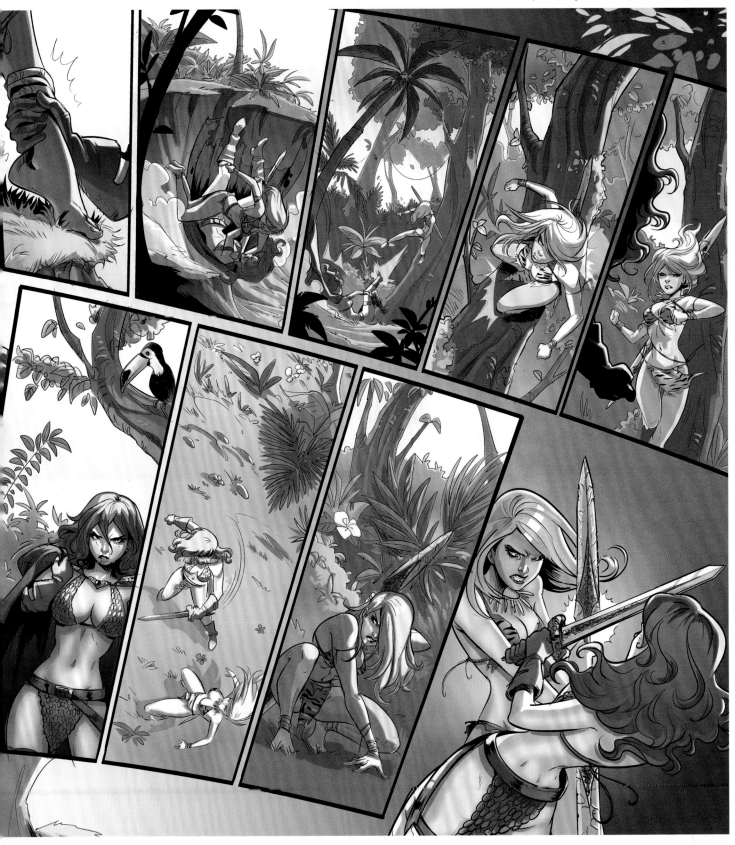

LOCATION OF FIGURES IN THE PANEL

Next comes the location of the figures in the panels, and here we must also consider the speaking order of the characters featured. It is usually a good idea to have the first speaker in any panel situated at the left or at the top of the panel. We are going to read his or her word balloon first, so it is a good idea to situate that figure as close to their balloon as possible. The last thing we want is a muddle of word balloons crisscrossing all over each other.

Panels can feature various levels of depth, such as a foreground, middle ground, and background, and where your characters are placed will determine the relative size of each one. Figures in the foreground will appear larger (closer) to the reader than those in the background, and it's the artist's job to create a working perspective for the relationship in size between characters. This can help in arranging the order of word balloons and also in the way you want to tell your story. Who is important, the focal point in this sequence? Are there minor characters we can place in the background who might feature in this sequence later on? You may want to surprise your readers, but you also need to be aware of providing enough information in each panel so that everyone knows what's going on. Sometimes we might want to see a managing hand in the foreground, or a mystery figure in the shadows behind our heroes; whatever it takes to tell the story as effectively as possible.

Jimmy Broxton's page from *Vampirella* is a perfect example of figure placements. In the first two panels, he shows how small and remote the characters are in the snowy wasteland, while in the bottom panel they are arranged perfectly so we can read their dialogue balloons in the right order, and we can see how each figure responds to each other, being variously exhausted, angry, and commanding.

This series of panels shows figure location and placement, as they move closer to the viewer. Art by Jimmy Broxton from Vampirella Vol. 4 #0.

PANEL SIZES

Size is also determined by the overall description of the panel—is it a wide shot (also known as a long shot), medium shot, or a close-up? How much space in the panel does the character take up, and what else needs to be shown to accurately portray the actions in the script? Make room for the necessary elements in each panel as you block it out in your thumbnails. Size and shape can also determine the mood and impact of a sequence. If you want to show a killer punch, then a big panel almost filling the page will emphasize that action. But if what you're trying to show is a much smaller, less dramatic action, then a series of small, regular panels will physically slow the readers' eyes down, forcing them to take in all the information and dialogue in each panel.

We are used to square and rectangular panels, but the artist, of course, can bring in any type of shape they want, possibly to create a particular emphasis on one panel, or to break up the flow of action in some way. The crazier the panel shapes, the more disoriented it can make your readers—but always remember, this must all be to serve the story, not just to show off how imaginative you are!

A varying set of panel sizes are used to fit the action. Art from Swords of Sorrow: Red Sonja vs. Jungle Girl #1, by Mirka Andolfo.

PAGE-TURNERS

Not only do you need to think ahead about how each panel will be composed on the page, you must also be thoughtful about the way the pages will be sequenced within the book. An important momentum-driving feature in comics is the "mini-cliffhanger" (the aforementioned "page-turner"), which is what makes readers want to go on to the next page. It is a waste of good storytelling drama to place a cliffhanger at the bottom of a left-hand page, when the "reveal" is virtually given away without turning the page, at the top of the right-hand page. Sometimes the artist is at the mercy of their writer and simply has to follow their page-to-page script, but when working plot-first style or from your own script, you will have much more control over the pacing of your cliffhanger.

A tension-filled, revealing page-turner is among the greatest tools in the toolbox of a good comics story-teller. Learn to pace the unfolding of your action to match the built-in structure of page turns, and you will greatly increase the dramatic tension in your work. In this simple three panel sequence from *Swords of Sorrow: Red Sonja vs. Jungle Girl* #1, the first two panels establish that our heroes are escaping in a dragon-drawn cart, and then in the last panel we have our zinger—a twister that suddenly appears out of nowhere. It's a dramatic end to the page and makes us desperate to turn the page to find out what happens next.

Here is an example of a dramatic last panel which forces the reader to see what happens next. Art by Mirka Andolfo from Swords of Sorrow: Red Sonja vs. Jungle Girl #1.

ASYMMETRICAL AND INSET PANELS

Asymmetrical panels can be used to represent offbeat aspects of comic stories. Art by Jimmy Broxton from Vampirella Vol. 4 #2.

As a comics reader, you no doubt have come across examples of pages where the panels aren't shaped as squares or rectangles but are all sorts of odd shapes— rhombus, trapezoid, triangle, circle, and so on. And we've all seen pages where a smaller panel is drawn inside a bigger panel, an effect known as an inset panel.

These are effective devices, but like any device, must be used judiciously. Remember our motto: The story must be told clearly and effectively. The second a reader steps out of the story—even if it's to say, "What a cool page layout!" you run the risk of that reader stepping outside of the imaginary world and interrupting the flow of the story. That might work if you want to create a sudden shock or moment of surprise, but it has to be used at the right time. An inset panel might be used to show a close up of something in the bigger panel that the artist wants to draw your attention to. This device can also show that in some way the figures in the insets are situated in a particular setting, which is shown in the bigger panel. In both cases, the inset is used as a way of linking itself to the action going on in the bigger panel. If there is no connection in the story between the two panels, you should not use the inset device. Got it? Great!

EXPLORING THE NINE-PANEL GRID SYSTEM

As we've seen, comic pages can be constructed in various arrangements of differently shaped and sized panels, but a good storyteller can also make creative use of simpler, more regularly arranged panels. Comics have traditionally used very easy-to-understand layouts, with same-sized panels arranged in parallel grids, often in groups of four, six, nine, twelve, or more. While these sorts of pages may seem old school and a dampener on creativity, the fact is that these familiar grids can enable you to make some incredibly exciting and informative pages.

The nine-panel grid was an artistic choice made by Dave Gibbons when he began work on the classic *Watchmen* series. It allowed writer Alan Moore to control the flow of the story while it challenged Gibbons to creatively compose the story. Whenever he broke the grid, it signaled to the reader something special was happening. It was an influential technique for many artists and today is a common technique employed by writer Tom King in *Mister Miracle*.

By the way, let me pause for a moment to note that panel shape is also important. A panel with rigid, straight lines is the most common, but to signal we're somewhere (or some *when*) else, you might want to go with a wavy or curved panel. Absence of panel borders is also a clue, going back to that negative space we talked about. Rounding a panel or adding jagged accents also visually cues your reader that something unusual is happening and to pay attention.

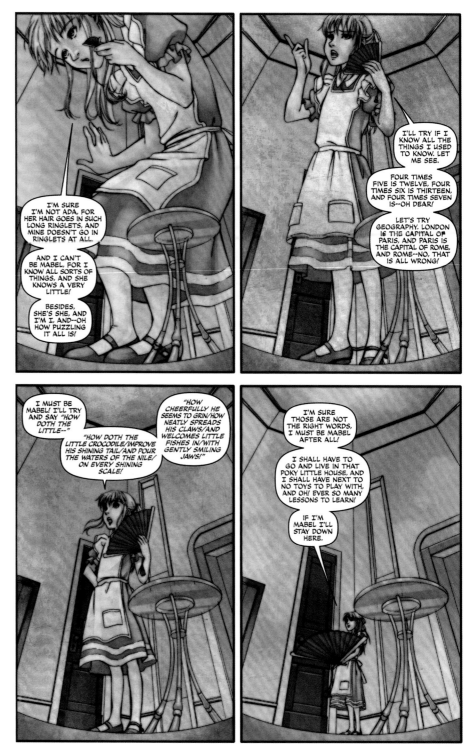

The standard grid of four same-sized panels perfectly serves this scene from The Complete Alice in Wonderland. By keeping the panels uniform in size (and keeping our viewpoint consistent from panel to panel), we're instantly able to see Alice shrinking in size. If artist Erica Awano had tried a more adventurous presentation—with strangely shaped panels for instance—it might not have been quite so obvious that Alice was changing size.

Similarly, this page from the same book shows how effectively a nine-panel grid can work to capture the mundane yet maddening repetition of Alice's conversation with the Cheshire Cat. The sequence starts with the two characters shown in the same panel, so we know what their physical relationship is to each other, and then flits back and forth between the two of them, just like a conversation in real life. So the repetition of the grid system perfectly echoes the pattern of a conversation and tells the story to the reader simply and clearly.

UNDERSTANDING A PAGE

So, armed with all these tips, suggestions, and techniques, let's look at how they all come together in a comic book page, and who better than a certain wall-crawling hero I co-created many moons ago—the Amazing Spider-Man himself. In this case, the page is taken from *The Amazing Spider-Man* #152, drawn by the long-time team of penciller Ross Andru and inker Mike Esposito. On the face of things, this is a very simple page, made up of six equally sized square panels featuring Spidey swinging around a near-deserted power plant late at night, searching for the elusive Shocker. But look again and you'll notice that each panel is taken from a different angle, and there are all sorts of interesting compositions and techniques going on. Let's look at it panel by panel to see which decisions Ross was making when he drew it.

Panel one. We start off with an establishing shot of the power plant so we can see where this scene is taking place. Spidey is swinging on his web in the middle ground, and very creatively, we see him in between some foreground structures, which are mostly in shadows. This creates quite an effective sense of depth, while still focusing on our hero. The plant is shown vanishing away into the distance using a one-point perspective (creating even more depth) with its vanishing point just below Spidey, so we're slightly looking up at him, which emphasizes that he's swinging high in the air above us.

Panel two. To make the page interesting, Ross changes our point of view so that we're looking down on Spidey, with a smaller section of the power plant shown below us. He's setting the scene for the key action that is about to happen. The plant is drawn in two-point perspective this time, with the vanishing points way outside the panel boarders to the left and right. Ross has thrown some heavy shadows on the left side of the buildings to give them a sense of weight, and one of them contrasts nicely against the white areas of Spidey's costume, really making him stand out.

Panel three. We're still up in the air looking down, but this time we see an extreme closeup of the web-head. In fact, it feels like we're right there with him looking down, where we can see, for the first time, a guard who seems to be frozen. Ross is very, cleverly moving our attention away from Spidey and onto the guard; and in doing so, he's changing the focus of the story and moving it along. There are many different tonal areas to the panel, with solid black to the left and right, contrasted with our hero's webbing, and some parallel lines behind the guard; so, it's an interesting balance of visual elements while still being easy to understand. There's not much background here, but just enough so that we know we're still in the same setting.

Panel four. What's the most important aspect of this panel? It's the wall-crawler's realization that the guard is frozen in shock—so we change our viewpoint and we're down on the ground with the guard, looking up. There are lots of interestingly shaped building parts here, drawn in two-point perspective, and our eye level is off-center, almost as if we're falling over. This makes for quite a dramatic, slightly disorientating panel. You'll notice there's lots of dialogue to fit in, so Ross has squeezed Spidey into a corner to make room for it all.

Panel five. Spidey is intrigued by what he's seen, so he feels he needs to investigate further by entering one of the buildings. Ross utilizes an extreme upshot here so we see our hero as a tiny figure silhouetted against the moon way at the top of the panel, emphasizing how high up he is. We don't need to see him swinging onto the building—that's implied by the fact that he's already there—we've already moved onto the next sequence in this scene. The perspective here is a three-point perspective, which is perfect for emphasizing extremes of height or depth.

Panel six. The focus of the panel is back on Spidey as he slides in through an open window, so we're right there with him just looking down from slightly above. His figure is shown against the solid black interior inside the room, which makes his body pop out more, making the action very clear to see. You'll notice that his body and the window are arranged diagonally across the panel. In fact, the bottom four panels all have lines that cross their panels diagonally, which makes for an interesting, dynamic page as a whole.

So there you have it, a page construction that is interesting to look at and that clearly tells the story. The artist has made many different choices in each panel, but each time, they are made to move the story along and give emphasis to the most important aspect of the story at that particular point. This is an artist who has taken the time to understand what the writer wants to say and knows how to illustrate this in the most effective, creative way he can. It's a comic page that really works.

Here's a page of interior art by Ross Andru from The Amazing Spider-Man #152.

"BORING" TALKY PAGES

Sometimes you're assigned a script that may have what seems to be panel after panel of people talking. This can be challenging for an artist. After all, comics are about action, aren't they?

And yet, think about your favorite stand-up comedian. When she gets up, all she really does is talk. But, somehow, you find that engrossing. So, if the script you're drawing is well written, then the dialogue should be engrossing and compelling (and should also convey information like plot and character details).

For those cases where—perhaps—the dialogue is not as exciting as it could be, legendary artist Wally Wood came up with something called "22 Panels That Always Work" to create drama and tension in scenes where characters are "just" talking. It's all here: from different sorts of close ups, to the way you might use shadows or foreground figures and different ways of constructing the contents of your panels. These are all great compositional tips that can make your pages look more varied and interesting. Artists have used Wally's guide for inspiration or simple time-saving steps.

Another thing to do, as long as it seems natural, is to have your characters doing something interesting while they're talking. The action depicted should ideally be related to who and what the characters are, and should be added only with approval of your editor. For instance, by showing the X-Men talking while battling menaces in the Danger Room or playing baseball during a picnic, you can convey information and personality, while still getting across important exposition or key emotions that also need to be conveyed to the reader.

Wally Wood's "The 22 Panels That Always Work": This is a comprehensive guide for various types of panels.

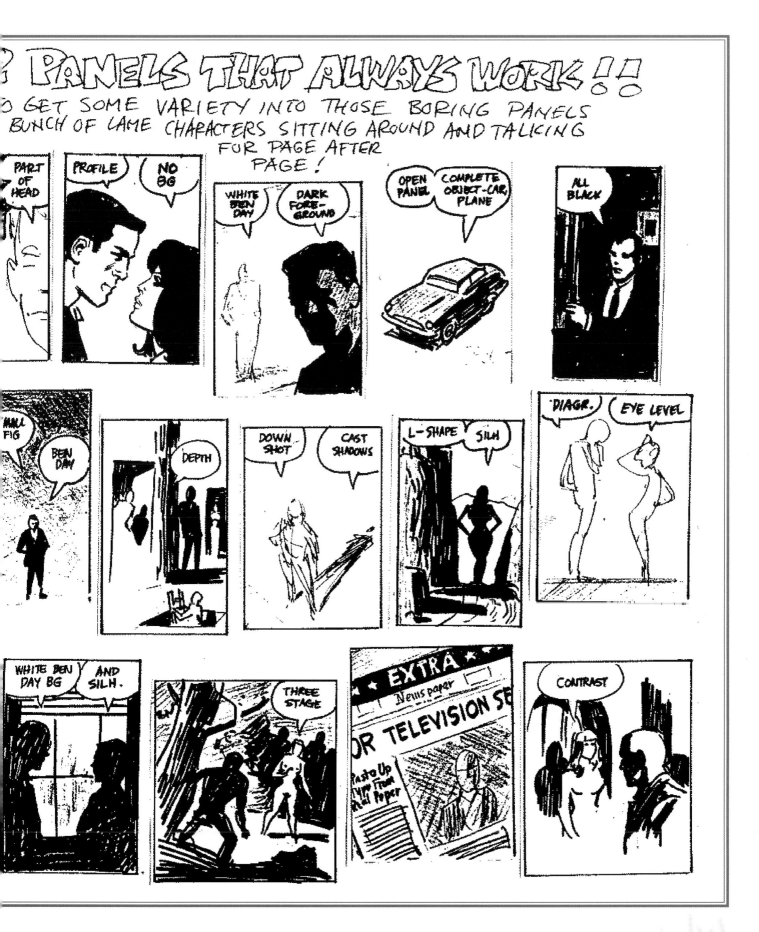

Iron Man upgraded! Art by John Romita Jr. and Bob Layton.

So you think you've mastered the many tips, tricks, and secrets I've shared with you so far? Well, just so you don't get too overconfident, I'm going to dig deep into my well of wisdom and grab even more nuggets of information that will make you that much more proficient as a teller of visual tales. In this chapter, we're going to talk about all the other areas of comics that creative types like you might need to master; namely covers, lettering, coloring, and how do draw bleed pages. But, let's start with the first thing that anyone sees in a comic: the cover.

COVERING COVERS

What's the purpose of a cover on a comic book, or on any type of book, magazine, or periodical, for that matter? Why not just start the comic with the first page of the story, which is sort of how the old Sunday funnies, the forerunners of today's comic books, used to do it? Let's face it, the ultimate purpose of a cover is to sell the comic to someone, so above all else it has to be exciting and eye-grabbing. However, covers are also highly sophisticated ways of conveying information to capture the attention of potential readers, information such as:

- What issue is this comic?
- Who is the main character?
- What kind of story is told inside?
- Why should the potential reader buy this comic right this second?
- Is the comic for kids? For adults? For everybody?
- What question(s) does it raise that the reader must know the answer to?

These days covers often feature the names of that issue's creative team so potential readers know if their favorite creators are involved in that story.

An example of the pulp magazines churned out with astonishing regularity in their heyday. Amazing Stories Volume 21 Issue #1, featuring art by H.W. McCauley

Bill Hughes's cover painting for Vampirella #2 goes to show that horror can be a very exciting and dramatic genre for graphic storytelling.

HOW DOES A COVER WORK?

If we take a look at some dynamite covers from Dynamite (sorry, I couldn't resist!), we'll see many different ways of grabbing the reader's attention. This is the "hook," the concept, design, or message that the artists and their editors want you to be thinking about when you look at the cover.

As I hope you can see from the examples in this section, there are basically two kinds of comic book covers: story-based ones, showcasing something from inside the comic, and poster-style ones, which usually consist of a cool shot of the title character or characters. In recent years publishers have also tried boosting sales with all kinds of gimmick covers, retailer-incentive covers, and even blank covers which your favorite artists can draw on in person. Let's have a closer look at how these work.

Joe Jusko's cover design is showing two things: John Carter in peril, which is exciting enough on its own, but also a beautifully-painted alien world, which you will want to see more of. Both hooks should make any fan want to buy this comic. Warlord of Mars #7 cover art by Joe Jusko.

Another high concept idea, courtesy of comic star John Cassaday: "Sherlock Holmes in prison? How did this happen?" Sherlock Holmes #2 cover art by John Cassaday.

"That is so weird! I have to see what's inside!" Evil Ernie #5 "Smiley" vector cover art by Jason Ullmeyer.

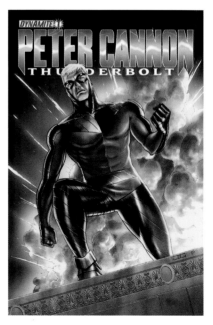

John Cassaday again with an iconic superhero pose, which makes the reader think, "Who is this incredible new character?" Peter Cannon: Thunderbolt #1 cover art by John Cassaday.

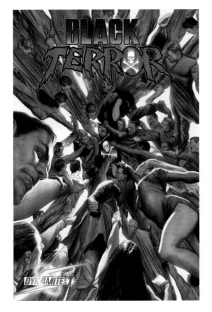

Cover maestro Alex Ross overwhelms the senses here, filling each square inch of the cover with a tsunami of figures attacking the Black Terror. We are thrown right into the middle of a story and can't help wondering what this bizarre group scene is all about. Black Terror #7 cover art by Alex Ross.

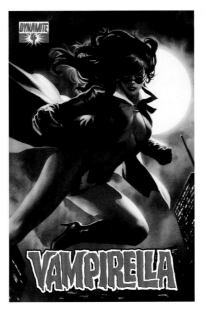

The ever-popular portrait cover, in this case painted by Jelena Kevic Djurdjevic, sells the comic on the strength of its artwork and the iconic power of its star. Vampirella #4 cover art by Jelena Kevic Djurdjevic.

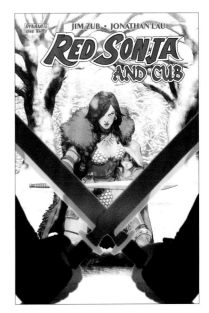

This cover design from Jeffrey Cruz works on several levels. First, it's the title's hero (or heroine) in danger. Secondly, it's an unusual design with the crossed swords in the foreground creating a sort of frame for Red Sonja. But, thirdly—and this is what we call a high concept—it's riffing on the legendary manga series Lone Wolf and Cub, so the reader thinks, "Red Sonja with a kid? Just like that classic manga? That is so cool I'll take a chance on this." Red Sonja and Cub One-Shot cover art by Jeffrey Cruz.

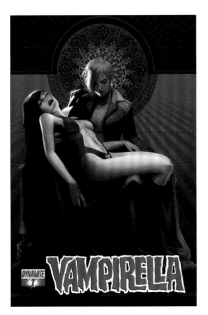

Another stunningly painted Jelena Kevic Djurdjevic cover that works on several levels. To start with, it's certainly easy on the eye, but it's also got a strong conceptual hook; "Vampi is . . . dead! This might be a gimmick, but I need to know for sure!" Eagle-eyed art fans might also recognize the pose from Michelangelo's famous Pieta statue in the Vatican. This is the sort of fun tribute artists just love to do. Vampirella #7 cover art by Jelena Kevic Djurdjevic.

Jae Lee's bold cover dispenses with background, so we concentrate our attention on the Black Bat in mortal peril. (You'll have noticed long before now that heroes often have a bad time of it on covers). We're thinking both, "How did the Black Bat get in such a bad spot?" and, "Man, isn't that a cool drawing!?" The Black Bat #10 cover art by Jae Lee.

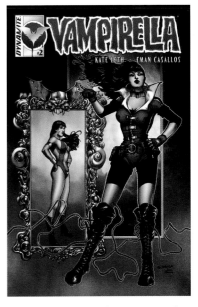

Sergio Davila's poster-like cover image does not illustrate a scene from the story, but it is there to intrigue the viewer. "Who's that other Vampi? Guess the only way to find out is to buy the comic!" Vampirella Vol. 3 #2 cover art by Sergio Davilla.

POSTER COVERS

The poster cover has to be bold, important, and make an immediate impact; the selling point is largely on the strength of the artwork and the iconic composition of the image rather than any sort of clever concept or story scene. Artists love them as they provide a chance to really show off their drawing skills with a full figure illustration or striking close up of the hero. In recent years, the poster-style cover seems to have become increasingly prevalent. Perhaps this is because readers of periodical comics are often fans who already know the storylines from online and print previews, or they may be regular readers who buy titles they like regardless of what's on the cover.

And, let's be honest, artists find it easier to sell the original artwork after publication. Remember how I told you this was your business? Well, managing your original artwork, which is either scanned and retained by you or submitted and eventually returned by your publisher, is a component. Artists can take their original work to conventions or stores and sell them for ridiculous prices, or engage an agent to handle the sale in exchange for a percentage of the price. Either way, this has become a vital component to a working artist's cash flow, so treating the originals carefully, storing them properly, and determining when, where, and how to sell the pages is important. Now, in my case, no one buys my artwork—and for good reason—and I have always been a mite envious of my peerless pals who have found good homes for those hundreds or thousands of pages.

Jim Lee is a modern master of the memorable poster image, and in the cover from *Superman* he really gets across both the strength and nobility of this legendary superhero. Jim and his inker Scott Williams never stint on the detail and, while the cover includes an elaborate depiction of Metropolis in all its glory, the focus here is always on Superman himself.

Superman in his watchful and heroic posture from Superman (Vol. 2) #204 with cover art by Jim Lee.

STORY COVERS

Nothing gives the reader a better idea of a particular issue's contents than using a scene from the story on the cover. In the distant past, editors (yours truly included) would often come up with a cover idea and then commission a story around it, but these days, the story usually comes first. Brian Bolland has had a long history of creating startling and unforgettable covers, and this example from *Wonder Woman* is no exception. Brian has chosen to go straight to the most dramatic scene in the issue with Wonder Woman about to become a dinosaur's lunch! We'll need to buy the issue to find out not only how she got there, but how she gets out of it as well, and that's the job of a cover in a nutshell: to get the fans intrigued enough that they simply have to find out more.

Of course, a story-based image can also be a poster-style one. It may, like a movie poster, highlight certain elements of the comic story to be seen in the pages ahead. All covers should have impact and make you want to pick up (and ideally buy) the comic.

Something that's always been true of comics is that the cover, whatever the type, is often drawn by an artist different from the one who draws the interior of the book. Some artists—Jack Kirby, Gil Kane, Adam Hughes, Alex Ross, Arthur Adams, and Frank Cho—are terrific at creating striking single images that make eye-jolting covers, each in their own unique ways. Jack Kirby's dynamic and exciting artwork is legendary, and for the cover of *Fantastic Four* #100, Kirby and inker

Brian Bolland uses effective arrangement of elements in this cover to Wonder Woman *(Vol. 2) #80.*

Joe Sinnott take us right into the heart of a maelstrom of action. From Doctor Doom and Dragon Man to Puppet Master and Hulk—all the Fantastic Four's foes are there, but Kirby marshals it all together brilliantly and the cover remains clear and easy to read, which is quite a trick.

As great a storyteller as Gil Kane was, he was also a brilliant designer, leading us to make him Marvel's top cover artist in the 1970s. His particular strong point was creating incredibly dynamic figures, often drawn with extreme foreshortening to heighten the sense of energy and movement. His cover for *Giant-Size Defenders* #1 is a classic poster design, with the fun concept of having his heroes appear to be literally bursting out of the comic!

The main characters are front and center in this cover for Giant-Size Defenders #1 by Gil Kane.

GIMMICK COVERS

Additionally, there are different kinds of gimmick covers, often used for anniversary or milestone issues of a series. Enhanced covers are ones that add shiny holographic foil, embossing, neon color, and other eye-catching print treatments to an otherwise standard cover to attract attention. Alternate or variant covers, on the other hand, are the result of different artists doing covers for the same content. These covers are often allotted to retailers based on a variety of formulas. In recent years, with the ability of printing presses to do relatively small runs, there are even covers that are localized for specific cities or retailers. Both enhanced covers and alternate covers are intended to appeal to collectors and encourage them to buy more than one copy of a comic—one to read, and one (or more!) to save.

When *Archie* was rebooted in 2015, for example, the comic was released with twenty-two different covers including images by stars like David Mack, J. Scott Campbell, and interior artist Fiona Staples, along with a blank-covered edition (these are made available so fans can bring them to conventions and hope to get their favorite talent to provide a unique drawing, making the copy one-of-a-kind). Now, none of those stellar talents are the type of artist usually associated with Riverdale's best-known teenager, so their very involvement was a signal to readers that something different was going on; more than enough to get people to pick up the issue. Incentive covers don't need to sell the comic in the same way that a regular cover would. Their selling point is the comic's rarity or the presence of a collectible superstar artist. This means the artist has the freedom to create a quirky scene, pop culture

Popular cover gimmicks used today are cosplay covers featuring top cosplayers dressing up as their favorite hero, heroine, villain or vamp!

homage, amusing spoof, or sexy pinup. Or possibly all four at once! Adam Hughes is widely collected for his alluring pinup girls, which makes him the perfect artist for incentives like the *A-Force* #1 variant edition Hughes's illustration doesn't particularly tell a story, but his drawing of Medusa certainly looks seductive, and his army of fans will go to great lengths to track his work down wherever it appears.

Some publishers have taken to doing theme cover months, so the entire line has a uniform style of variant cover, depicting their characters, in one instance, as action figures still in their packaging. Weird, if you ask me, but they really do sell and will continue to be done until the day they stop selling. We saw this happen back in the 1990s, so I wait for history to repeat itself.

Adam Hughes uses both exquisite design and technical rendering in this A-Force #1 cover

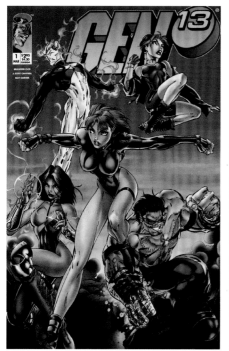

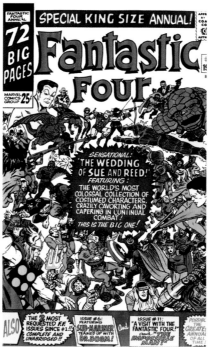

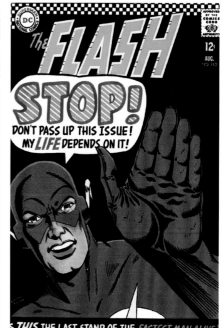

This image is exciting and energetic enough not to need any other type but the logo in introducing these new characters. From Gen 13 #1 with art by J. Scott Campbell.

This oversized issue has so much going on that type became necessary to aid in telling the audience what's inside the book. Cover art to Fantastic Four (Vol. 1) Annual #3 by Jack Kirby.

The dialogue type is just as important in this design to the cover art of The Flash #163 by Carmine Infantino and Murphy Anderson.

As with the cover image, the aim of cover copy (meaning text on the cover besides the title of the comic) is to make the comic appealing to a potential reader. Of course, sometimes a cover has little or no promotional or explanatory copy. There are different theories and philosophies about having writing on the cover or not. Essentially, lots of copy means a potential reader is spending some time reading it and thinking about it, making them more inclined to purchase the issue. Sometimes the cover copy is integral to the impact of the overall concept: One of the very best of those was Carmine Infantino and Murphy Anderson's cover to *The Flash* #163, as the hero holds his hand up and implores the would-be reader, "Stop! Don't pass up this issue! My life depends on it!"

On the other hand, light copy (just a title, say) or no copy at all gives the image the chance to make maximum impact and, ideally, make the viewer want to read or buy the comic.

Above all, my friends, is the need for clarity. The reader has seconds to examine a cover and make a snap judgment. It is absolutely vital that the first thing on their minds is not confusion. If your readers cannot figure out what the heck is happening on that cover, they'll likely pass it by and select something else. It has to be clear who is on the cover and what is happening. Cover copy, including creator credits, are secondary to a compelling, exciting image that makes the reader's heart speed up, makes their mind wonder what happens inside the mag, and makes their hand reach for his wallet.

LETTERING

So far, we've concentrated on the pictures in a comic, but what about the words? Anything that features words, from the logo on a comic cover, to story titles, dialogue, and captions in the comic book itself, is known as lettering, and the person responsible for adding these to the comic is the letterer. You might think that as an artist, lettering doesn't concern you. After all, your job is to tell a story in pictures. The lettering is almost an afterthought, something you hastily pick a font for and then get an intern to do as cheaply as possible. Heck, the internet is loaded with free comics fonts, so lettering must not have a whole lot of value.

Guess what? Nothing could be further from the truth. We've touched on this earlier but it bears further discussion, especially for a cover. Sure, lettering just conveys the dialogue and captions of your story—you know, the words—but doing this properly is an artform in itself. If the lettering of those words isn't clear, legible, and expressive, then the story suffers. The images may (or may not) convey the broad strokes of the story, but it's the lettering that tells us important details about plot and character, and about how the characters relate to one another in ways that art alone can't.

Don't forget, lettered balloons, captions, and sound effects are actually artwork and elements of design too. They help give your comic its unique look and feel. These lettered elements take up real estate in panel and on page. How balloons and captions are placed and arranged will affect how your story is read. Poor or sloppy lettering can detract from an otherwise

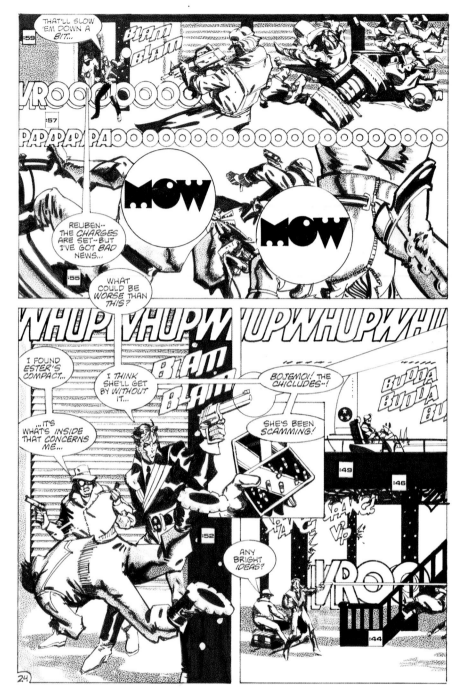

An excellent example of how sound effects become part of the pacing and design, from this interior page to American Flagg! *art by Howard Chaykin with lettering by Ken Bruzenak.*

well-told story, and lettering with placement that isn't carefully considered might cause confusion for the reader.

The good news and bad news is that there are so many fonts available to letter with (and, of course, there's also good, old-fashioned hand lettering) that the temptation to give each character a distinct shape and style of dialogue lettering is strong. But, as with color (which we'll discuss on page 168), there can be too much of a good thing.

If each character has a different style of lettering, then the impact of any one special style is lost—plus, the pages become a mishmash of hard-to-read typefaces that can easily turn a reader off. What's the good of your brilliant dialogue and witty captions if no one wants to take the time and effort to—or isn't able to—read them?!

But those caveats aside, we are in a Golden Age of Lettering. You can achieve all sorts of effects and moods with lettering. Just remember that fancy lettering can't make up for deficiencies in script or art. Lettering can enhance a good story, but it can't save a dull one.

A different typeface is used for Lucifer's dialogue to show a divine characteristic to his speech. Art by Jimmy Broxton from Vampirella Vol 4 #5.

LOGOS

Even going back to comics' earliest days, the comic's logo was given careful consideration. After all, it occupies the top third of the cover, and back in the days of spinner racks, that's usually all you saw at first. The logo has to be unique, often reflecting the tone of the series such as the webbing found in *The Amazing Spider-Man* logo or the word Batman surrounded in a bat silhouette. The logo, you hope, will signal this book has a reader's favorite character in it, something the reader is happy to read. But, if you're fortunate and the character winds up being merchandised, or best of all, turned into a filmed property, the logo may be seen everywhere. If you're creating something on your own, it's important to have your own logo designed, and trust me, paying a professional letterer for this service can be money well invested in your future.

A comics logo can greatly depict what kind of genre we may read about. Various examples by Marvel Comics and Dynamite Entertainment.

BALLOON PLACEMENT

One consideration about word balloon placement is whether every balloon has to "float," with space all around it. Or is it better to push balloons into a panel corner and make the panel borders double as balloon borders? There are fierce advocates for both arguments.

What about multiple balloons originating from one or two characters? Does having the balloons intertwine enable more "realistic" back-and-forth conversations, or is a reader stymied by the way the balloons swirl around each other? Is the illusion of hearing dialogue ruined or enhanced by elaborate placement of balloons?

And do the balloon's pointers (tails) have to aim at the speaker's mouth, or is just being aimed in a character's general direction enough?

There are no right and wrong answers here. Although, like you probably do, I have my preferences. But these are things comics creators need to be aware of and make decisions about. (Of course, the publisher you're working for may have its own opinion about such matters—in which case you'd be wise to adhere to the house style.) As always, the most important thing to keep in mind is to make the story flow and to let the reader follow the writing as clearly and most effectively as possible.

This page from Hack/Slash Vampirella #2 *has careful balloon placement in the absence of panel borders. Art from Rapha Lobosco.*

COLORING

There used to be—I kid you not—a mere sixty-four colors used for comics. That's right, the same number of colors you'd find in a deluxe box of Crayola crayons. Each of those comics colors was a combination of magenta (red), yellow, and cyan (blue).

Those days are long gone. We now live in a world where colorists can choose from literally millions of colors. Using Photoshop and other software, they can achieve all sorts of wild and wonderful effects that just a few years ago no one could ever have dreamed of. What color power we have now!

With so many color choices, you can make yourself crazy picking the right combination of hues, but the underlying principles are the same as ever. How do you use color to enhance a story's mood and excitement, yet also make it easy to follow? How do you make sure events and characters look consistent from one panel to the next?

Add to those considerations these more modern concerns. Will my reader be looking at the story in print or will he or she be looking at it on some kind of a screen? And if on a screen, will it be a 34-inch diagonal desktop, a 13-inch laptop, an 8-inch tablet, a 4-inch smartphone, and so on? Whatever screen—how bright will it be? Will my subtle colors make things clear and dynamic or will it all turn to mud?

Since most coloring is done on backlit screens, your best bet for seeing a comic in color the way the colorist intended for it to be seen is on a screen. (Of course, most people still seem to like to get their comics on paper.)

And if the coloring is seen in a physical comic book, then things can get really complicated, because different types of paper absorb color ink differently, so the way things look on one kind of paper may be completely different from how they look on another kind of paper (and will look different at different points in a press run). Luckily, there's now software that will enable you to simulate how the printed color will appear. So if you were wondering why, in the day and age of infinite color choices, comics sometimes aren't as easy to read in terms of visual clarity as they were fifty years ago—now you, sort of, know why.

What all this means for you as a colorist—or as someone who's hiring—is that you have to make sure that the finished work is as clear and easy to read as possible. Look at how the issue prints on a color printer or on a simulator. Observe how the printed comic looks. That way, you can adjust your coloring so it will print as well as possible moving forward.

Coloring technology changes by the week. If you want to keep up and see how the pros are doing it, then YouTube and other video sites have a bunch of videos that can show you how to color. Make sure to use

A simple color palette can go a long way as expressed by Dave Stewart for the cover to Hellboy: Box Full of Evil *#2.*

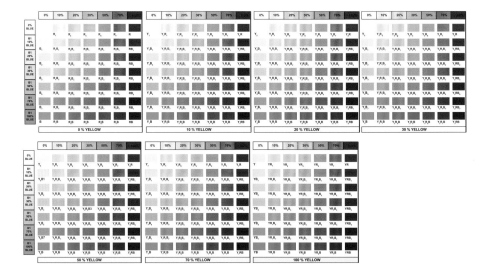

Check out this old-school color chart.

the latest videos. One from a few years ago may be entertaining and instructive—but it will be way out of date in terms of the tech.

As to which colors you decide to use, there are two important approaches to consider: Am I coloring this panel realistically or emotionally? If the point of the panel is to simply get across information about where the action is happening, then coloring the objects, settings, and characters as they would look in real life is probably the way to go. Remember, just because the computer can give you every color known to man doesn't mean you have to use them!

Photoshop continues to be the default software for most colorists as evidenced by its robust color output.

Areas are selected and filled in Photoshop using the lasso tool as one of many tools for coloring. Art by Rapha Lobosco and color by Chris O'Halloran.

Comics can be viewed on a wide variety of devices in today's technological age.

The image has to be clear and easy to understand. Colorists must also be sure to help create a sense of depth, and not to clutter up the artwork with so many different tones and colors that the image loses that depth.

However, in some instances you might want to use color to create a sense of mood, or to use it to create depth in non–realistic, creative ways. It can be enormously effective to use tones of one single color in a panel so that the color enhances the mood of the action; maybe using reds or oranges for moments of passion or somber blues or greens for a somber or thoughtful scene. There can be a temptation to meticulously add all sorts of effects, shines, and brush effects to computer coloring but sometimes less is more. *Hellboy* colorist Dave Stewart is the master at this; he uses very simple flat colors, with no shading or effects, but always chooses the best combination of subtle colors to create atmosphere, contrast, and great depth. Hellboy is bright red, but Stewart isn't afraid to color him in shadowy blues, moody browns, or even purple, lilac, or green. He is always aware of what sort of light is affecting his characters, what time of day it is, and where the action is taking place. He is also a master at creating a sense of depth, be it those moments where Hellboy needs to recede into the background, or really pop off the page.

LET IT BLEED

Going back again to the stone age of comics (that's the twentieth century to you and me), the standard look for a page of comics was for there to be panels with art, and around those panels—beyond the borders of the artwork—there would be white space. Of course, covers had no such white space; the art on a cover goes right up to the edge of the page, with no white area around it (in most cases anyway). The original art paper for a cover will have two borders, one that matches the edge of the comic and an outer edge for some excess art beyond it, just in case the cover image is not lined up correctly when it is printed. It pays to plan for any slight imperfections in the printing process.

At some point in the 1980s, it became possible to do bleeds on interior art as well as for covers. Once again, comics creators gained another new tool in their storytelling arsenals. And once again, many new choices had to be made as a result.

If you've seen comics from the 1990s—when bleed pages became commonplace, then you know that it was standard in some circles to have every page bleed on all four sides. Often the problem was that when all pages bled, then the effect ceased to be special. Worse, when two facing pages bled and were colored similarly, it became confusing to figure out what order to read the panels in, or whether the pages were meant to be a double-page spread or not.

Having said that, we've all seen some awesome pages, both single pages and spreads, that use the bleed effect creatively and effectively. Like any other creative decision, you have to think about the end result. What will the reader see? Will it excite or confuse them? Will it be impactful or dizzying? Will it advance plot and characters or will it take the reader out of the story?

These are things to look out for and, once again, things you can only learn through study (of other people's work) and experience (doing your own trial-and-error explorations). Think back to those halcyon days of yore when you were nothing but an avid reader, counting down the days to New Comic Book Day, and rushing to your local comic shop. Which titles excited you, which covers grabbed your attention, what got you interested in a certain character or artist or even publisher? Now, look back at those with a less emotional and more critical eye. What was done to achieve that emotional response, and how can you bring the same feeling to the work you are creating? Just as ballplayers study film of their own work, they study footage of their opponents and others, examining how they achieved their own greatness. What can you take from others and put into your own work?

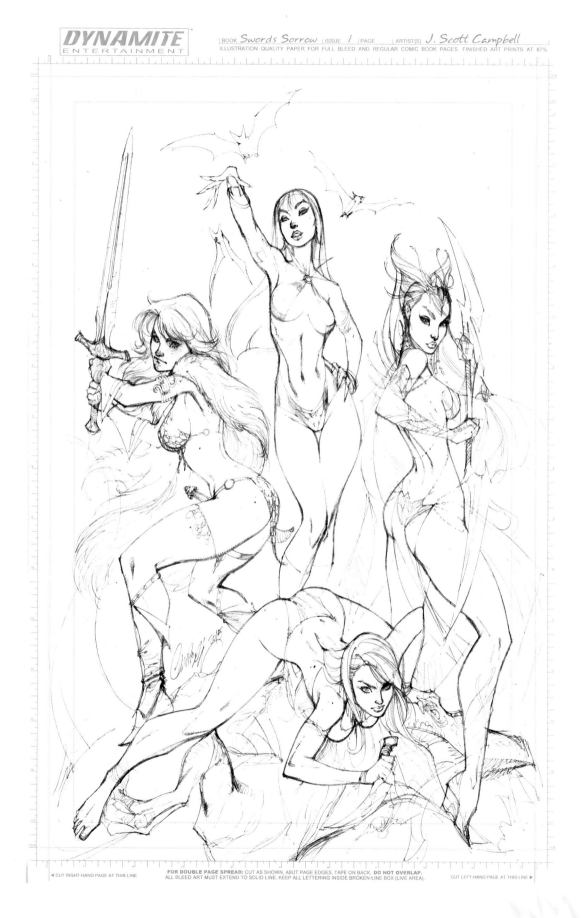

The artist is careful not to place any important elements outside the blue guidelines. Pencil art on board from Swords of Sorrow #1. Art by J. Scott Campbell.

◀ CUT RIGHT-HAND PAGE AT THIS LINE **FOR DOUBLE PAGE SPREAD:** CUT AS SHOWN, ABUT PAGE EDGES, TAPE ON BACK. **DO NOT OVERLAP.**
ALL BLEED ART MUST EXTEND TO SOLID LINE. KEEP ALL LETTERING INSIDE BROKEN-LINE BOX (LIVE AREA). CUT LEFT-HAND PAGE AT THIS LINE ▶

BOILING IT DOWN

What I've been trying to say in this chapter is that, once you've mastered the various skills I've been talking about in this book, you ultimately have to figure out how to use them simultaneously to make the best comics you can.

And because I am—as you know—an incredibly generous soul, I'm going to give you a list of a dozen things I've learned in my decades making comics that might just make your creative life easier and more rewarding. And if not, it will at least give you something interesting to talk about when there's a lull in the conversation at the next comic convention you headline.

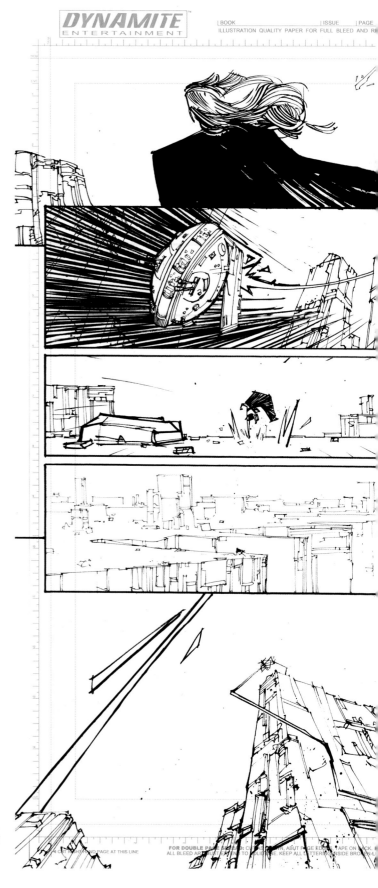

The artist placed some aspects of the drawing outside the page's guidelines, but in the age of computer design and coloring this can be easily adjusted in the final product. Interior pencil art from John Carter: The End #1 *by Hayden Sherman.*

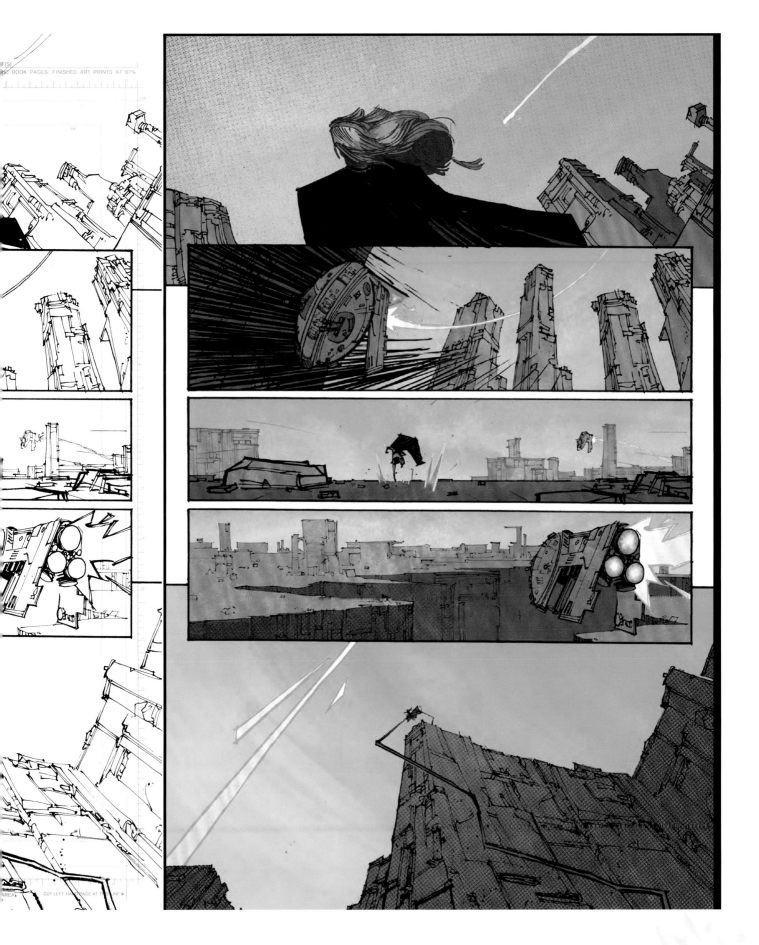

TWELVE UNUSUALLY USEFUL TECHNIQUES TO MAKE YOUR COMIC CHARISMATICALLY COOL

COVERS

1. Have your hero do something he or she never would so the reader has to buy the issue to find out why they're doing it.

2. Have a major life change for a character: marriage, death, turning into a werewolf— or even all three at the same time!

3. Have a really offbeat, unexpected artist draw it.

4. Have the logo be part of the cover's excitement—have it be broken, exploded, smashed by a character, pressing down on a character, be a building in the background (à la Will Eisner), and so on!

A classic Victorian approach to cover design. Art by John Cassaday.

Virtually stacked art in Photoshop. This is the color that appears "behind" the line art.

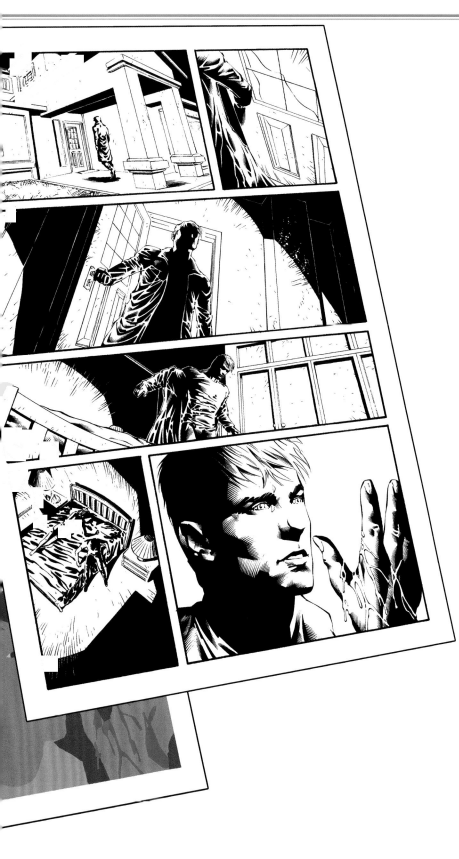

LETTERING

1. Despite my warnings about overdoing it, giving characters distinct balloon shapes and/or lettering styles can be very effective when used judiciously.

2. Experiment with color inside balloons, captions, or as part of balloon outlines.

3. Come up with a cool new way to show mental telepathy "speech."

4. Go nuts with sound effects for explosions, punches, kisses, and so on.

COLORING

1. Go retro and use all flat colors.

2. Place black-and-white characters against a color background—or vice versa!

3. Where appropriate color a scene in different shades of the same color.

4. Remove the black holding lines from backgrounds so the art stands as a pure color creation. It'll make your backgrounds look painted, sort of like the background in animated films.

PUTTING IT ALL TOGETHER

Let's put the lessons from this chapter to use with a page—say, *The Complete Alice In Wonderland* story pages.

The Complete Alice In Wonderland #1

Panel One.
This is a wide panel with Alice crawling along the rabbit hole towards us. We can see the round bright shape of the rabbit hole entrance in the left background, and the rabbits backside going out of shot to the right in the right foreground. Between the rabbit hole entrance and the rabbit, in the centre midground we have Alice crawling along on her hands and knees as she follows the rabbit. Roots hang down and brush against her face, little bugs and beetles hurry out of her way as she passes by. She doesn't look even remotely scared. One caption from the narrator.

CAP: THE RABBIT HOLE WENT ALONG LIKE A TUNNEL, AND THEN DIPPED SUDDENLY DOWN, SO ALICE HAD NOT A MOMENT TO THINK ABOUT STOP-PING HERSELF.

Panel Two.
This is a tall panel with Alice falling into frame at the top of the panel. Instead of her skirt inflating like the Disney film, we envision that she should slowly tumble head over heels over the course of the following panels. We thought this would look like she was actually falling rather than floating, and it would enable her to reach out for objects at different angles making the panels more interesting to both draw and read.

Here she is just falling into shot, so maybe we can only see two thirds of her, with her feet still being up out of sight off panel top. She is reaching out to take a jar labelled "Marmalade" off a shelf she is falling past. The rest of the panel is a dark vertical tunnel, which has items of furniture randomly placed here and there on the walls. We had the idea that the items on these panels could prefigure the rest of the story, and kind of resemble things Alice might have herself at home. (I think we stole this from the David Bowie film *Labyrinth* by the way). The walls are dotted with roll top desks, and little glass fronted cupboards and bookcases, it has tall grandfather clocks and rocking chairs. The shelves and cupboards have all kinds of things on them (apart from the marmalade Alice grabs) including a teapot, a cup and saucer, a top hat, a little toy rabbit with buttons for eyes, some playing cards, chess pieces, a nursery rhyme book, open at Humpty Dumpty, to name just a few. You don't have to fit them all in, but it would be cool if there were things to spot in each panel, and if those items were ones that cropped up again in the rest of the book. Some (like Humpty Dumpty) don't happen until issue 3 or 4 but that will be a nice thing to realize when you re-read it for the second time.

One little thing we also thought of was that in each of the falling panels there should be a framed picture somewhere of the Cheshire cat. They don't have to be the in the same frame, or in the same place in the panel even. In the picture in Page Two Panel Two, it's the whole cat, in Page Two Panel Three, it is vanishing away, so we can see through part of it, in Page Three Panel One it's just the head that's left, and on Page Three panel Two it's just the smile. There are two captions from the narrator and one balloon from Alice.

CAP: SHE FOUND HERSELF FALLING DOWN WHAT SEEMED
 TO BE A DEEP WELL.

CAP: EITHER THE WELL WAS VERY DEEP OR SHE FELL VERY
 SLOWLY, FOR SHE HAD PLENTY OF TIME AS SHE WENT
 DOWN TO LOOK ABOUT HER.

Panol Three.

This is another tall panel, but Alice is further down now. All the objects and pieces of furniture are different now, so we have an overstuffed armchair, a cuckoo clock, a candelabra, and other items dotted here and there. Maybe there's a framed print of a Gryphon or a copy of *The Jabberwocky* on a bookshelf. Alice is opening the jar of marmalade as she falls, peering into it to see if there is any actual marmalade inside. Her feet stick out towards the left now, her body turning as she falls. There are two balloons from Alice.

ALICE: WELL! AFTER SUCH A FALL AS THIS I SHALL THINK
 NOTHING OF TUMBLING DOWNSTAIRS! HOW

ALICE: WHY, I SHOULDN'T SAY ANYTHING ABOUT IT, EVEN IF I
 FELL OFF THE TOP OF THE HOUSE!

The full page sequence as illustrated by the artist.
Art by Erica Awano

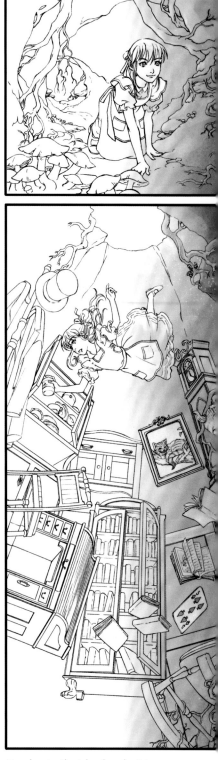

Now here're the inks, done by Erica Awano on full bleed pages. Note how the artist indicated thick panel borders so that this page takes a more traditional approach where we'll see that the gutters between the panels will stay white.

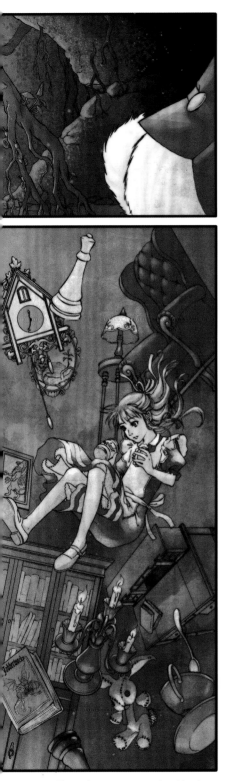

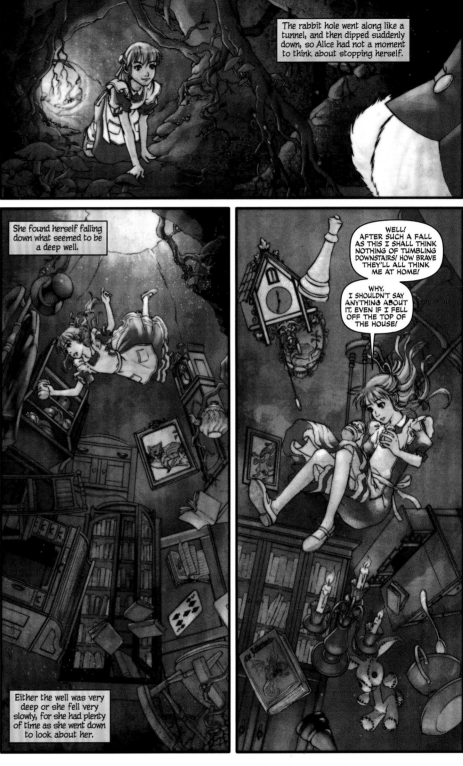

Next, the pages are rendered in the Colorist's tool of choice—in this case—Photoshop. Now a new dimension is brought to the art with the color; that of classic children's book style of art.

Next, the narration boxes and word balloons are placed on the page. The narration box has a lettering style with added texture and color to give it the feeling of 19th century paper. You can do anything with comics.

An example of a Western character that was turned into a manga for Western audiences. From Vampi (2000) #1. Art by Kevin Lau.

While Western comic books and Japanese manga may coexist in the same medium, there are some fundamental differences between the two forms in each culture. As you may expect, the mores and style each culture utilizes to convey their respective stories differ widely. While the term manga essentially translates to "comic," American comics and Japanese manga are separated by great differences in pacing, storytelling, and themes (including the use of adult motifs such as sex and violence, of which manga tends to use more of than its U.S. counterparts). Also, manga is more universally accepted in the general populace of Japan than comics are in the West (or at least here in America where many still unfortunately think of them as kiddy fare).

WHAT IS MANGA?

Now, you may ask: Stan, what makes manga so different? Well, quite frankly, there are quite a few serious differences between manga and American comics. Perhaps the greatest difference is that manga are generally read in the reverse order, or—technically speaking—"backwards" in relation to comics here in the good ol' U.S. of A. That is to say, instead of picking up a manga book with the spine on the left side and the open side on the right and reading from front to back, you would instead turn the book over (with the closed spine to the right and the open side to the left) and begin reading from the "back" of the book towards the front. To make matters even more complex, in reading individual pages, you go not from left to right, but right to left. Plus, you read each page from the top right panels to the left and then down the page (just as you would an American comic—except, you know, backwards). Further, when read in the original Japanese, the lettering tends to appear vertically (which is how script is written in Japan). Manga is usually (though not always) printed in black and white, as opposed to books being printed in color, which is the norm in the U.S. Manga tends to be more visual compared to that of American comics. It often contains fewer words.

The stories in manga are also usually much longer than Western comics. More often than not, Japanese manga is initially published in magazine format—serialized in incredibly thick anthology titles (such as *Shonen Jump* or *Hana to Yume*), much akin to the way that early prose short stories were published in pulp anthologies in the United States. Then after these stories run the full course of a tale, they are later released in a collected edition. As a rule, manga is not published in the thirty-two page comic book format like in the U.S., but in smaller sized paperback or hardback collections, often around one-hundred pages long. They tend to be serialized and running over hundreds of pages and for many years. *Golgo 13*, running since 1968, for example, has a whopping 110 collected volumes, carrying the story across generations.

There is actually quite a bit more manga in Japan than there are comics in America. In fact, nearly forty percent of all magazines and books published in Japan today are said to contain manga.

Here's Wolverine in a very specific, authentic manga style. The Wolverine manga books are even printed back-to-front and are read right-to-left.

EAST VERSUS WEST

One of the major differences between Western comics and manga is found in the pacing of each form's stories. Western comics tend to be paced far faster than their manga counterparts. Manga is paced much slower, in a much more deliberate manner. It places less emphasis on the actual action within the story's setting (until it really gets going, of course) and can often concentrate on plot and emotions instead. Much of the reason for this is that the *mangaka*—which is what manga creators are called—have so much more room to play around with than American creators. They don't need to be in so much of a rush to make their stories reach their conclusions and can concentrate on characterization and conversations instead. Due to this leisurely pace, a greater patience from readers is necessary. The result winds up being a more gratifying payoff for when the storytelling does gain steam. Unlike Western comics, which dedicate full-page spreads to action, manga tends to dedicate full-page spreads to emotional reactions.

A mash-up of manga style meets a Western horror character. Splash page from Vampirella 2099. Art by Kevin Lau.

UNIVERSAL ACCEPTANCE

Another very interesting aspect of manga in Japan is that—in spite of my years of helping push comic books to the forefront of pop culture consciousness not only in the good ol' U.S. of A., but all around the Western world (and points East) manga has achieved a level of mass acceptance in Japan that comics simply haven't reached here in the United States. As I understand it, part of the greater appeal of comics in Japan comes from the fact that manga was never really considered kid's stuff as comics were for so long in the States. In Japan, they are seen as mainstream and are as widely read as standard print novels and magazines. Consequently, this means that their subject matter is much more diverse, embracing a wide variety of styles, genres, and influences. Further, it's not just a small subculture of Japanese citizens or mostly younger males who read manga. There are people of all ages and backgrounds, from all walks of life in Japan who read them. Men and women, young and old, rich and poor—everyone seems to love manga.

Takehiko Inoue's Slam Dunk is a coming-of-age story and also one of Japan's most popular manga series ever.

CREATOR VERSUS CREATORS

Here in the United States, fans (or anyone who has read my books on the topic) know that comics tend to be created by teams of artists. On average, comics have up to four or five people—or more—working on a single book. There is (generally speaking) a writer, penciler, inker, colorist, and letterer all working on a single issue, and that's not even taking into consideration editorial and other managerial work. Over in Japan, many of the top creators both write and draw their own strips, although there are exceptions. *Death Note* and *Bakuman* artist Takeshi Obata has usually worked with a writer, in these cases Tsugumi Ohba, and the legendary *Lone Wolf and Cub* was a collaboration between writer Kazuo Koike and artist Goseki Kojima. Many artists have assistants or even whole studios though some do work alone. Typically, a manga artist would have an assistant for inking, one or two background artists, a letterer and someone to apply tones (most manga is printed in black and white). The all-female group Clamp was originally comprised of eleven(!) members, but soon contracted to four, with lead creator Nanase Ohkawa producing storyboards for the other three members to finish in ever switching roles. There are many variations in workload across the Japanese comics field.

Osamu Tezuka, considered the "Father of Manga," produced a staggering 150,000 pages of manga artwork in addition to his animation work. Here in the States, we remember him for *Astro Boy*, *The Amazing 3*, and *Kimba the White Lion*. His influence in Japan is immeasurable, and those who draw in the anime or manga style owe a debt of gratitude to Tezuka for his inspiration.

MANGA STYLES

As in the West, manga also sports numerous art styles. One of these is called *chibi* (Japanese for "cute"). For those not familiar with this style of art, it features an exaggerated form of manga illustration that shrinks characters (especially females) down to a smaller size to greatly increase their cuteness. The facial features especially are often exaggerated, with many characters—again, especially female characters—having outsized eyes, as well as a small nose and mouth.

This style was largely influenced by Osamu Tezuka, who also gave his heroes large eyes. Eventually the chibi style became one of the main characteristics of manga and anime (or animated manga). The oversized eyes allow the expression of a wide range of emotions, something that becomes essential for action-based manga and anime. In manga, the more a character is perceived to be "alive," the greater the engagement between the character and the audience. An adult has to suspend his or her disbelief in order to accept the "illusion of reality" to identify with a character.

But even though the big-eyed look is there in many different types of manga, it is by no means ubiquitous, and there is an enormous variety in styles in the art form. Many female creators choose to draw in heavily detailed, patterned styles, while a more action-oriented artist like Ryoichi Ikegami of *Crying Freeman* fame is much more realistic.

Since manga stories tend to be so long and lean towards original works, quite a number of mangakas are needed to produce strips at such high volume. While there are some exceptions to this rule, such as the *Star Wars* manga, and the Spidey stuff that I showed you earlier, as it stands, the majority of mangaka are simply just not interested in producing adaptations of other creator's works. Plus, the manga marketplace is actually relatively easy to break into. So easy in fact that many mangaka simply go the self-publishing route and don't bother seeking out a publisher for their early works. Self-published (or *doujinshi*) works are quite popular. Many mangaka start out as doujinshi authors and from there are able to attract a publisher based on the strength of their work.

A GUIDE TO DRAWING "CHIBI" STYLE CHARACTERS

Start with the various shapes we learned for drawing a body (see page 38), but in a more stylized cartoon look. Draw a large circle for the head and a centerline down to the bottom of the torso. Keep proportions of the body fairly short in comparison to the head. Keep the eyes very big, just as we see in almost all manga art.

Here is the final line art and proportions. Add dimension and light to the eyes, style the hair to your preference, and set your chibi's facial expression. Notice that the head is almost half of the entire character's build.

Add color and shadows to bring your chibi to life. Here is the final color art for the Vampirella chibi character.

ACTION VERSUS EMOTION

Typically, Western comics tend to focus most on action scenes, while manga can often focus more on the emotional side of a story (though there are also some action-packed manga out there). This characteristic makes manga seem slower paced compared to American comics. Emphasis is placed largely on character developments in these stories. Perhaps one of the fundamental differences between American comics and manga is that manga uses a style that is almost akin to cinematic pacing. In American comics we jump straight into the action, compressing it into a few explosive panels. In manga each panel can be a tiny moment in time, like an individual frame in a movie. So, it's not unusual to follow characters walking for several pages, or a single conversation to go on for page after page. The best manga artists, like *Death Note's* Takeshi Obata for instance, really do compose their scenes like a film director, constantly moving our point of view around, gradually focusing in or pulling away from the action, and throwing in silent panels in a way that few Western creators would do. But Manga is not usually laid out like storyboards, with one panel following the other in a succession of grid layouts. Their pages are often full of differently shaped panels, many overlapping each other or bleeding off the page in all sorts of crazy configurations. In some series, no two-page layouts are alike.

Let's have a closer look at the two predominant manga styles, *shoujo* and *shonen*, and see how they approach drawing Japanese comics in different ways.

Sailor Moon, created by Naoko Takeuchi, is considered to be one of the most popular "shoujo" manga series, not only in Japan but around the world.

A "shonen" manga that stands out amongst the teen male audience is One Piece, created by Eiichiro Oda and follows the adventures of a boy named Monkey D. Luffy and his crew of pirates in search of the treasure known as "One Piece" to become the next Pirate King.

SHOUJO

Shoujo—or romance manga—is a genre predominantly aimed at a young female audience and often drawn by female creators. Shoujo is typically characterized by a focus on personal and romantic relationships. With a demographic largely comprised of teenage female readers (the term "shoujo" is a romanization of the Japanese word *shoujo*, which literally means "young woman"), shoujo manga covers many subjects in a variety of narrative styles, including historical, dramatic, sci-fi, and others. Strictly speaking, shoujo manga does not so much comprise a style or genre, but rather indicates its target demographic, though there is very much a particular look that many shoujo series share.

Many shoujo series are quite light-hearted, amusing, and romantic, and a classic example is Natsuki Takaya's *Fruits Basket*. The characters are drawn in a simple, almost cartoony, style with exaggerated features and elongated bodies. But, if the line work is simple, the tone work is wildly inventive, creating all sorts of eye-catching patterns and effects. The layouts are incredibly diverse, with overlapping panels often drawn at crazy angles and an attractive use of negative space. In fact, "attractive" is probably the best description of the art as a whole. These are pages that are designed to be eye-candy.

By comparison, Clamp's many manga series like *Cardcaptor Sakura*, *Chobits*, *xxxHolic*, and *Tsubasa* are much more action-packed, so the emphasis in their art is often on movement and dynamism. In *xxxHolic*, the figures are even more elongated than in *Fruits Basket*, but the mood is much darker, more gothic, and magical.

See how by (once again) altering (mostly) the eyes, the artist can age (or de-age) the character by several years. Vampire Knight artwork by Matsuri Hino.

There are fewer of the pretty patterns of *Fruits Basket* but lots of inventive, detailed Art Nouveau–inspired costumes and designs. The emphasis is on swirling lines, smoke, flowers and anything that can create a mood. It is gothic fantasy for a female audience, and even if it looks pretty, it is definitely aimed at an older audience.

Clamps's *Cardcaptor Sakura* is a popular example of the magical girl genre that was first popularized in the west by *Sailor Moon*, which was created by Naoko Takeuchi. *Sailor Moon* is credited with helping redefine the genre, as previous incarnations of magical girls did not use their powers to fight evil—but the concept is now considered one of its standard archetypes. Since their initial appearance, the very pretty Sailor Moon and her friends have received wide critical acclaim and fan support. The entire manga series has sold over thirty-five-million copies worldwide, making of it one of the highest-selling shoujo series ever created. Not only is the manga itself extremely popular, but the anime is also a fan favorite around the world. As a result, it's arguably one of the most influential manga series ever, and it is responsible for boosting the popularity of Japanese animation and manga in the Western hemisphere.

Check out this example of shoujo eyes. Art by Macoto Takahashi from his art book Dreaming Girls.

SHONEN

Another subgenre of manga is shonen (sometimes rendered *shōnen*, or *shounen*), which literally means "a few years." Shonen generally refers to a boy around elementary school through high school age. It is used in everyday conversation when referring to the period of youth without regards to gender. In the United States, we generally refer to this demographic as teens or adolescents and shonen manga are typically thought of as action comics aimed at a male audience, though some strips have a broad audience of both genders.

The first manga series to make a splash in the West was a shonen series, the unforgettable *Akira* by Katsuhiro Otomo, which was many fans' first exposure to Japanese comics when Marvel's Epic imprint released it in 1988. Otomo's style is a perfect example of action, manga-style. While the characters are less realistic than Western comic drawings, the strip's backgrounds are incredibly detailed and realistic, as is the futuristic hardware. What really grabbed fans' imaginations was the way the strip moved—it was exciting and fast paced, with action sequences stretched over numerous pages, and each panel full of layer upon layer of whizz-lines to really emphasize that movement.

The next big manga hit show-cased an entirely different approach: *Lone Wolf and Cub* drawn by Goseki Kojima. The line work in *Akira* was detailed, slick, clean and very polished looking, but by comparison *Lone Wolf and Cub* was rough, dark, and dirty—the perfect way to evoke the

Here's a cover from the popular manga anthology, Shonen Jump.

atmosphere of the violent olden days of the samurai. Kojima's layouts were much simpler than most manga artists', and his drawings more realistic, with incredibly dense inking made up of hundreds of tiny cross-hatched pen lines, but he shared Otomo's great gift for movement and for stretching out his action scenes.

These days shonen strips like *Bleach*, *Naruto*, *Dragon Ball Z*, *Attack on Titan*, and *One Piece* are among the biggest sellers in the genre. In fact, it's almost impossible to go to a comic convention these days without falling over cosplayers dressed as at least one of these characters.

For an action shonen manga, look at the example. The art has a pretty straightforward style with no small amount of detail (remember to read it right to left). Mangaka tend to prefer utilizing a great deal of bold black "speed" lines which render pages very clear. They give each page a crisp, clean touch. With this page, the mangaka took time to draw some backgrounds, which also helps gives context to what the characters are doing in the story. Often the mangaka might choose to forego backgrounds. Generally speaking, the fight scene here does contain quite a good deal of detail and speed motion lines to help render the entire sequence with some measure of immediacy.

An example of motion using color as opposed to typical manga that's rendered in black and white. Interior page from Vampi vs Xin #2. Art by Kevin Lau.

FURRY FRIENDS, MAGICAL CREATURES, MONSTERS, AND MECHAS

So, once you've mastered the techniques of manga and figured out whether shoujo or shonen is the way to go, who are you going to put in your strip? Unlike American comics, Japanese strips rarely star colorfully clad superheroes—manga tends to deal more with furry beings, magical creatures, monsters, and yes, mechas. Manga—more so than American comics—often deals with myth and legend. Japan is a land already heavily influenced by centuries of myth. From this background, the mangaka tap into the preexisting mythology to develop their stories. Therefore, much of what we see in manga tends to revolve around not so much spandex-clad humans, but gods, monsters, and all sorts of legendary creatures—as well as samurais, warlords, and other historical figures. This has fundamentally affected the very nature of the types of tales that the mangaka tell, on a genetic level.

While U.S. comic book stories tend to be good guys and bad guys who are out for personal gain, manga stories quite often operate on a larger, grander—one could say more cosmic—scale. Needless to say, almost at the same time these stories also deal more with the human condition—people's lives, their emotions, and their passions. All of this makes for a very different experience reading—and thus writing and drawing—manga, one that we heartily recommend that you, as a member of the master class of individuals who are looking to break into this field, should attempt.

To be sure, manga isn't for everyone (but then again, neither are our own comic books), but there are many talented mangaka producing some top-flight manga. Not to mention that it really is one of the fastest growing segments of the entire comic book pop culture universe.

Let's not forget the giant robots that have filled the toy shops, picture palaces, and comic shops for decades now, better known in Japan as *mecha*. The Japanese love their mechas. Anyone who has ever read *Voltron*, watched *Transformers*, or bought themselves a *Zoid* know that.

So you truly want to take the next step to enter the master class of comic book creators—to become a mangaka yourself—or at least try your hand at working in the manga style? After finishing this book, you'll want to go out and pick up some manga for your very own collection. You'll also want to acquire all the art books on manga you can get your hands on, as well as checking out some of the very good computer software programs that will help you perfect your techniques.

Hamtaro is a classic example of furry friends–type manga which was created by Ritsuko Kawai.

Interior art of Ichigo from the manga Bleach.
Art by Tite Kubo.

Here's a manga-stylized demonic character. From Vampi #16 with art by Makoto Nakatsuka.

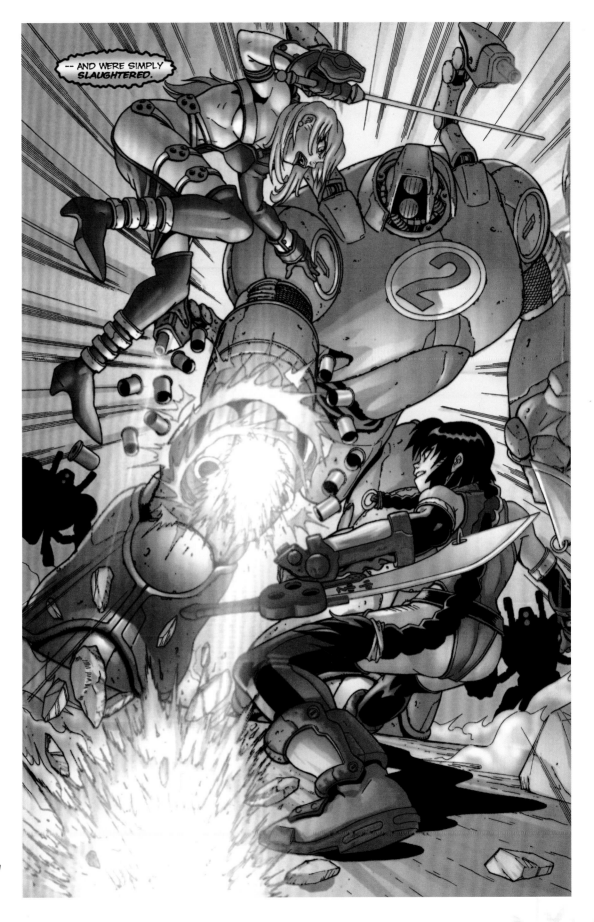

Mecha or mechs are another hugely poplular element of manga. From Vampi #16 with art by Makoto Nakatsuka

The Photoshop user interface provides all that is necessary for today's comic production. Art by Chris Caniano.

An example of a Western character that was turned into a manga for Western audiences. From Vampi (2000) #1. Art by Kevin Lau.

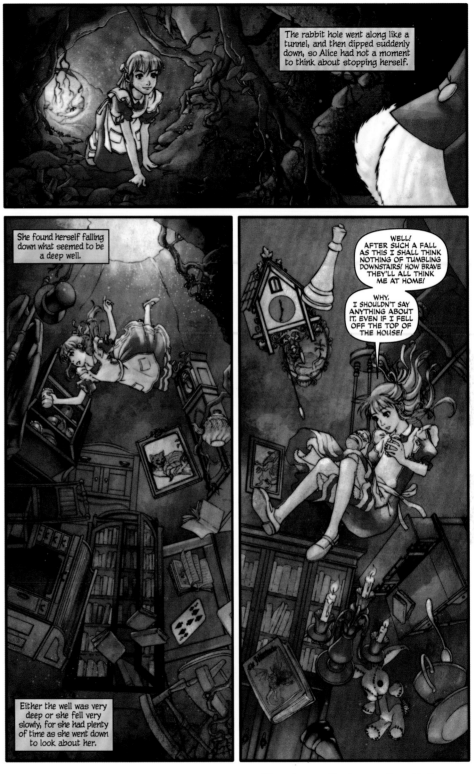

The rabbit hole went along like a tunnel, and then dipped suddenly down, so Alice had not a moment to think about stopping herself.

She found herself falling down what seemed to be a deep well.

Either the well was very deep or she fell very slowly, for she had plenty of time as she went down to look about her.

WELL! AFTER SUCH A FALL AS THIS I SHALL THINK NOTHING OF TUMBLING DOWNSTAIRS! HOW BRAVE THEY'LL ALL THINK ME AT HOME!

WHY, I SHOULDN'T SAY ANYTHING ABOUT IT, EVEN IF I FELL OFF THE TOP OF THE HOUSE!

Next, the pages are rendered in the Colorist's tool of choice—in this case—Photoshop. Now a new dimension is brought to the art with the color; that of classic children's book style of art.

Next, the narration boxes and word balloons are placed on the page. The narration box has a lettering style with added texture and color to give it the feeling of 19th century paper. You can do anything with comics.

Technological advances have transformed not only our personal lives, but the workings of every business as well—and the comic book industry is no exception. **Thanks to email and the internet, it's easy for creators to keep in touch with their publishers, their editors, and their fellow comic book makers. Sending documents and scanned art files has never been easier (or quicker, too).**

Back in my day (The Dark Ages), you would have to wait for letters and packages to arrive in the traditional mail. Don't even get me started on how much money it used to cost to call someone in another state! Mortgages were cheaper than long distance phone calls! And back when I was in charge of the House of Ideas, most artists lived within commuting distance of the Marvel Bullpen. If you wanted to work for the big players in comics, you had to move to the New York Tri-State area. Now, when almost all artwork is delivered electronically, you can live anywhere from Texas to Timbuktu—it really doesn't matter.

Arguably, technological advances have impacted comic book artists the most by helping them become more efficient. As you might have already guessed from reading this book (or experienced on your own), drawing comic books is fun, but it is also very demanding on one's time—especially if panels and pages have to be re-drawn. The good news is that the latest versions of programs like Photoshop and Clip Studio Paint have tools and features that can dramatically cut down on the amount of time you spend working on your art. Besides that, these programs can also greatly enhance the quality of one's

artwork. They won't draw for you, but they do have some great applications that can add spectacular visual effects to the work you've already drawn. Even if you prefer to draw only with pencils, pens, and paper, you should give Photoshop and Clip Studio Paint a try—just to see what you can do with them. It's like sampling a new brush, always seeing what new tools can do for you. The software has the potential to make your experience as a comic book artist more convenient and successful, especially if you adhere to the following tips I'll cover in this chapter.

Here we see the user interface for Clip Studios Paint.

Interior page pencil art is first overlaid with cyan for printing, then ink over that to save the original pencil artwork. Art by Carlos Gomez from Red Sonja Vol. 4 #16.

SAVING YOUR WORK

This first tip applies not just to comic book artists, but to anyone and everyone who works on a computer: Save your work as often as possible, even if you are nowhere close to being finished with it. I suspect those of you who have taken a computer class in school have already had this tip drilled into you by your teachers. There's a reason why this tip is important though. Nearly everyone can share a tragic story (or several tragic stories!) about their work-in-progress being lost because of an unexpected power failure or similar accident. Thankfully, most software programs now have built-in features that automatically save your work on a regular basis. But take it from me, even those aren't foolproof.

Second tip: Back up your work. Again, if your computer fails, your work could be lost forever. An external hard drive and/or backing up your files to a cloud-based service is a must for your sanity. Back in the day, we insisted our artists keep photocopies of their work, just in case. There's the famous story of nefarious Neal Adams having his portfolio of work stolen while he slept on a New York subway, never to be seen again. There were no copies, and Neal had to start over. (And then this happened again, twenty-one years later, when he left his portfolio in a yellow taxi cab in Manhattan!) Should you still use pen and paper, scan the work before sending it off, because, as you see, things happen.

As I told you earlier in the book, most artwork is scanned in at 300, 600, or even 1200 dpi and should be saved as a TIFF file. Don't be tempted to save it as a JPEG to save on memory space, or make your art easier to send—you'll want your art to be as high resolution as possible. Many artists scan their work as black and white images, or possibly greyscale if the page has any grey tones or pencil marks on it you want to retain. One good tip is to scan your page in as a 24-bit color image and then adjust the contrast to make your blacks blacker. This is the best way of capturing all the subtlety of your inking while still giving your publisher beautifully crisp and dark artwork they can print from.

Don't forget to save your work! Red Sonja interior art by Carlos Gomez and colored by Mohan.

PULL COLOR FROM PHOTOGRAPHS

Here's a tip for you aspiring colorists. As I discussed in Chapter 8, a colorist's job is both complicated and also vitally important. You have to determine the perfect color for each part of the comic's artwork. If you do your job right, the art becomes even more stunning and dynamic. The best coloring work makes art pop right off the page. But, the wrong mix of colors can make an entire page appear garish and unsightly. It is no exaggeration to say that colorists are the linchpins of comic book creation. You hold everything together!

To help select the most appropriate color from the millions that are available, colorists often look at photographs and try to duplicate their hues and tints. You can use the Photoshop eyedropper tool to take the guesswork out of determining the exact color that appears in a photograph. Simply take the eyedropper and touch the photograph. The tool not only detects the exact color in the photograph but then puts that color in your digital paintbrush. Now you can color with confidence!

Use the eyedropper tool to sample the desired colors and values from reference photos to keep the palette consistent.

DIGITAL ART TECHNIQUES

It used to be oh so simple—all an artist had to master was a pencil, a brush, a pen, and the odd eraser or two. These days digital techniques have given you guys no limits to the different ways you can construct a page, often using this handy little tool called Layers. Both Photoshop and Clip Studio Paint allow you to work in image layers, and you should take full advantage of these features. Think of layers as separate sheets of transparent paper that the software program allows you to stack on top of each other. That means you can draw breakdowns on one layer, and then ink over the breakdowns on a second layer. The breakdowns layer can then be deleted when you're finished. This is one of the advantages that a drawing tablet has over paper. No erasing!

The ability to print your art out in non-repro blue (a particular hue of blue your scanner can't detect) has also given artists all sorts of chances to perfect their work. Some like to print out their rough breakdowns (which might be drawn digitally or scanned in and blown up in Photoshop) in blue, draw more tightly on top of them, and then scan in the finished pencils. These pencils can then be printed out in blue themselves and inked by hand, or inked digitally on your computer. Of course, if you are working entirely digitally you don't necessarily need to think about "inking" your work. You could choose instead to go straight in over your breakdowns using any of the many digital brushes available in software packages. Yet another option, for the very neatest of you, is to scan in your pencils, darken them and clean them up digitally, removing any of the more scribbly bits. Whatever works for you is just fine.

Only by trial and error will you learn what works best for you. Even then, you may want to do different approaches given the nature of the assignment. For example, a particularly atmospheric vampire tale might need lots of tonal work that wouldn't be as appropriate for a jungle tale.

Organization is key. Separate elements of the art can be placed on separate layers to protect other individual elements. It's key to not color or draw over different parts of the drawing. Check out the Layers palette in Photoshop.

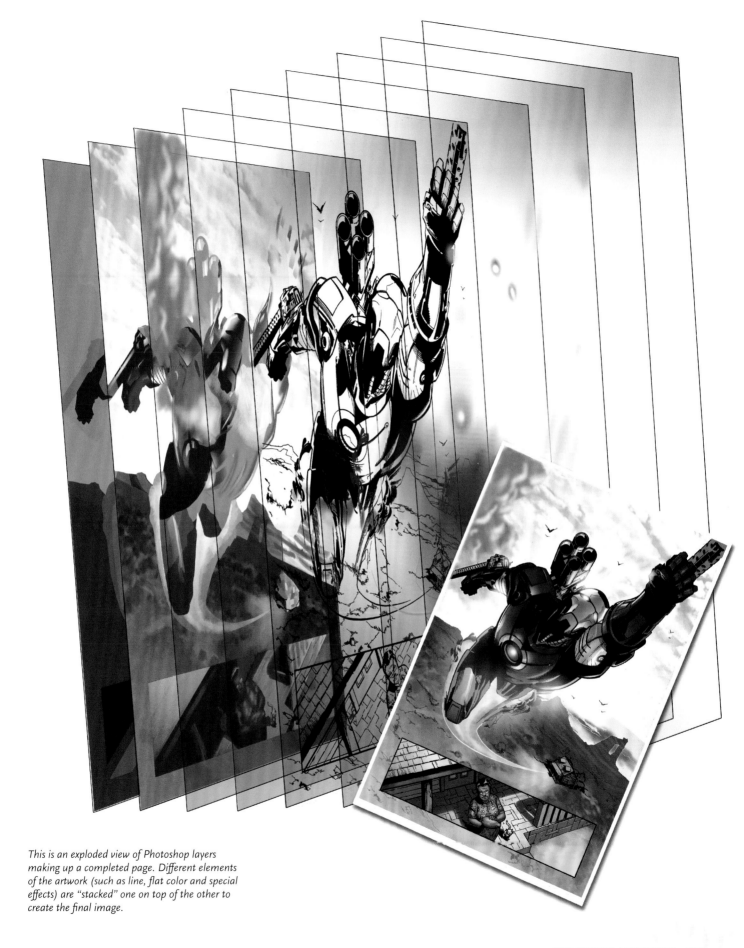

This is an exploded view of Photoshop layers making up a completed page. Different elements of the artwork (such as line, flat color and special effects) are "stacked" one on top of the other to create the final image.

LET SOFTWARE PROGRAMS FIX YOUR MISTAKES

Hey, we're all human. That means it's inevitable that we're going to make some mistakes. Let's say you're drawing a scene where a despicable despot pulls a gun on your stalwart superhero and fires. In an extraordinary display of athleticism, your superhero nimbly dodges the bullets, and then disarms the villain. Evil is foiled again! But, before you move on to draw the next panel, you realize you made a mistake. As you look back over your work, you see that the first panel begins with the villain holding his gun in his left hand, but by the end of the last panel he's holding it in his right hand. Oops! You goofed. And now you're going to have to redraw all those panels where the gun is in the wrong hand, right? Wrong! With a few mouse clicks, a program like Clip Studio Paint can correct that mistake. You just trace the villain using the lasso tool, which isolates the figure from the rest of the artwork in the panel. You can then flip him through a command in the edit dropdown. Voila! The gun is now in the correct hand!

By isolating elements within the panel, the lasso tool can help you make any number of corrections, adjustments, and changes. For instance, you can move characters' eyes higher or lower on their face, or make the eyes bigger or smaller. Heck, you can make entire characters larger or smaller if you want to! My point is that by correcting your mistakes, the software programs save you valuable time.

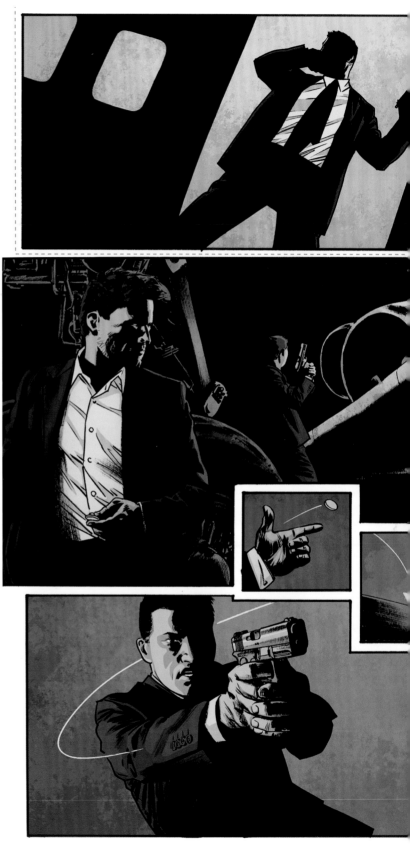

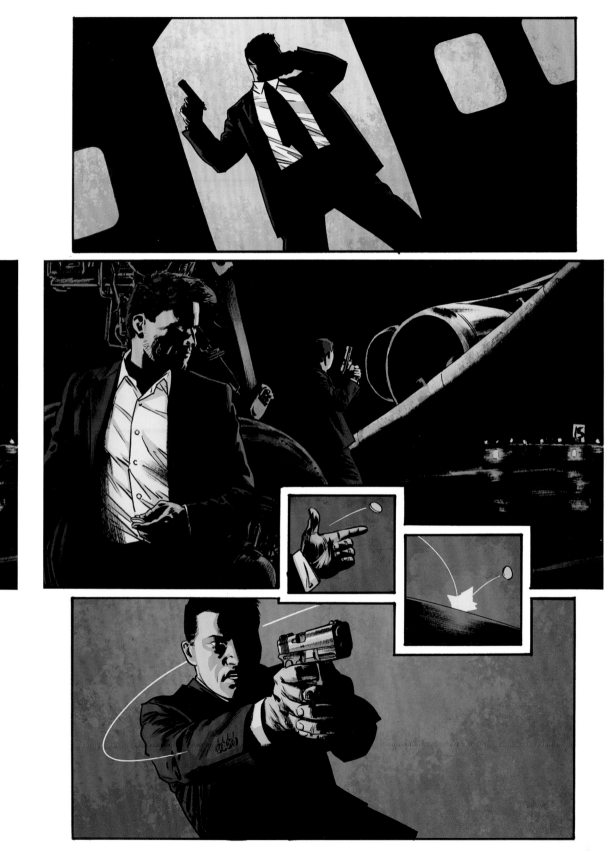

An interior panel is easily flipped over to correct mistakes. Art from Uncanny #1 by Aaron Campbell and Bill Crabtree.

ADVANCED SOFTWARE PROGRAMS

In days gone by, most artists would have to draw from their imaginations, photos, clippings from magazines, or even from life. These days digital companies are determined to make life as easy as possible for you.

SketchUp is a free 3D program, although there is also a professional version you can buy which offers more features. It's quite a simple 3D software package that allows you to either build or download models. These can be models of anything: buildings, cars, weapons—you name it. You can rotate the model to any angle you like and even light it, though this feature is pretty limited. Some publishers

already have SketchUp models of certain vehicles or secret hideouts which you can call up to help you keep the strip looking consistent.

Daz3D is the program for posing figures. It's commercial software that comes with a few basic figures which you can alter in different ways. You can also purchase other figures. This means you can create the perfect pose for whatever situation you happen to be drawing. The digital software also offers up video tutorials, gallery, and a user forum to share ideas or get tips.

Autodesk SketchBook (a free download) and Clip Studio Paint come with perspective rulers. Clip Studio Paint

also gives you the option of importing 3-D models right into your drawing and moving them around to suit your needs. Photoshop has this option too, although its perspective rulers are more limited than Clip Studio Paint's. So, no more taping enormous bits of rough paper to the edge of your page for those far-off vanishing points. Phew!

Here we see the user interface for SketchUp.

This is the user interface for Daz3D.

Clip Studio Paint has robust perspective tools to benefit comics artists.

RECYCLE YOUR ARTWORK

When appropriate, don't hesitate to take your artwork from one page and recycle it on another page. For instance, let's say you just finished a panel and you really like how you drew one of the characters. The character's anatomy, facial expression, and posture are all perfectly rendered. And now that you think about it, you could also use the same rendition of the character on another page ahead. In that case, save yourself the time of redrawing the character in exactly the same way and instead isolate the character with the lasso tool, copy it and drop it onto the later page. This isn't exactly cheating because you are recycling your own artwork. Your editor will appreciate your efficiency. (And I should know, I was an editor for many, many years. Nothing impressed me more than artists who handed me work in on time.) Be warned though, only use this trick very sparingly and where appropriate. In sequences where repetition is called for, this is perfect, but if you've been asked to stage an imaginative battle royal, your editor won't be pleased.

A copy of the first panel was made and the artist slightly reworked the facial expressions on the second. This is an important time saving element. From King: Flash Gordon #3 featuring art by Lee Ferguson, Marc Deering, and Omi Remalante.

USE REFERENCE MATERIAL

Okay, you have all the tools and you have a script, but you've never drawn a World War I biplane before. Any comic book artist will tell you that photo reference material is invaluable for making their artwork as authentic and realistic as possible. If you haven't done so already, you should begin stockpiling pictures of people, buildings, cars, and so on. Keep all of these photos in a folder on your computer so that when you need to draw something you're not familiar with, you can easily and quickly access a photo for reference.

Now I want to describe another keen Clip Studio Paint feature: The program lets you drop one of your reference photos onto a new layer. You can then place your art layer over the photo layer, and "abracadabra"—you can now easily trace the photo. No more looking back and forth between the photo and your artwork. This is particularly helpful when you need a landscape in your background, like a countryside or a cityscape. Once you've finished drawing, just delete the photo layer and you are left with the art layer alone. The final image will still be your artwork, your interpretation of the photo, but you'll have saved so much time.

Now to sound like your father (okay, grandfather): Be careful how you use your reference material. A lot of the work you stockpile will likely be owned by others, check for the copyright symbol. If you use it and the photographer or artist recognizes it, you open yourself up to a costly (and time-consuming) lawsuit. Feel free to trace and gather inspiration from the work, but do not steal someone else's work. There are plenty of images available in the public domain—all you have to do is look online. A terrific source is the photography stored at the Library of Congress (http://www.loc.gov/pictures/), which is easily searchable.

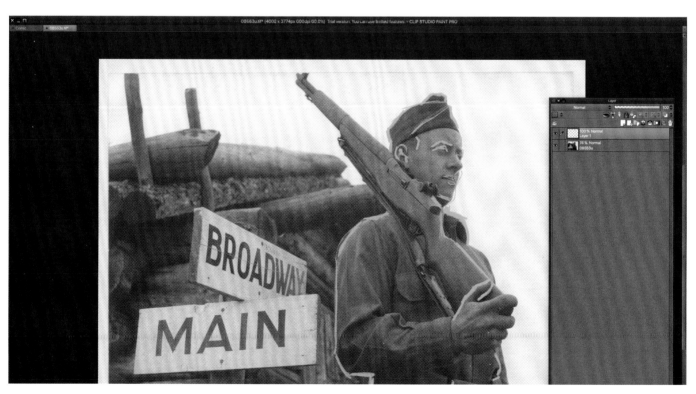

A separate empty layer is placed over the image layer so that the tracing can be done without harm to the image.

USING FTP (AND OTHER METHODS) TO TRANSMIT FILES

You will soon learn that one of the drawbacks of using high-resolution images is that they take up a lot of space on your computer. This is especially true after they are colored and lettered. Hi-res comic book pages are often very big files, so big that you won't be able to email them as attachments. And there will be times when you will need to send those pages to an editor or a publisher or another comic book creator. So, what do you do?

Here are three options. First, you can use FTP (File Transfer Protocol). This is an application specifically designed for the quick and secure transfer of files through a network. It's very easy to use. After you log on to the FTP server, you (and whoever else has access to the server) can then upload, download, copy, delete, and rename files. Most publishers have their own FTP sites which are free for you to use. Another alternative is a file transfer site like dropbox.com that allows users to create a special folder on their computers which can then be shared with other users who also have the login information. Whatever files you deposit into your Dropbox folder also appear in the Dropbox folder of your collaborator and vice versa. WeTransfer.com is another useful site. Via the website, you can send up to two gigabytes of files to another person for free! This is particularly helpful if you have to send several hi-res images all at once. You just put them all within a zipped folder and off it goes via WeTransfer.com. The person you're sending the files to gets an email with a download link.

FileZilla is one of the most popular and dependable FTP clients for download, and it's free!

SHOWCASE YOUR WORK ONLINE

As an artist, you should always look to improve your work. Be proud of your talent, but never stop striving to be better. Never stop learning. With the right attitude and the right work ethic, you will be a better artist ten years from now than you are today—and an even better artist twenty years from now than you will be ten years from now! Eliciting the feedback of your peers is one path to improvement. And by "peers," I mean other artists. No one else will better understand and appreciate your specific challenges, and no one else can better suggest ways to improve your art.

The best place to find your peers is online at one of the websites where artists post their artwork and interact with each other. The largest and most popular of these sites is deviantart. com. There you will find hundreds upon hundreds of talented artists showcasing a wide array of art styles and techniques. Even if you don't yet feel ready to post your artwork for the world to see, you should still register as a member. The sooner you register, the sooner you can become familiar with and comfortable among the community of artists you aspire to join. That way, when the time comes that you are ready to post your artwork, the other members will be more open and helpful with their feedback.

For any artist, be they a humble beginner or a big name pro, having a presence on a social media platform like Facebook, Twitter, Tumblr, or Instagram can be essential. Not only is it a great way of getting your artwork seen by the public, it's also the best way to publicize your latest projects, in-store signings, and convention appearances (hey, let's dream big here!). These sites offer artists ways to keep in touch with their fans like never before and allow potential publishers to get in contact with you. There's really no such thing as too much exposure.

Deviant Art has been the most popular artists' portfolio site since it opened way back in 2000.

POST YOUR COMIC AS A WEBCOMIC

For decades, the only way to get your comic book in front of the eyes of a large readership was to pitch it to a publisher and then hope it was accepted and published. Nowadays, there are still plenty of comic book publishers willing to consider submissions. If you have your heart set on being published by a specific company, I would urge you to find that publisher's submission guidelines. (They are usually posted somewhere on the publisher's website.) These guidelines tend to vary from publisher to publisher, so make sure you read them carefully and adhere to them when you are submitting your comic book.

However, in the event that you can't find a publisher to accept your work, you shouldn't get depressed or feel defeated. That's because in this day and age, you don't need a publisher! You can be your own publisher! Now I can hear you asking, "Don't I need money to be a publisher? Or at least a website?" Nope and nope! You can accomplish this using just your existing social media accounts (Facebook, Twitter, Instagram, and so on). All you have to do is turn your comic book into a webcomic that you can promote and hype online. Separate your comic book into individual pages and then post a new page on all your social media accounts on a regular basis. By "regular," I mean a new page at least once a week. That's the only way to make sure your network of contacts remains invested in the story you are telling. If you wait several months before posting a new page, people may no longer be interested (and it's more than likely that they'll have forgotten what your story is even about!).

To spread the word about your own webcomic you might want to connect with other artists and pledge to promote each other's webcomics. This way, your work is simultaneously presented to several networks of readers, not just your own, and you'll be part of an ever-growing community of online artists. And there are a growing number of hubs for webcomics created by veteran artists or newcomers like yourself. This is another way to have your work looked at by peers and readers. Like I said, you don't need a publisher! You can do this all yourself.

We live in an ever-changing world of digital technology, and it seems like there are always new ways of creating your artwork and getting it seen by more and more fans. And no doubt the ways that people will read your work will continue to change with it. Who knows what the future will bring; 3-D hologram comics perhaps? Animated comic strips zapped straight to your TV? I'm guessing the good old paper comic book will still have its fans, but for the rest, the sky's the limit!

Redtail's Drea

Read it in English:

Lue suomeksi:

Home About Archive Characters Gallery Fanart Store

"A Redtail's Dream" is a webcomic about a young man and his shapeshifting dog on an involuntary journey on the other side of the Bird's Path in the realm of dreams. They have to rescue their fellow Villagers before their souls pass on to Tuonela, the land of eternal sleep.

The comic is now complete, it ran for two years from September 2011 to November 2013, is 556 pages long and available in both English and Finnish. Enjoy reading it, and afterwards you can find my current webcomic over at sssscomic.com.

~Minna
Sundberg

A Redtail's Dream *by Minna Sundberg is a very popular and renowned webcomic.*

Iron Man and Iron Fist locked in a stalemate on the cover to Iron Fist #1.
Art by Mike Esposito.

So, you've read the book, taken in all my tips about drawing, inking, coloring, and lettering. You know how to use reference material, how to construct a background in perspective, and how to fill your stories with believable and imaginative characters. Now's your chance to bring all those skills together and actually draw your own comic strip! At last! Here's a little something I dreamt up myself, pitting the Terrific Trifecta against the Menace of the Monster Machine. Let's see what you can do with it!

PAGE ONE:

SPLASH PAGE.

Low angle perspective of a thirty-foot-tall, ape-like monster rampaging down the skyscraper-filled streets of a major American city in broad daylight. Baring his fangs, the monster is coming right at us! At the bottom of the page are several civilians of various ages also running towards us as they desperately try to flee the monster.

At the very bottom of the page are the CREDITS—story title: Trifecta, the super-heroic trio, confronts 'The Monster Machine!'

PAGE TWO:

PANEL ONE.

Medium shot of two civilians. A heavyset, middle-aged businessman collides into an attractive young woman in her early 20s. The businessman is looking behind him as he runs from the left side of the panel towards the right side. He doesn't even see the woman as he knocks her down.

BUSINESSMAN: THERE'S NO STOPPING IT! THERE'S NO STOPPING IT!!!

YOUNG WOMAN: UGH!!

PANEL TWO.

Fish-eye-lens view of the young woman lying on her stomach on the ground. She looks like she's in a lot of pain. She struggles to lift herself off the street. In the background, directly above the woman, is the monster. He's looking at the skyscraper next to him.

YOUNG WOMAN (TO HERSELF): OW! HELP ME!

PANEL THREE.

Medium shot of the monster taking a powerful swipe at the skyscraper next to him. Large pieces of debris go flying in every direction.

SOUND EFFECT: SMASH!!

PANEL FOUR.

High angle perspective (as if from the monster's point of view) of the young woman who now lies on her back. The large pieces of debris are headed directly toward her. Realizing she's going to get crushed by the debris, the woman screams in terror.

YOUNG WOMAN: AIEEEE!!!!!

PAGE THREE:

PANEL ONE.

Same perspective as panel 4 of the previous page. The debris crashes to the street, but the woman is now gone. Instead, a blue streak stretches from one end of the panel to the other end. It weaves in and out of the falling debris. It's the super speedster known as SPRINT, one of the members of TRIFECTA. He's saved the young woman, but he's moving so fast that we can't see him (or the woman that he's now carrying).

SPRINT: GOT YOU!!

PANEL TWO.

Long shot of Sprint and the young woman. Sprint has raced to one of the city's public parks, far away from the rampaging monster. (In fact, we can see the monster way off in the distance in the background.) Sprint has come to a sudden halt (the blue streak caused by his superspeed trails him) and he lets go of the young woman. Sprint has a HUGE grin on his face as he flirts with the young woman. For her part the young woman looks relieved, thankful that Sprint saved her.

SPRINT:	YOU'LL BE FINE HERE, MISS.
YOUNG WOMAN:	YOU SAVED ME! HOW CAN I EVER THANK YOU?
SPRINT:	WELL, ARE YOU FREE FOR DINNER TONIGHT?
RADIO TRANSMISSION:	<FLIRT LATER, SPRINT!>

PANEL THREE.

Long shot of the other two members of TRIFECTA flying directly at us. (Perfect opportunity for some dramatic foreshortening!) Occupying the left side of the panel, TITAN looks grim, serious, determined. Beside him, occupying the right side of the panel, PULSE looks a little more relaxed. She glances over at Titan and smiles in admiration.

| TITAN: | TRIFECTA HAS A JOB TO DO! |
| PULSE: | I GET GOOSEBUMPS EVERY TIME YOU SAY THAT, TITAN! |

PANEL FOUR.

Long shot of Titan simultaneously launching himself and growing in size in order to confront the rampaging monster (whom we don't see in this panel). Titan's fists are clenched as he prepares himself for battle. This panel shows a series of figures: (1) The background figure is Titan at regular height, (2) the middle figure is Titan at double his natural height, and (3) the foreground figure is Titan at triple his normal height. The coloring of the first two figures should be desaturated so that the third foregrounded figure is most emphasized. Readers will understand clearly then that Titan is growing in size.

| TITAN: | PULSE, COORDINATE YOUR FORCE FIELDS WITH SPRINT'S SPEED TO SAVE AS MANY INNOCENT LIVES AS YOU CAN! I'LL USE MY GROWTH POWERS TO TAKE ON 'KING KONG' HERE! |

PAGE FOUR:

PANEL ONE.

Long shot of Titan and the monster charging towards each other. Titan is on the left side of the panel while the monster is on the right side of the panel. A slightly low angle perspective will emphasize the enormity of the two combatants, who both have their teeth clenched with one of their arms cocked back, ready to strike.

PANEL TWO.

The monster delivers the first blow! In the background the monster swings his arm forward, punching Titan right in the jaw. Occupying the foreground, Titan snaps his head backward (toward us), his face grimacing in pain.

| SOUND EFFECT: | CRACK!! |
| SOUND EFFECT: | WHRRR! |

PANEL THREE.

Long shot of Titan picking himself up from the street. He rubs his jaw with one of his hands. In the background Sprint runs by.

TITAN:	WAIT A MINUTE. DID ANYONE ELSE HEAR THAT?!
SPRINT:	HEAR WHAT?! YOU GETTING PUNCHED IN THE HEAD?!
TITAN:	NO. THE DISTINCT SOUND OF HYDRAULICS.

PANEL FOUR.

A series of figures that shows Titan shrinking down in size (in other words, the opposite of what was presented on page 3, panel 4). The first figure in the foreground is double the height of the middle figure, which is double the height of the third figure. Again, desaturate the coloring of the first two figures so the third figure (the shortest figure) is most emphasized. Titan looks like he's headed toward the monster's legs, which occupy the panel's background.

| TITAN: | I'M GOING TO SHRINK DOWN TO TEST A HYPOTHESIS. |

PAGE FIVE:

PANEL ONE.

With Titan gone, here's our opportunity to show the super-heroics of the other two members of Trifecta. Long shot: Sprint and Pulse stand side-by-side, working together to protect a group of scared civilians who are crouching on the ground. Sprint has extended his arms out in front of him in order to rotate them at super speed, causing a vortex that blows debris away from them. Pulse, on the other hand, raises her hands above her head to project a force shield that stops big chunks of building from falling on them.

SPRINT:	I HATE IT WHEN TITAN USES BIG WORDS LIKE THAT.
PULSE:	THAT'S BECAUSE YOU NEVER GOT PAST THE SIXTH GRADE, SPRINT.
SPRINT:	OUCH! WITH TEAMMATES LIKE THESE . . .

PANEL TWO.

Close-up of Titan's face. His head is surrounded by wires and machinery.

| TITAN: | ALL RIGHT, I'M INSIDE. |
| PULSE (RADIO TRANSMISSION): | <INSIDE THE MONSTER?> |

PANEL THREE.

Long shot of Titan flying within a metallic tunnel that is congested with wires and bolts and rods. Running down the middle of the tunnel is a very thick cord that Titan identifies as the robot's main power line.

| TITAN: | NO, PULSE. NOT A MONSTER. AS I SUSPECTED WHEN I HEARD THE HYDRAU-LICS, IT'S A MACHINE. THE MONSTER IS A ROBOT. I'M GOING TO FOLLOW THIS MAIN POWER LINE AND SEE WHERE IT LEADS. |

PAGE SIX:

PANEL ONE.

Medium shot of Pulse as she continues to project force fields to protect the civilians. She looks like she's starting to get a bit tired. She's sweating and her face looks strained from the exertion of all the force fields she's been projecting.

| PULSE: | WHATEVER YOU'RE DOING, MAKE IT QUICK! SPRINT AND I ARE GETTING A BIT TIRED OUT HERE! |
| TITAN (RADIO TRANSMISSION): | <I SEE A LIGHT! I THINK THERE'S A CONTROL ROOM WITHIN THE ROBOT!> |

PANEL TWO.

Long shot of Dr. Nero and Titan within a cramped control room full of computer consoles and view screens (one of the view screens even shows Pulse and Sprint down on the street). (NOTE: Behind Titan is a sealed escape hatch.) Dr. Nero occupies the left side of the panel, near a console that has various levers and buttons. Dr. Nero is a frail-looking old man, who looks menacing despite his advanced age. He has turned around to look behind him as Titan appears in the room. Titan occupies the right side of the panel and has quickly grown to his normal height. Make sure to supply some kind of visual effect to indicate that Titan is growing as he enters the control room.

| TITAN: | OH, FOR THE LOVE OF—! IT'S DR. NERO! HE'S CONTROLLING THE ROBOT FROM INSIDE! |

PANEL THREE.

Close-up of Dr. Nero. He scowls, practically spitting out his words. This close-up truly reveals how old Dr. Nero looks. His horribly wrinkled face makes him look well past one-hundred-years old.

| DR. NERO: | ENVIOUS OF WHAT I'VE INVENTED??!! I ALMOST HAD YOU FOOLED ABOUT MY MONSTER'S TRUE ROBOTIC NATURE, DIDN'T I? |

PANEL FOUR.

Medium shot of Dr. Nero who occupies the foreground. He's right in front of us. There's an evil gleam in his eye. He has turned his attention back to his control console. Behind him, in the background, Titan is angry. He points at Dr. Nero in a threatening manner.

| TITAN: | YOU CAN NEVER MANAGE TO FOOL US FOR VERY LONG. NOW SHUT DOWN YOUR MONSTROSITY SO I CAN GET YOU BACK TO THE OLD AGE HOME IN TIME FOR THE NEXT BINGO TOURNAMENT! |
| DR. NERO: | MOCK ME ALL YOU WANT, BUT AS I'VE SWORN TO YOU BEFORE . . . |

PANEL 5.

Close-up of Dr. Nero's hand as his index finger presses a button marked "Self-Destruct."

| DR. NERO: | . . . I WILL FOREVER BE REMEMBERED AS THE WORLD'S GREATEST MASTER-MIND! |
| SOUND EFFECT: | CLICK! |

PANEL ONE.

 Medium shot of Titan (from Dr. Nero's perspective). Titan looks up at the ceiling as he hears the automated announcement that the self-destruct sequence has begun. Titan looks very confused.

COMPUTER VOICE: <SELF-DESTRUCT SEQUENCE INITIATED. DETONATION IN FIVE SECONDS.>

TITAN: WAIT, WHAT?!

PANEL TWO.

 Medium shot of Dr. Nero (from Titan's perspective). Nero has a maniacal grin on his face. He has his hands out in front of him as if to simulate the power of an explosion.

DR. NERO: "YOU HEARD CORRECTLY, TITAN. YOU HAVE NO TIME TO STOP THE SEQUENCE, AND YOU CAN WELL IMAGINE THE DESTRUCTIVE POWER A BOMB THIS BIG HAS."

PANEL THREE.

 Exterior shot from outside the robot's head, we see Titan violently kick open the hatch door.

TITAN: NEW CRISIS, GANG!

SPRINT (RADIO TRANSMISSION): "<NOW WHAT?!!!!>"

PANEL FOUR.

 Interior shot: We're back inside the control room where Titan has Dr. Nero slung over his shoulder as he makes a mad dash for the exit (the door that he just kicked open).

TITAN: NERO JUST SET THIS ROBOT TO SELF-DESTRUCT, AND IF IT DETONATES, IT COULD LEVEL THE ENTIRE CITY! PULSE, YOU'RE GOING TO HAVE TO CONTAIN THE EXPLOSION WITHIN ONE OF YOUR FORCE FIELDS.

PANEL FIVE.

 Close-up of Pulse. She's so exhausted that she has no confidence that she can do what Titan is asking of her.

PULSE: ME? I'VE NEVER ENCLOSED AN EXPLOSION THIS BIG . . . AND I'M NEAR EXHAUST-ED ALREADY.

PANEL SIX.

 Exterior shot: Carrying Dr. Nero over his shoulder, Titan flies out of the hatch.

TITAN: YOU'RE OUR ONLY CHANCE! TIME'S RUN OUT! DO IT NOW!!!!

PAGE EIGHT:

PANEL ONE.

 Medium shot of Pulse stretching her arms out before her in order to project force fields. By the look on her face, she's straining, desperately expending every last ounce of energy she's got in order to protect the city from the robot bomb.

PANEL TWO.

 This Panel takes up half the page. Low-angle perspective with Pulse in the foreground and the robot towering over her in the background. We're behind Pulse, watching her encase the robot with her force field just at the moment of detonation. The explosion ripples and buckles the force field, which holds nonetheless. Still carrying Dr. Nero over his shoulder, Titan descends from above the force field. He has the perfect view of Pulse's heroic feat.

TITAN: YOU DID IT, PULSE!! YOU SAVED THE CITY!

SOUND EFFECT: BABOOOOOMMMMM!!!

PANEL THREE.

 Long shot of Trifecta, reunited to wrap things up. From left to right stand Pulse, Titan, and Sprint. The street is absolutely littered with debris, and in fact, some light debris is still raining down. Feeling weak and looking like she's going to collapse, Pulse leans herself against Titan, who holds Nero by the collar of his shirt. Sprint runs in from the right side of the panel and angrily points his finger at his two teammates.

PULSE (WEAK VOICE): YEAH, HOORAY FOR ME. AND NOW I AM GOING TO TAKE A NAP.

TITAN: AND NOW I AM GOING TO TAKE NERO BACK TO PRISON.

SPRINT: AND NOW I AM NOT CLEANING UP THIS MESS ALL BY MYSELF!

THE END

IN MEMORIAM

by Roy Thomas

So here we are at the fourth and final volume.

I've been intrigued to read the previous three iterations, in which Stan presided over lessons in writing and drawing comic books in general, and Marvel-style superheroes in particular.

He was perhaps the ideal person to spearhead such a project; since not only was he the foremost comics writer (and editor) of the last half of the twentieth century, he also served as Marvel's art director, officially from the 1940s through the early 1970s, and unofficially for the rest of the latter decade, until he moved to Los Angeles to concentrate his efforts on getting Marvel's heroes first into quality animation entries and then into live-action TV shows and films.

Although Stan wasn't an artist, the "art director" title was not just an honorary one. For decades, he pored over each and every page of penciled artwork, and most inked ones as well . . . and he had a swift eye for a dull figure or poor storytelling.

Besides that, he was, in his own way, a comics fan. He would suddenly wax enthusiastic over a page of artwork, whether it was done by a familiar, seasoned pro or a brand-new recruit. I recall how thrilled he was that day in late 1965 when Jack Kirby turned in the pencils for the *Fantastic Four* issue that introduced a space-soaring character called "the Surfer." Stan, inspired in his own way, christened him "the Silver Surfer" when adding dialogue to the story, giving him not only a noble nomenclature but a definite color scheme. Thus were his writing, editorial, and art-director skills all put on display in one fell swoop.

Working for and with Stan, from the day I began in early July of 1965 until our last collaboration in the mid-1990s on a comic for the next-released Excelsior line he intended to edit in California, was always an exciting experience. His enthusiasms were as boundless as his abilities. Of course, over the years, he was blessed to work with some of the best artists in the business. In the 1940s and for most of the '50s, there was, above all, the great Joe Maneely, who could draw damn near any kind of story, and do it well—and *fast*. In the latter 1950s, two more prodigious talents wandered into the company, then known as Timely, at a propitious moment—Jack Kirby and Steve Ditko. Working with them, utilizing not only their manual artistry but also harnessing their considerable brainpower to his own, Stan produced, in a period of three short years, *The Fantastic Four*, *The Incredible Hulk*, *The Amazing Spider-Man*, *The Mighty Thor*, *The Astonishing Ant-Man*, *The Invincible Iron Man*, *Nick Fury—Agent of S.H.I.E.L.D.*, *Dr. Strange*, *Captain America*, *Sub-Mariner*, *The Avengers*, *The X-Men*, and *Daredevil*. Even on the handful of characters he did not totally co-create with Kirby, such as Cap and Prince Namor, he left an indelible stamp that turned them into something even greater than they had been before.

It was a joy and a wonder to me to stand, several days a week from mid-1965 through the early 1970s (and even after), at his side and watch him point out the strengths and weaknesses in the artwork for which he had (probably overnight!) written dialogue that had just as much to do with the sales success of Marvel Comics as did the beautiful, power-packed illustrations before him. He knew full well how important his scripting was to Marvel's ever-increasing popularity, which is why he had taken so long to hire new writers such as myself, whom he felt he could train to tell stories the way he wanted them told. (Although, even then, we were acutely aware, especially during our early months, how far short of the mark our own efforts fell compared to most of what he wrote. And later, when some of us adequately gained our own voices, so that we could mesh our own ideas and specific skills with what he had taught us, Stan was smart enough to know when it was time to step aside and, at least for the most part, let his fledglings fly or fall on their own.)

Stan wasn't perfect, of course. No one is.

In the end, perhaps he wasn't able to find a way to bridge a growing gap between himself and some of the most talented and headstrong of his artists, such as Ditko, Kirby, and Wally Wood. But, while he hated to see each and every one of those Olympians depart, he felt, at the same time, that he had recruited a new generation of artists to help him carry the torch; the likes of John Romita (with whose help he steered *The Amazing Spider-Man* to even greater heights), John Buscema (whose *Silver Surfer* was, for its two-year life, the toast of college students all over the country), Gene Colan (who could combine nigh-photographic realism with heart-stopping superhero action), Jim Steranko (who combined his Kirby influences with pop-art imagination to take things to the next level), Marie Severin (whose humor work alone made her one of the greats), and the list goes on.

Nothing stopped Stan. When I suggested "Dr. Voodoo" as the name and concept of a new supernatural hero,

Stan turned the moniker over in his head for roughly three seconds and then said "*Brother* Voodoo." It was an improvement.

Even when he faltered, as when he proposed a new comic be titled The *Mark of Satan*, and I suggested that such an approach wouldn't exactly put us in solid with the so-called Bible

November 9, 1965, and the morning after.

At around 5:30 p m. on the 9th, there was a power blackout over most of the American Northeast, which plunged all of New York City and environs into darkness until well into the next morning. My new fellow Marvel staffer Denny O'Neil and I, after being

was just beginning to come back on—and were astonished to find Stan already there, having made it in from his home out on Long Island, with a briefcase full of fully dialogued pages of a *Daredevil* issue that had needed scripting. Yes, the blackout had hit Long Island as well as Manhattan, but Stan knew that the production man-

From left to right: Irwin Hasen, Roy Thomas, John Romita, *and* Stan Lee - Chicago Comic Con, 1995

ager needed those pages written by the next morning, so he and his wife, Joan, set up what he referred to as a "candle brigade" to provide just enough light—and, on his manual typewriter, using the two-finger typing method by which he had always done his writing, he scripted dialogue for virtu- ally a full comic book. All while his young acolytes had goofed off and sought the ready excuse of "well, there's a blackout!"

Like I said, nothing stopped Stan Lee.

Not power blackouts, not defec- tions of artists, not the inevitable ups or downs of comics sales over the years—nothing.

Well, eventually, Stan left this mortal coil, as all must do one day. But, even though he always insisted that he was "not a legacy type of guy," he did leave a legacy—a legacy that combined talent and hard work, and yes, as he would have insisted, a decent helping of *luck* from time to time as well.

A legacy called Marvel Comics.

Belt and maybe *Son of Satan* was a way to slice the difference, well, once again he thought it over for a passing moment and then told me to go off and do it. Just as he had when I told him about Steve Englehart and Jim Starlin's idea for *Master of Kung Fu*—or my own thoughts for a secret-identity kung- fu hero called *Iron Fist*—or when he guided writer Archie Goodwin and me to help him shape the first solo African American superhero, who became *Luke Cage, Hero for Hire.*

But there isn't a better way to show Stan's indomitable spirit than to recount the events of Tuesday,

eventually led off our subway train through creepy tunnels by a man with a lantern, gave up on any idea of writ- ing anything that night. I was right in the middle of dialoguing an issue of *Millie the Model*, but what was I gonna do? No light—not to mention no electricity to power my Smith-Corona portable typewriter. So Denny and I went out with a friend and sat around talking and carousing by candlelight at a Greenwich Village restaurant called the Red Lantern.

Next morning, we came into the office—walking the sixty or so blocks from the Village because the power

INDEX